South African Photography
Südafrikanische Fotografie
1950–2010

South African Photography
Südafrikanische Fotografie
1950–2010

Herausgegeben von / **Edited by**

Delia Klask Ralf-P. Seippel

Inhalt **Contents**

Vorwort

Im Jahr der Fußballweltmeisterschaft, wenn alle Augen auf Südafrika gerichtet sind, richten wir unseren Blick auf 60 Jahre Fotografie in jenem Land, das in seiner politischen, gesellschaftlichen und künstlerischen Entwicklung einen eindrucksvollen Wandel vollzogen hat.

Es ist eine Reise in das Land der Apartheid, der Trennung zwischen den Hautfarben, zwischen arm und reich, eine Reise in ein Land der Unterdrückung und des politischen Kampfes um Freiheit und Gerechtigkeit.

Es ist die Reise in ein Land des Aufbruchs und der Hoffnung auf eine Zukunft in Freiheit.

Die Ausstellung bietet erstmals einen umfassenden Blick auf die Geschichte der Fotografie in Südafrika. Die Bedeutung dieses Mediums geht weit über einen dokumentarischen Charakter hinaus. So erweist sich der Weg von der Apartheid bis heute auch als der Weg einer wachsenden künstlerischen Autonomie, die sich in den gezeigten fotografischen Arbeiten spiegelt.

Wir danken den Künstlern, dass sie sich dieser Ausstellung mit viel Engagement gewidmet haben und uns ihre Arbeiten für diesen einmaligen Blick auf die Fotografie Südafrikas zur Verfügung stellen. Ralf Seippel hat als Initiator und Koordinator dieser Ausstellung Menschen zusammengeführt und die Brücke geschlagen zwischen Südafrika und den deutschen Partnern. Dafür danken wir ihm recht herzlich.

Hamba Kahle!

Gisela Kayser
Freundeskreis Willy-Brandt-Haus e.V.

Karla Nieraad
Stadthaus Ulm

Stephan Mann
Museum Goch

Peter Senft
IG Metall

Foreword

In the year of the Football World Cup, when all eyes are focussed on South Africa, we will be turning our attention to sixty years of photography of a country, which in its political, social, and artistic development underwent an impressive change.

It is a journey into the country of Apartheid, the segregation between skin-colours, between poor and rich, a journey to a country of oppression and the political fight for freedom and justice.

It is a journey to a country on the move and of hope for a future in freedom.

For the first time ever, this exhibition presents an extensive insight into the history of South Africa's photography. The meaning of this medium extends well past a documentary character. The journey from Apartheid until today also accounts for the growing artistic autonomy, which mirrors itself in the photographs presented here.

We would like to thank the artists for devoting themselves with such dedication to this exhibition, making their works available for this unique view into South African photography. As the initiator and co-ordinator of this exhibition, Ralf Seippel has brought people together and built the bridge between South Africa and the German partners. For this, we would like to offer him our sincere thanks.

Hamba Kahle!

Gisela Kayser
Freundeskreis Willy-Brandt-Haus e.V., Berlin

Karla Nieraad
Stadthaus Ulm

Stephan Mann
Museum Goch

Peter Senft
IG Metall

Vorwort der Herausgeber

Manche Ausstellungsprojekte sind so zwingend, dass man sich wundert, warum sie noch niemand realisiert hat. Südafrika hat politisch, gesellschaftlich, wirtschaftlich und kulturell in den letzten 60 Jahren mehrfach negativ wie positiv Weltgeschichte geschrieben. Die Apartheid, der Widerstand und der Weg in die Freiheit, auch unterstützt durch den wirtschaftlichen und kulturellen Boykott der Weltgemeinschaft, haben der journalistisch dokumentarisch intendierten Fotografie eine besondere Rolle zugewiesen.

Kaum ein Land hat über einen solch langen Zeitraum eine so große Anzahl von begnadeten Fotografen vorzuweisen. Fotografie als Dokumentation, erwachsen aus der europäischen Bildtradition, verbunden mit höchster technischer und ästhetischer Qualität und immer einhergehend mit hohem persönlichem Engagement ist bis heute für viele Fotografen Südafrikas selbstverständlich.

Das *Drum*-Magazin der 1950er- und frühen 1960er-Jahre hat durch seine unerschrockenen Journalisten wie Henry Nxumalo und seine engagierten Fotografen wie Bob Gosani, Peter Magubane, Ranjith Kally und G. R. Naidoo sowohl Südafrika als auch die Welt über die sich stetig verschlimmernden Verhältnisse und Diskriminierungen des Apartheidsystems informiert. Die Fotografien und Berichte von den Missständen der Farm- oder Minenarbeiter, den politischen Gefangenen, von den Räumungen und der Vertreibung der Bewohner von Sophiatown und District Six, über die Gerichtsprozesse, über das Bantu-Bildungsgesetz (Bantu Education Act, 1953), den Protestmarsch der 20.000 Frauen nach Pretoria im August 1956 bis hin zum Sharpeville-Massaker 1960 sind ohne Zweifel historische Dokumente. Diese Fotografen haben aber auch die wunderbaren Momente im alltäglichen Leben, in all der Bedrängtheit, abgelichtet und in betörende Bildern aus den Bereichen Musik, Tanz, Sport und Mode eingefangen.

David Goldblatt, Peter Magubane, Cedric Nunn, Paul Weinberg, Sam Nzima, George Hallett, Gideon Mendel und gille de vlieg haben die radikalisierten 1970er- und 1980er-Jahre durch die Dokumentation der Parallelwelten begleitet und für uns überliefert: Das Leben in den Townships und in den weißen Vororten ebenso wie die politischen Demonstrationen und Kämpfe. In all diesen Fotografien wurde Zeitgeschichte auf höchstem Niveau festgehalten.

Die Zeit der Veränderungen nach den ersten freien Wahlen 1994 und der Versuch der Aufarbeitung und des Dialogs durch die Wahrheits- und Versöhnungskommission (Truth and Reconciliation Commission, 1996–1998) gaben den Fotografen George Hallett, David Goldblatt, Santu Mofokeng, Cedric Nunn, Andrew Tshabangu, Jodi Bieber, Pierre Croquet, Bonile Bam und Mikhael Subotzky die Möglichkeit, Tradition und Modernität miteinander zu verbinden.

In der Ausstellung wie im Katalog erleben wir nicht nur eine Wanderung durch die Zeitgeschichte, wir erfahren ebenso ästhetische und inhaltliche Wandlungen.

Wir möchten uns auf diesem Wege bei allen für ihre Bereitschaft bedanken, trotz der extrem kurzen Vorbereitungszeit an den Ausstellungen teilzunehmen, Werke zu leihen und die Produktion tatkräftig zu unterstützen. Wir möchten aber auch nicht verhehlen, dass es uns trotz großer Bemühungen nicht gelungen ist, die eine oder andere Position, die wir gerne gezeigt hätten, aus welchen Gründen auch immer, zu integrieren.

Diese Aufnahmen gäbe es nicht ohne die Fotografen, ihren Mut und ihre Beharrlichkeit.

Die Ausstellungen und den Katalog gäbe es aber auch nicht ohne das Engagement von Freunden und Förderern, und ihnen gilt es ebenso zu danken:

Peter Senft für den Mut, das Projekt von Beginn an zu begleiten, mit unermüdlicher Energie voranzutreiben und andere Förder einzubinden, Gisela Kayser vom Verein Freundeskreis Willy-Brandt-Haus, Berlin, Stephan Mann vom Museum Goch und Wiebke Ratzeburg vom Stadthaus Ulm nicht nur die Ausstellung zu zeigen, sondern auch und vor allem für das Vertrauen, in die Realisierbarkeit der Ausstellung in nur drei Monaten. Markus Braun und Christina Hackenschuh für die Gestaltung des Kataloges, den Autoren Luli Callinicos, Andries Oliphant und Wiebke Ratzeburg für die interessanten und historisch wichtigen Beiträge, der Otto Brenner Stiftung und Wolfgang Schröder sowie meinen Kolleginnen und Kollegen und deren Assistenten in Deutschland und Südafrika, das Bailey's African History Archive (BAHA), der Goodman Gallery, der Bailey Seippel Gallery, der Galerie Caprice Horn, Maker-Lunetta Bartz, David Meyer-Gollan, Paul Weinberg, den beteiligten Fotografen und ihren Studios und hier im besonderen Dennis da Silva von Silvertone.

Delia Klask, Köln
Ralf-P. Seippel, Johannesburg

Foreword by the Editors

Some exhibition projects are so obligatory that it makes one wonder why no one has ever done them yet. In the past sixty years, South Africa has politically, socially, economically, and culturally written history in a negative as well as in a positive way. The journalistic documentary intended photography has been given a special role through Apartheid, the resistance and the path to freedom, supported by the economic and cultural boycott by the world community.

Scarcely has a country been able to produce so many exceptionally gifted photographers over such a long period of time. Photography as documentation, deriving from the European image tradition, connected with the highest technical and aesthetical quality and always accompanied with great personal dedication, is still self-evident for many South African photographers today.

The *Drum* Magazine of the nineteen-fifties and early nineteen-sixties, has been able to inform South Africa as well as the world about its steadily worsening conditions and the discrimination of the Apartheid system due to its fearless journalists such as Henry Nxumalo and its committed photographers including Bob Gosani, Peter Magubane, Alf Kumalo, Ranjith Kally, and G. R. Naidoo. The photographers and the reports of the grievances of the farm and mine workers, the political prisoners, from the evictions and banishments of the inhabitants of Sophiatown and District Six, the court proceedings, the Bantu Education Act of 1953, the protest march of the 20,000 women in August 1956 to Pretoria, up until the Sharpeville Massacre in 1960, are without doubt historical documentations. However, these photographers have also managed, in all the oppression, to capture the wonderful moments of every day life in beguiling images from the areas of music, dance, sports, and fashion.

David Goldblatt, Peter Magubane, Cedric Nunn, Paul Weinberg, Sam Nzima, George Hallett, Gideon Mendel, and gille de vlieg accompanied and conveyed to us the radical nineteen-seventies and nineteen-eighties by documenting the parallel worlds: The life in the Townships and in the white suburbs as well as the political demonstrations and fights. In all of these photographs, contemporary history has been recorded at the highest level.

The time of change after the first free elections in 1994 and the attempt of the rehabilitation and dialogue by the Truth and Reconciliation Commission (1996–98) gave the photographers George Hallett, David Goldblatt, Santu Mofokeng, Cedric Nunn, Andrew Tshabangu,

Jodi Bieber, Pierre Croquet, Bonile Bam und Mikhael Subotzky the possibility to combine tradition and modernity with one another.

In the exhibition as well as in the catalogue, we experience not only a journey through contemporary history, but we also experience the transformation aesthetically and also with regards to the content.

By this means, we want to thank all of them for their willingness to take part in the exhibitions, to loan works, and to actively support the production, in spite of the extremely short time we had for organising the show. However, we do not want to deny that despite our efforts it was impossible, for whatever reasons, to include all photographers in the show.

These photographs would not exist without the photographers, their courage and persistency.

The exhibition and the catalogue would also not exist if it was not for the dedication of friends and sponsors. Therefore, we wish to thank Peter Senft for his courage to accompany this project from the very beginning; Gisela Kayser from the Freundeskreis Willy-Brandt-Haus, Berlin; Stephan Mann from the Museum Goch, and Wiebke Ratzeburg from the Stadthaus Ulm, not only to show this exhibition, but also and especially for their belief in the feasibility of this show in only three months time. Furthermore we would like to thank Markus Braun and Christina Hackenschuh for designing the catalogue; the authors Luli Callinicos, Andries Oliphant, and Wiebke Ratzeburg for the interesting as well as historically important articles; the Otto Brenner Stiftung and Wolfgang Schröder as well as my colleagues and their assistants in Germany and South Africa; the Bailey's African History Archive (BAHA); the Goodman Gallery; the Bailey Seippel Gallery; the Galerie Caprice Horn; Maker-Lunetta Bartz, David Meyer-Gollan, Paul Weinberg, and the participating photographers and their studios and here in particular Dennis da Silva from Silvertone.

Delia Klask, Cologne
Ralf-P. Seippel, Johannesburg

Das Leben unter der Apartheid

Luli Callinicos

1948 brachten die weißen Wähler Südafrikas die Nationale Partei an die Macht. Ihre Politik der Apartheid versprach eine strengere und systematischere Ausrichtung der Rassentrennung und weiße Vorherrschaft als die, welche die politische Kultur seit der Kolonialzeit bestimmte.

Für viele schwarze Männer und Frauen brachte dies keine großen Veränderungen. »Es war für uns nicht besonders wichtig, ob uns die Weißen mehr Smuts [dem früheren liberal konservativen Premierminister] oder mehr Malan [dem ersten reaktionären, rassistischen Apartheidpremier] gaben«, so Chief Albert Luthuli, der Präsident des African National Congress (ANC). »Wir waren alle härter geworden, und keine Wahl schien die Richtung, in die man uns zwang, zu ändern.«[1]

Sie wurden bald sehr unsanft überrascht. In schneller Folge brachte die neue weiße Regierung eine Fülle von Gesetzen ein, um jeden Aspekt im Leben der Schwarzen zu reglementieren. Apartheid bedeutete, dass jede ethnische Gruppe (»Volksstamm«) ihr eigenes kleines Territorium erhalte, in denen sie endlich »unabhängig« sein sollten. Aber bis zu dem Zeitpunkt, wenn theoretisch alle Schwarzen in ihr jeweiliges Homeland (= Heimatland) zurückgekehrt sein würden, musste man Regelungen schaffen, die ihr Leben in den Städten ordneten. Auch in den ländlichen Gebieten, den »Reservaten«, gab es eine leichte Desorientierung, wie Luthuli es nannte.[2] In keinem Teil des Landes waren Weiße in der Mehrheit. Obwohl sie nur 15 % der Bevölkerung stellten, beanspruchten sie 90 % des Landes.[3]

Die nachfolgend aufgeführten Gesetze sind nur die wichtigsten, die in den ersten fünf Jahren der Apartheid verabschiedet wurden.

· Das Bevölkerungszensusgesetz (Population Registration Act) von 1950 klassifizierte bei jedem Mann, jeder Frau, jedem Kind gemäß der staatlichen Definition die »Rasse«. »Rasse« war nach staatlicher Überzeugung gottgegeben, und jede farbige Person wurde »wissenschaftlich« überprüft und als »Bantu«, »Farbiger« oder »Asiate« registriert.

· Das Gesetz zu gruppenspezifischen Gebieten (Group Areas Act) von 1950 legte nach Rassen getrennte (und ungleiche) Viertel in den Städten, den Kleinstädten und den ländlichen Gebieten fest. Aus gemischtrassigen Gebieten in den Stadtzentren wurden die Schwarzen vertrieben, und in Schuhkartonhäuser in den eingezäunten neuen Townships wie Soweto (Abkürzung für South Western Township), angrenzend an Johannesburg, verfrachtete.

· Das Gesetz über gemischtrassige Ehen (Mixed Mariage Act) von 1949 und das Gesetz zur Unmoral (Immorality Act) von 1950 machte gemischtrassige sexuelle Verbindungen ungesetzlich. Verstöße wurden mit Gefängnis bestraft.

· Das Gesetz zur Unterdrückung des Kommunismus (Suppression of Communism Act) von 1950 verbot die kommunistische Partei von Südafrika. Unter Kommunismus wurde alles verstanden, was zu einer radikalen politischen Veränderung führen sollte. Kommunisten wurden von der Teilnahme an jedweder politischen Organisation ausgeschlossen und auf bestimmte Gebiete verwiesen. Oliver Tambo, der Sekretär der Jugendorganisation der kommunistischen Partei, sah weitere Auswirkungen voraus. »Heute ist es die Kommunistische Partei«, sagte er, »morgen werden es die Gewerkschaften, der Indische Kongress oder unser ANC sein.«[4]

· Das ironischerweise so benannte Gesetz zur Abschaffung der Pässe (Abolition of Passes Act) von 1952 machte es zu einer Straftat, wenn man nicht jederzeit gegenüber der Polizei, die auf den Straßen patrouillierte, einen Pass vorweisen konnte. Das Passbuch, das nur die Nichtweißen mit sich führen mussten, enthielt ein Foto, Einzelheiten der Herkunft, den Namen des »Häuptlings«, also Arbeitgebers, einen Nachweis über die Arbeitsstationen, Steuerzahlungen und einen Nachweis über bisherige polizeilich erfasste Taten. Kein Schwarzer konnte ohne eine Erlaubnis sein ländliches Gebiet in Richtung Stadt oder Kleinstadt verlassen. Wenn man das Stadtgebiet erreicht hatte, musste man innerhalb von 72 Stunden eine Arbeitserlaubnis beantragen. Nur schwarze Männer und ab 1960 auch schwarze Frauen, die für die weiße Bevölkerung von Nutzen waren, bekamen eine Aufenthaltserlaubnis.

· Das Gesetz über die Bantu-Verwaltung (Bantu Authorities Act) von 1951 regelte die Einrichtung von schwarzen Homelands und die Regionalverwaltung. Mit dem Ziel, eine größere Selbstverwaltung in den Homelands zu etablieren, verbot das Gesetz die Repräsentation von Schwarzen im Nationalparlament, wie zum Beispiel den kleinen Rat der indigenen Vertretung. Schwarze waren in den »weißen Gebieten« keine Bürger; rechtlich waren sie »sojourners« (= Reisende), was sie zu Ausländern in ihrem Geburtsland machte.

· Das Gesetz über die Trennung der gewählten Volksvertretung (Separate Representation Act) von 1951 führte zusammen mit dem Ergänzungsgesetz von 1956 dazu, dass die Farbigen aus den Wahllisten gestrichen wurden.

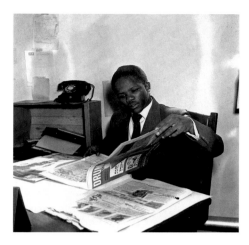

Bob Gosani
Jake, Autor der »Inside Story«!, 1953
Jake the Inside Story!, 1953

· Das tief greifende und destruktive Gesetz zur Bantu-Bildung (Bantu Education Act) von 1953 führte zur Schließung von schwarzen Missions- und Kommunalschulen, die von staatlichen Schulen abgelöst wurden. Deren Curriculum beschrieb der Aktivist Pater Trevor Huddleston als eine »Erziehung zum Dienen«.[5]

Viele andere Gesetze hatten die Überwachung von jedem schwarzen Mann, jeder schwarzen Frau und jedem schwarzen Kind zum Ziel und stellten sicher, dass sie von der weißen Minderheit fernblieben, mit Ausnahme von Hausangestellten.

Rassische Zugehörigkeit bestimmte, wo ein Mensch leben durfte, wie er reisen, welche Schule er besuchen durfte, welche Art von Arbeit ihm erlaubt war, welchen Lohn er bekommen sollte, in welchen Gegenden er sich aufhalten, wen er heiraten, welchen Alkohol er trinken durfte, wann er nachts die Straße verlassen musste, welche Gesetze zu beachten waren, welche öffentlichen Plätze er betreten und in welchen Teilen der Gefängnisse er gefangen gehalten werden durfte.

Diese Regelungen waren aber nicht allein ein Mittel der sozialen Kontrolle. Die tiefer greifende Entmachtung und Entwürdigung der Schwarzen durch diese Gesetze stellten eine auf Rassismus basierende Ausbeutung für die Wirtschaft Südafrikas sicher. Das System organisierte zum Beispiel den Bedarf von Arbeitern für weiße Farmer. Die Unglücklichen, die auf Nachfrage keinen Pass vorzeigen konnten, wurden sofort eingesperrt und umgehend zu harter Arbeit auf den Farmen der Weißen verurteilt, wo sie lange Arbeitszeiten hatten und oft übel drangsaliert wurden.

Unter der Apartheid wurde das von der Bergbauindustrie perfekt entwickelte System der Wanderarbeiter ausgeweitet. Es trennte weiterhin Familien, machte die Arbeiter zu Fremden für ihre Kinder und beschränkte die Frauen auf ländliche Gebiete. Und tatsächlich war es sogar so, dass viele Wanderarbeiter nicht wollten, dass ihre Familien in den feindlichen und unwirtlichen Gegenden der Städte korrumpiert, unterdrückt und gedemütigt werden sollten. In den Städten mussten die Männer in spärlichen Männerheimen der Bergwerke, der Stadtverwaltungen oder der Baustellen, wo sie einen Hungerlohn verdienten, wohnen. Die Arbeitgeber argumentierten, dass die Familien auf dem Lande in ihren angestammten Dörfern sich selbst versorgen konnten und daher nicht vom Lohn leben mussten.

In Wirklichkeit führte aber die geringe Größe des Landstückes, das den Schwarzen zugewiesen wurde, dazu, dass die Familien sich immer

weniger selbst ernähren konnten und daher auf die Unterstützung vonseiten der Migrantenarbeiter angewiesen waren. Auch in den Townships waren Armut und Hunger an der Tagesordnung. Eine Vielzahl von Gesetzen verhinderte, dass Schwarze vom Ausbildungssystem profitierten, nicht das Recht besaßen, über ihren Lohn zu verhandeln, ebenso durften sie nicht streiken oder demonstrieren, und sie durften auch nicht irgendwo hinziehen, wo sie bessere Arbeitsbedingungen gehabt hätten.

Bemerkenswert war, dass die vom System unterdrückten Frauen und Männer erstaunlich ruhig blieben. Überlebensstrategien wurden mehr und mehr vordringlicher. Die Menschen lernten, das System zu überlisten. Es gab einen lebhaften Handel mit gefälschten Pässen und verbotenen Waren sowie Wege, Polizisten oder Verwaltungsangestellte zu schmieren.[6]

Dugmore Boetie beschreibt in seinem Buch eines dieser erfolgreichen Unternehmungen. Er zog einen Arbeitsoverall an, den ein gekaufter indischer Schneider mit dem Logo eines großen Kaufhauses versah. Er ging in das Kaufhaus von Abteilung zu Abteilung, nahm Einrichtungsgegenstände oder Waren an sich und ließ glauben, er wolle sie ausliefern, und verließ das Kaufhaus. Keiner hielt ihn an.

»Ich machte mir zwei Tatsachen zunutze. Erstens: Kein Weißer achtet auf das Aussehen eines Schwarzen. Nur seine Hautfarbe zählt. Für sie sehen alle gleich aus. Sie sind nicht einmal an deinem Namen interessiert … Zweitens, und das mag ich am meisten, ihre totale Missachtung deiner geistigen Fähigkeiten. Deshalb können sie sich im Traum nicht vorstellen, dass ein Schwarzer das machen kann, was ich in dem Kaufhaus gemacht habe … Das Beste von allem, und das gilt für Schwarze wie Weiße, sie mochten mich. Einige weiße Verkäuferinnen schickten mich los, um Sandwiches und Zigaretten zu holen … Der einzige Platz, den ich gemieden habe, war das Büro des Buchhalters. Ich bin doch nicht gierig.«[7]

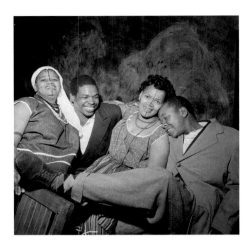

Bob Gosani
Der neue und der alte Look gehen tanzen, 1955
The new look and old look went dancing, 1955

Die Neuankömmlinge in der Stadt, gleich ob sie aus den »Bantus-
tans« (Homelands) kamen oder Flüchtlinge von Kleinbauernhöfen und
Knechte auf weißen Farmen gewesen waren oder Hausangestellte,
die in den Hinterhöfen in den weißen Vororten gelebt hatten, behiel-
ten sich den Sinn für ein irgendwie geartetes eigenständiges Leben,
meistens griffen sie, um zu überleben, auf indigenes Wissen und auf
die Kultur ihrer Heimatregion zurück.

Traditionelle Gemeinschaftskultur ist in afrikanischen Gemeinden
hoch im Kurs. Egal wie wenig zu Hause auf den Tisch kommt, für einen
Besucher ist immer noch Platz. Dies hat man schon lange beobachtet
und ausgenutzt: »Es ist nicht erforderlich, für einen besseren Lebens-
unterhalt der Bevölkerung zu sorgen, da sich die Einheimischen un-
tereinander helfen«, so der aalglatte Kommentar im Bericht über die
Angelegenheiten der Einheimischen von 1932.[8]

Frauen, die es fertigbrachten, ihren Männern in die Townships zu fol-
gen, übernahmen die unterschiedlichsten Tätigkeiten, vornehmlich im
informellen Sektor. Sie machten für andere die Wäsche, bauten Gemü-
se an oder stellten Waren her, die sie am Straßenrand verkauften; oder
sie brauten illegal traditionelles Bier (Alkohol war Schwarzen verboten)
oder stärkere hausgemachte Alkoholika und schenkten diese an heim-
wehkranke Wanderarbeiter am Wochenende aus. Mit den Einkünften
aus diesen unterschiedlichen Erwerbstätigkeiten konnten Frauen ihre
Kinder in die Schule schicken. (Unterricht und Schulspeisung waren
nur für weiße Kinder umsonst.) Viele Frauen wurden jedoch erwischt
und hatte nicht genug, um sich mit Schmiergeld aus der Klemme zu
befreien, sodass sie im Gefängnis landeten.

In den Townships wurden »shebeens« (illegale Kneipen) immer popu-
lärer. Sie waren die Zentren des sozialen Lebens, der Musik und des
Tanzes und eben eine Bühne für viele Talente, die ihre Fähigkeiten
präsentierten. Die Stadt war ein Schmelztiegel. Paare kamen sich über
Kulturschranken näher. Kinder wuchsen vielsprachig auf, lernten fünf
oder sechs Sprachen und entwickelten neue Stadtdialekte. Wenn ge-

braut wurde, standen sie Schmiere und gaben ihren Müttern ein Zei-
chen, wenn verdächtige Polizeifahrzeuge durch den Stadtteil fuhren.

Apartheid wirkte auf die Strukturen der Schwarzen antagonistisch,
denn viele von ihnen hatten wenig Hemmungen, Gesetze zu bre-
chen. Jugendliche schlossen sich Gangs an und wurden Experten
im Taschendiebstahl, kleinen Straftaten und sogar Hauseinbrüchen.
Einige waren erfolgreich genug, sich einiges leisten zu können. Mode
war erstaunlich erfindungsreich, zweifarbige Autos waren »in« und die
jungen Frauen waren auf raffinierte Weise glamourös. »Lebe schnell,
sterbe jung und sei ein gut aussehender Leichnam«, war die Devise
derjenigen, für die schreckliche Armut oder staatliche Ausbeutung
keine Alternative war, für die es sich zu leben lohnte.[9]

Sophiatown, früher eine gemischtrassische Vorstadt von Johannes-
burg, war ein Beispiel für die Vitalität, den Humor und die Kreativität
von umtriebigen Stadtbewohnern. Wie andere Vorstädte war auch So-
phiatown gefährlich. Morde waren an der Tagesordnung; Alkohol war
allgegenwärtig, und Verhaftungen waren ein tägliches Geschäft. Es war
aber auch die Heimat von Intellektuellen und Künstlern. Viele Autoren
von *Drum* lebten in Sophiatown wie zum Beispiel Henry Nxumalo, Blo-
ke Modisane, Todd Mtshikiza, Casey Motsisi, Lewis Nkosi und Nat Na-
kasa. *Drum* war Vorreiter für investigativen schwarzen Journalismus mit
dem klaren Ziel, die Wirklichkeit und die Ungerechtigkeit von Apart-
heid aufzuzeigen. Damit war die Auflage zu steigern. Und so bleibt die
Zeitschrift ein bitteres Zeugnis des Lebens unter der Apartheid.[10]

Für die Gesetzesgeber hatte die Apartheid unbeabsichtigte Konse-
quenzen. Es diente, wie Luthuli ausführte, der größeren Mobilisierung
und brachte die Unterdrückten mehr zusammen als je zuvor. Der Af-
rican National Congress (ANC), der 1912 gegründet wurde, vereinte
alle Afrikaner unterschiedlichster Ethnien und formulierte deren For-
derungen gegenüber der herrschenden Klasse.

In den Jahren vor und nach dem Zweiten Weltkrieg, als sich Wei-
ße dem »Kampf für Demokratie« anschlossen, verdoppelte sich die
schwarze Bevölkerung um Johannesburg. Neuankömmlinge waren
sowohl gut ausgebildete junge Leute wie auch Fabrikarbeiter, die Ge-
werkschaften gründeten. Die Widersprüche des Krieges blieben ihnen
nicht verborgen.

Der ANC wurde durch eine beeindruckende Generation von jungen
Aktivisten beeinflusst, mehrheitlich ausgebildet an schwarzen Univer-
sitäten.[11] 1944 gründeten diese jungen Leute die ANC Youth League.

1949, ein Jahr nachdem die Apartheidregierung an die Macht gekommen war, veröffentlichte die Jugendorganisation ein historisches Papier, das Programm der Tat, in dem sie für Massen- und Protestaktionen eintraten und die elegant formulierten, aber unfruchtbaren Protestbriefe an die Regierenden heftig kritisierten.

Die 1950er-Jahre waren gekennzeichnet von einer Reihe von Protestkampagnen, Streiks und »Wegbleiben« von der Arbeit, die der ANC und seine Allianzpartner, insbesondere der südafrikanische Gewerkschaftsdachverband South African Congress of Trade Unions (SACTU) organisierten. Die Strategie der »Defiance«-Kampagne von 1952 war die des zivilen Ungehorsams, die sich an Ghandis 40 Jahre zuvor zuerst in Südafrika eingesetzte Methode des passiven Widerstandes orientierte.

Schwarze Afrikaner, Farbige und Inder mussten lediglich durch die »Nur für Europäer«-Eingänge der Läden, Postämter oder Busse gehen, um das Gesetz zu brechen. Oder sie mussten sich auf die falsche Parkbank setzen. Einige Weiße nahmen teil und wurden festgenommen, als sie ohne Erlaubnis in die schwarzen Townships gingen. Die Aktion wurde begeistert angenommen. Es entwickelte sich ein Gefühl der Überlegenheit bei den Unterdrückten, das ihnen eine Ahnung für die Wirksamkeit gab und das zur nächsten Kampagne führte.

1955 kamen in Kliptown, Soweto, 7.000 Menschen zum Volkskongress zusammen. Dieser gründete sich auf eine Umfrage, die Freiwillige über zwei Jahre im ganzen Land durchgeführt hatten. In Bussen und Eisenbahnen, in Fabriken, auf den Straßen, in den Hütten und Baracken war die Frage: »Was sind deine Forderungen, damit die Menschen ein Leben in Freiheit führen können?«

Der Prozess der Befragung war ebenso wichtig wie der Kongress selbst, denn das Ergebnis war ein Dokument, das den einfachen Menschen gehörte. Die Freiheitscharta umfasste zehn Forderungen, die ohne Gegenstimmen auf dem Kongress angenommen wurden. Chief Luthuli war der Motor, der darauf drängte, dass die Charta an jeden Ortsverein des ANC ging und ein Jahr später vom ANC formell angenommen wurde. Die Freiheitscharta wurde zur Verkörperung der Werte des ANC in der Zeit des Exils und war die Inspiration für die fortschrittliche Verfassung des demokratischen Südafrikas von 1996.

Der Volkskongress begrüßte die Allianz, die zwei Jahre früher entstanden war. Geführt vom ANC, bestand die Allianz aus dem südafrikanischen Gewerkschaftsdachverband SACTU, dem Indischen Kongress,

dem Kongress der Farbigen und dem kleinen weißen Kongress der Demokraten.

Die Freiheitscharta jedoch machte die Trennlinie innerhalb des ANC deutlich. Eine sehr eloquente Gruppe von Afrikanisten war gegen den ersten Paragrafen, »Das Land gehört allen, die in ihm leben.« Sie waren auch nicht einverstanden mit den nach Rassen bestimmten Allianzpartnern und die generelle multirassistische Struktur. Eine Serie von kontroversen Debatten und Versammlungen folgten. Da sie die Freiheitscharta nicht ändern konnten, verließen 1959 die Hauptakteure der Abweichlergruppe den ANC und gründeten eine neue Partei, den Pan Africanist Congress (PAC).

1956 organisierten sich die Frauen und gingen gegen den Plan der Regierung vor, dass auch afrikanische Frauen einen Pass tragen mussten. Trotz eines riesigen Polizeiaufgebots missachteten 20.000 Frauen den Versammlungsbann und zogen am 9. August 1956 nach Pretoria zu den Union Buildings, dem Regierungssitz, um 100.000 Unterschriften zu überreichen.

Nur wenige Aktionen brachten greifbare Verbesserungen für die Schwarzen. Doch sie brachten dem System Unannehmlichkeiten, machten schwarze Nöte öffentlich und stärkten das Bewusstsein der einfachen Leute, dass ihre Stimme durch Organisationen gehört wird.

Es war offensichtlich, dass diese Kampagnen und Proteste die Autoritäten angriffen. Die Regierenden erließen noch mehr, noch strengere Gesetze, und sie griffen noch schärfer gegen politischen Protest durch. Einschnitte, Bann und Verbannung von führenden Persönlichkeiten, den Medien verbieten, das zu zitieren, was sie gesagt haben oder gar Fotos von ihnen zu veröffentlichen, bewirkte wenig, die politischen Aktivitäten zu stoppen. Sowie einer gebannt wurde, war sofort ein anderer da, der seinen Platz einnahm.

In den frühen Morgenstunden des 5. Dezember 1956 schlugen schwere Polizeistiefel an die Türen der Wohnungen von Männern und Frauen, um sie wegen Hochverrats anzuzeigen. Das Gerichtsverfahren gegen 156 respektable Südafrikaner quer durch das gesamte Rassenspektrum wurde bekannt als die Südafrikanische Opposition. Das Verfahren zog sich hin, beschränkte die Führung bis 1961. Bis dahin waren der ANC und der PAC bereits verboten.[12]

Trotzdem wurden die Kampagnen fortgeführt, entweder geleitet von SACTU, den Gemeinden selbst oder in einigen Gegenden vom neu

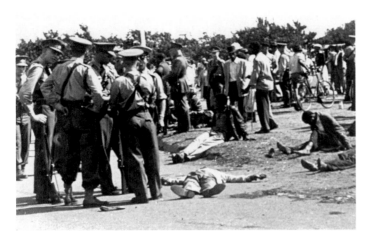

Peter Magubane
Fünf Monate Albtraum, Sharpeville, 1960
Five Months Nightmare, Sharpeville, 1960

formierten PAC. Es ging um höhere Löhne oder Busboykotte wegen drastischer Fahrpreiserhöhungen, die die großen Entfernungen, die schwarze Arbeiter aus den Townships täglich zu ihren Arbeitsplätzen zurücklegen mussten, deutlich machten.

Es gab auch Boykotte gegen Waren. Auch wenn die große Mehrheit der Schwarzen hoffnungslos arm waren, besaßen sie doch aufgrund ihrer Anzahl eine große Kaufkraft bei Grundnahrungsmitteln. Als die Journalisten Henry Nxumalo von *Drum*, Ruth First von *New Age* und der Gewerkschafter Gerd Sibande die Situation der groben Ausbeutung von Landarbeitern in Osttransvaal anprangerten, startete der ANC einen populären und effektiven Kartoffelboykott.

Dann passierte am 21. März 1960 etwas schockierend Unerwartetes. Als Teil der vom PAC organisierten Anti-Pass-Kampagne kam es zu einer Zusammenkunft in der Polizeistation der Township Sharpeville. Die Protestierenden wollten ihre Pässe zurückgeben. Sollten sie in Polizeigewahrsam kommen, wollten sie auch die Zahlung einer Kaution verweigern; sollten sie verurteilt werden, wollten sie die Geldstrafe nicht zahlen. Ähnliche Zusammenkünfte hatte der PAC an mehreren Stellen seines Einflussgebietes organisiert. In Sharpeville jedoch wuchs die Menschenmenge an und wartete mehrere Stunden. Die Polizisten wurden nervös und forderten Verstärkung an, die Stimmung wurde spürbar angespannter. Einer warf einen Stein. Darauf fiel ein Schuss, und ein Kugelhagel folgte. In wenigen Minuten waren 69 Menschen tot.

Diese Tragödie änderte den Weg der Geschichte. Die Nachrichten gingen um die Welt. Ein sich verteidigendes weißes Regime setzte Robert Sobukwe, einen Akademiker und Führer des PAC, der seinen Pass in der Polizeistation von Orlando abgeben wollte, gefangen. Er saß sechs Jahre in strikter Einzelhaft auf Robben Island. Um die Panik unter den Weißen einzudämmen, verhängte Premierminister Verwoerd den Notstand, Tausende wurden inhaftiert und ANC und PAC eilig verboten.

Es folgte eine Hexenjagd auf diejenigen, die in den Untergrund gingen, unter anderem Mandela und Sisulu, die aber über Pressemitteilungen und Sendungen von Radio Freedom, das von einer geheimen Station aus operierte, in Kontakt mit der Öffentlichkeit blieben. Ein Exodus ins Exil folgte. Oliver Tambo erhielt von Chief Albert Luthuli den Auftrag, Südafrika zu verlassen und als Kopf der Mission im Exil die internationale Unterstützung zu organisieren. Sharpeville wurde zum Sinnbild der Unterdrückung und sensibilisierte die Welt. Chief Luthuli, der die Tragödie mit Ruhe und Übersicht aufarbeitete, war der erste Afrikaner, der im Dezember 1960 den Friedensnobelpreis erhielt.

Kurz danach wurde Umkhonto we Sizwe (MK), der »Speer der Nation« gegründet. Erst hunderte, dann tausende Männer und Frauen verließen das Land, um sich im Ausland militärisch schulen zu lassen. Die Regierung antwortete mit einem Gesetz, das eine Inhaftierung ohne Urteil und ohne Kontakt zur Familie und zu Anwälten bis zu 90 Tagen zulässt. Bald wurde es auf 180 Tage erweitert. In dieser Zeit wurden die Verhör- und Foltermethoden drastisch verschärft.

1962 wurde Nelson Mandela, der Führer des ANC im Untergrund, gefangen genommen und zu fünf Jahren Haft auf Robben Island verurteilt. Ein Jahre später wurde das geheime Hauptquartier des Oberkommandos des ANC auf der Liliesleaf Farm im Johannesburger Stadtteil Rivonia überfallen und die Führer festgesetzt. Zusammen mit Mandela wurde sie angeklagt und zum Tode verurteilt. Doch wegen der großen internationalen Aufmerksamkeit wurde diese Strafe zu lebenslanger Haft auf Robben Island umgewandelt. Einer von den weißen Angeklagten, Denis Goldberg, wurde ins Zentralgefängnis in Pretoria gebracht und wegen seiner Hautfarbe von seinen Kameraden getrennt. Eine triumphierende Regierung erklärte den ANC für zerschlagen.

In der Tat gab es die nächsten zehn Jahre keinen Massenprotest in Südafrika mehr. SACTU-Führer, die argumentierten, dass der Klassenkampf der schwarzen Arbeiter nicht von der Freiheitsbewegung getrennt werden könne, gingen in wachsender Zahl ins Ausland und schlossen sich MK an. Ohne die Führer der Gewerkschaften und der politischen Opposition stabilisierte sich das Regime zunehmend. Um von den billigen schwarzen Arbeitskräften zu profitieren, kamen internationale Investoren nach Südafrika zurück. In den darauf folgenden Jahren wuchs die Wirtschaft jährlich um 6,5 %.

Die Regierung kam zurück auf ihr Programm der »großen Apartheid« und vertrieb gewaltsam tausende von »überzähligen« Menschen aus

»schwarzen Ecken« in »weißen Städten« zu Camps auf dem Lande wie etwa Limehill, Dimbaza, Onverwacht, Sada oder andere Orte. So wurden Zentren der Armut, der Arbeitslosigkeit und des Elends geschaffen. In den unruhigen Zeiten nach Sharpeville wurden die Passgesetze auch auf Frauen ausgeweitet, zuerst auf dem Lande, dann in den Kleinstädten und dann in den Metropolen.

Aber der Erfolg der Apartheidregierung in der Umsetzung ihrer Politik führte zu Widersprüchen. Die Arbeiterunterkünfte wurden immer größer, und eine schwarze Arbeiterklasse entstand. Eine neue Generation von schwarzen Städtern wurde geboren, und sie bildeten in den neuen Gettos zusammenhängende Gemeinden.

Obwohl man sich bemühte, die Bevölkerungsgröße der Schwarzen in den Städten zu beschränken, wuchs die Anzahl der Jugendlichen, die nur das Leben in der Stadt kannten. In Meadowlands, Soweto, wohin die Bewohner von Sophiatown 1950 umgesiedelt worden waren, wussten die Kinder wenig oder gar nichts von den Aktionen des Widerstandes oder hatten nichts von der Existenz der Youth League der früheren Jahre gehört. Anfang der 1970er-Jahre kamen aus diesen Gemeinden Künstler, Musiker und Aktivisten der Zivilorganisationen. Den Townships waren grausam Gemeindezentren, Sporteinrichtungen oder Einkaufszentren oder wenigstens eine moderate Infrastruktur wie geteerte Straßen, Elektrizität oder Straßenbeleuchtung vorenthalten worden. Trotz aller Widerstände entwickelten sich der soziale Zusammenhalt, die Vitalität und der Einfallsreichtum.

Im März 1973 brach in den Industriegebieten von Durban und Pinetown in Natal spontan ein massiver Generalstreik aus. Der Funke verbreitet sich schnell, und innerhalb von Monaten entstand eine Organisation von schwarzen Gewerkschaften. Schwarze Arbeiter, denen das Wahlrecht und eine politischen Vertretung vorenthalten worden waren, erkannten ihre ungeheure Kraft – die Kraft, die Wirtschaft, die auf ihre Arbeit angewiesen war, zum Halten zu bringen.

Mitte der 1970er-Jahre entwickelten sich die schwarzen Arbeiter und ihre Kinder zu einer wichtigen Macht für den sozialen und ökonomischen Umbruch in den kommenden Jahren.

1 Albert Luthuli, *Let My People Go*, London 1962, S. 97.

2 Ebd.

3 JB Vorster, der erst Justizminister war, dann Premierminister und zuletzt Präsident des Apartheidstaates, liebte es darauf hinweisen, dass die durch die Rassen getrennten Territorien sich nicht von den ungleich großen Staaten in Europa nach 500 Jahren Krieg, Eroberung und Entmachtung unterschieden.

4 Zit. in: Luli Callinicos, *Oliver Tambo: Beyond the Engeli Mountains*, London 2004, S. 161.

5 Trevor Huddleston, *Naught for Your Comfort*, London 1971.

6 Viele Autobiografien zeichnen die Überlebensstrategien der Schwarzen in der Stadt nach.

7 Dugmore Boetie mit Barney Simon, *Familiarity is the Kingdom of the Lost*, London 1969.

8 Zit. in Luli Callinicos, *A Place in the City*, Johannesburg / Kapstadt 1993, S. 36.

9 Mike Nicol, *A Good-Looking Corpse*, London 1991.

10 Vgl. Z.B. Bloke Modisane, *Blame Me on History*, London 1963; Casey Motsisis, *Casey & Co: Selected Writings of Casey »Kid« Motsisi*, hrsg. von Mothobi Mutloatse, Johannesburg 1978; Todd Matshikiza, *Chocolates for my Wife*, London 1961, also Kapstadt 1982; Essop Patel (Hrsg.), *The World of Nat Nakasa: Selected Writings of the Late Nat Nakasa*, Johannesburg 1971; Can Themba, *The Will to Die*, London 1972; Lewis Nkosi, Home and Exile, Kapstadt 1965; Miriam Tlali, *Muriel at the Metropolitan*, Johannesburg 1975; Mtutuzeli Matshoba, *Call Me Not a Man*, Johannesburg 1979; Don Mattera, *Memory is the Weapon*, Johannesburg 1987, Anthony Sampson, *Drum*, London 1958.

11 Dazu gehörten Anton Lembede, Walter Sisulu, Oliver Tambo, AP Mda und Nelson Mandela.

12 Anthony Sampson, *The Treason Cage*, London 1958.

Living under Apartheid

Luli Callinicos

In 1948, South Africa's white voters brought the National Party to power. Its policy of Apartheid promised a more rigorous and systematic application of racial segregation and white domination that had been the country's political culture since colonial times.

For many black men and women, the change was of little significance. 'It did not seem of much importance whether the whites gave us more Smuts [the former prime minister] or switched to Malan', recalled Chief Albert Luthuli, President of the African National Congress. 'Our lot had grown steadily harder, and no election seemed likely to alter the direction in which we were being forced'.[1]

They were soon to be rudely surprised. In rapid succession, the new white government introduced a mass of laws designed to control every aspect of the lives of black people. Apartheid meant that each ethnic group ('tribe') should have its own small territory, where they could ultimately be 'independent'. But until, in theory, every black man, woman, and child could be 'returned' to their assigned homelands, legislation would need to manage their presence in the city. Even in the rural areas (the 'reserves'), there was a 'swift deterioration' noted Luthuli.[2] In no part of South Africa were the whites in the majority. Yet, forming about 15% of the total population, the white government claimed 90% of the country's land.[3]

The following are just some of the main laws passed in the first five years of apartheid.

· The Population Registration Act of 1950 classified every man, woman, and child according to the state definition of 'race'. 'Race' was deemed to be God-given and every person of colour was 'scientifically' examined and registered as 'Bantu', 'Coloured', or 'Asiatic'.

· The Group Areas Act (1950) ensured separate (and unequal) racialised spaces in the cities, *dorps* (small towns), and rural areas. Multiracial areas in the city centres were cleared of black residents, who were removed to matchbox houses in fenced-in new 'townships', such as Soweto (short for South Western Township), adjoining Johannesburg.

· The Mixed Marriages Act (1949) and the Immorality Act (1950) outlawed interracial sexual relations. The penalty was imprisonment.

· The Suppression of Communism Act (1950) outlawed the Communist Party of South Africa. Under its definition of communism it broadly covered any call for radical change. Communists could be banned from participating in any political organisation and were restricted to a particular area. Oliver Tambo, Secretary of the Youth League at the time, foresaw its implications. 'Today it is the Communist Party', he said. 'Tomorrow it will be the trade unions or the Indian Congress or our African National Congress'.[4]

· The ironically named 'Abolition of Passes Act' (1952) made it a criminal offence to be unable to produce a pass at any time when required by the police, who prowled the streets. A pass book, which only Africans were required to carry, included a photograph, details of origin, the name of one's 'chief', employment record, tax payments, and a record of any encounters with the police. No black person could leave a rural area for a town or city without a permit. On arrival in an urban area, permission to seek work had to be obtained within seventy-two hours. Only those men (and from the nineteen-sixties, women) who were useful to the white economy would be given permission to stay.

· The Bantu Authorities Act (1951) set out to establish black homelands and regional authorities. With the aim of creating greater self-government in the homelands, the Act abolished residual black representation in the national government, such as the small Native Representatives Council. No blacks in so-called 'white areas' were citizens; legally, they were mere 'sojourners', rendering them foreigners in the land of their birth.

· The Separate Representation of Voters Act of 1951, together with its 1956 amendment, led to the removal of Coloureds from the common voters' roll.

· The deeply destructive and far-reaching Bantu Education Act (1953) had the effect of shutting down the black missionary and community schools, replacing them with state-run schools with curricula which activist Father Trevor Huddleston indicted as 'education for servitude'.[5]

Many other laws monitored the movements of every black man, woman and child and ensured they were segregated from the white minority except as servants.

Racial classification determined where a person was permitted to live, how to travel, what school to attend, what type of work one was permitted to find, what wage to earn, which area to move about

in, whom to marry, what liquor to consume, what time to be off the streets at night, which laws to observe, what public spaces to enter, and in what prison quarters to be incarcerated.

But these were not simply a matter of social control. The deepening disempowerment and indignity imposed on black people through these laws ensured continuing racial exploitation in South Africa's economy. The system subsidised, for example, the labour needs of white farmers. The unfortunate men who were not able to produce their passes on demand would be promptly arrested and swiftly sentenced to hard labour on white-owned farms, where they were overworked and often cruelly abused.

Under Apartheid, the system of black migrant labour perfected by the mining industry was reinforced. It continued to separate families, rendering workers strangers to their children, and locking women into the rural areas. And indeed, many migrants would not want their families to be corrupted, undermined, or humiliated by the alien and hostile environment of the city; for in the city, most men were housed in bleak, single-sex hostels in mining, municipal, or construction compounds, where they earned a pittance. Employers argued that their families were self-sufficient in their traditional homesteads and therefore did not need a living wage. In reality, the limited amount of land assigned to blacks was less and less able to sustain families without the money sent home by the migrants. In the townships too, poverty and hunger were widespread. A plethora of laws deprived black workers from benefiting from the apprenticeship system, from bargaining rights to improve their wages, from the right to strike or picket, or to move to a more favourable labour area, and so on.

Remarkably, men and women oppressed by this system proved to be surprisingly resilient. Strategies of survival became more inventive. People learned to 'beat the system'. There was a brisk trade in forged passes and forbidden consumables and ways of bribing policemen and bureaucrats.[6]

In his book, Dugmore Boetie describes one of his successful ventures. He put on a worker's overall, having hired an Indian tailor to embroider the logo of a large department store on it. He walked into the store, moving from one floor to the other, picking up appliances and goods as if to take them to despatch, and walked out with them. Nobody stopped him.

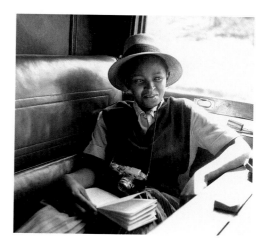

Bob Gosani
Jazz auf Rädern! Dolly Rathebe, 1955
Jazz on Wheels! Dolly Rathebe, 1955

I took advantage of two facts. One: to all whites, a black man's features don't count. Only his colour does. To them, we are all alike. They don't even bother to know your real name … The second fact—and I like it best—is that they have a total disregard for our mental efficiency. That's why they couldn't dream that a black man could be capable of doing what I did in this big bazaar … Best of all, the staff, both black and white, took a liking to me. A few white salesladies would send me out for sandwiches and cigarettes … The only place I kept well away from was the paymaster's office. Hell, I'm not greedy.[7]

Even newcomers to the city, whether from the 'Bantustans', or refugees from the families of sharecroppers and labourers on white-owned farms, or domestic workers living in the backyards of the white suburbs, fashioned some sort of a life for themselves, often drawing on indigenous knowledge and culture from back home to sustain them.

Traditional collective culture stood African communities in good stead. No matter how meagre the household meal, there was always room for an extra visitor. This had been noticed and exploited long ago: 'So far it has been unnecessary to provide relief for the permanent population, but that is due to the practice of natives helping each other', was the smooth comment of the Native Affairs Report of 1932.[8]

Women who managed to reach the cities and join their men folk in the townships took on a range of multi-tasking, mostly in the informal sector. They took in laundry, grew food, and created handicraft and sold these on the side of the road; or they brewed illegally (liquor was prohibited for blacks) traditional beer or stronger home-made alcoholic beverages and served drinks to homesick migrant workers every weekend. With the money they earned from these various activities, many women were able to send their children to school. (Education plus school feeding for white children was free.) Many a woman, how-

George Hallett
Vernon Terrace, District Six, Kapstadt, 1968
Vernon Terrace, District Six, Cape Town, 1968

ever, was caught, and lacking the means to bribe herself out of a fix, ended up in prison.

In the townships, 'shebeens' (illegal pubs) flourished. They were a haven of social encounters, hybrid music and dance, and a platform for many talented individuals to share their artistry. The city was a melting pot. Couples formed romances across cultures. Children grew up multi-lingual, learning as many as five or six languages, developing new versions of city slang. During brewing times, they stood on lookout a block away from their homes and gave their mothers a special warning cry as roving police vans approached.

Apartheid was structurally antagonistic to black people, many of whom consequently had little compunction in breaking the law. Young people moved in gangs and became experts in picking pockets, petty theft, and even housebreaking. Some were successful enough to indulge in conspicuous consumption. Fashion was stunningly inventive, two-toned cars were sleek, and the girls ever more ingeniously glamorous. 'Live fast, die young, and have a good-looking corpse' was the saying of those who felt an alternative life of dreary poverty and official abuse was not worth living for.[9]

Sophiatown, once a mixed-race suburb in Johannesburg, was an example of the vitality, humour, and creativity of a beleaguered townspeople. Like other townships, it was a dangerous place—murders were common, alcoholism rife, and arrests an everyday occurrence. It was also the home of artists and intellectuals. Many *Drum* writers lived in Sophiatown, including Henry Nxumalo, Bloke Modisane, Todd Matshikiza, Casey Motsisi, Lewis Nkosi, and Nat Nakasa. *Drum* pioneered investigative black journalism, their aim being in particular to show the realities and inequities of Apartheid. As they discovered, these stories boosted circulation, and their glittering testimonies remain an enduring record of life under Apartheid.[10]

For the lawmakers, Apartheid had unintended consequences. It served, as Luthuli pointed out, to mobilise and bring together the oppressed as never before. The African National Congress (ANC) had been formed in 1912 to unite all Africans in their various ethnic groups and represent their interests to the ruling class.

In the years before and during World War II, when whites joined up to 'fight for democracy', the black working population in Johannesburg nearly doubled. Newcomers included educated young people as well as factory workers who formed trade unions. The contradictions of the war were not lost on them.

The ANC was radicalised by a remarkable generation of young people, mostly university educated Africanists.[11] In 1944 these young people formed an ANC Youth League. In 1949, a year after the Apartheid government came into power, the Youth League produced an historic document, the Programme of Action, in which they argued for mass mobilisation and direct protest action, strongly critiquing the elegantly phrased but impotent letters of protest previously sent to the authorities.

The nineteen-fifties were marked by a series of public protest campaigns, strikes, and 'stayaways' from work, organised by the ANC and its alliance partners, notably the South African Congress of Trade Unions. The strategy of the 1952 Defiance Campaign was one of civil disobedience, modelled on Gandhi's method of passive resistance, which he had pioneered in South Africa forty years earlier.

Blacks—Africans, Coloureds, and Indians—had only to walk through a 'Europeans Only' entrance to a shop, post office, or bus to break the law. Or even, to sit on the wrong park bench. A few whites also participated, and were arrested when they entered black townships without permission. The campaign was enthusiastically received; it created a sense of empowerment amongst the oppressed, giving them a sense of agency, and also led to the next campaign.

In 1955, 7,000 men and women met at the Congress of the People in Kliptown, Soweto, to produce a 'Freedom Charter'. It was founded on the question that volunteers had been asking ordinary people throughout the country for two years. In buses and trains, in factories, in the streets, huts and shacks, their question was, 'what would be your demands to enable our people to live in freedom?'

The process of consultation was as important as the outcome, for it became a document that could be owned by ordinary people. The Freedom Charter, with its list of ten demands, was unanimously adopted at the Congress, but at the insistence of Chief Luthuli, was presented to every branch in the country and officially ratified by the ANC a year later. The Freedom Charter was to become the very embodiment of the values of the ANC throughout its period in exile and was the inspiration for democratic South Africa's enlightened Constitution of 1996.

The Congress of the People also welcomed the Congress Alliance, formed two years earlier. Led by the ANC, Alliance members were the South African Congress of Trade Unions, the Indian Congress, the Coloured People's Congress and the small white Congress of Democrats.

The Freedom Charter, however, also exposed the fault-line embedded within the ANC. A vocal group of Africanists objected strenuously to the first clause, 'The land belongs to all who live in it'. Nor were they comfortable with the racially defined alliance partners and its multiracial structure. A series of debates and confrontational meetings followed. In 1959, unable to alter the Freedom Charter, the core of the dissenting group left the ANC to form their own party, the Pan Africanist Congress.

In 1956 women organised themselves and resisted the government's plan to impose passes on African women. Despite a huge police show of force, 20,000 women were able to defy the ban on 'gatherings' and on 9 August marched en masse to the Union Buildings, Pretoria, the seat of executive government, to present their 100,000 signatures of protest.

Few of these campaigns brought material improvements to blacks. But they did inconvenience the system, publicised black grievances and reinforced the confidence of ordinary people to make their voices heard through organisation.

Clearly, the campaigns and protests rattled the authorities; increasingly the government introduced more stringent laws, clamping down ever more fiercely on political protest. Restrictions, bannings, and banishment of leading figures, forbidding the media to quote anything they said or even publish their photographs, did little to stop political activity; as fast as one person was banned so another took his or her place.

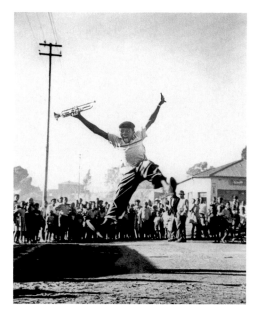

Alf Kumalo
Hugh Masakela in Sophiatown, 1956

Then in the early hours of 5 December 1956, heavy booted policemen knocked on the doors of scores of men and women, arresting them for High Treason. The trial of 156 remarkable South Africans across the racial spectrum was dubbed as 'South Africa's opposition'.[12] The trial dragged on, restricting the leadership until 1961, by which time the ANC and the PAC were banned.

Nevertheless, campaigns continued, either led by SACTU, the communities themselves, or in some places, by the newly formed PAC. These included strikes for higher wages and bus boycotts in protest against onerous fares, reflecting the distances that black workers had to travel everyday from their out-of-town ghettoes to their work.

There were also boycotts of consumer goods. Although the vast majority of blacks were desperately poor, through their numbers they had buying power for basic goods. When journalists Henry Nxumalo of *Drum Magazine* and Ruth First of *New Age* and trade unionist Gert Sibande began to expose the gross abuses of farm workers in the Eastern Transvaal, the ANC launched a popular and effective potato boycott.

Then, on 21 March 1960, the shockingly unexpected happened. As part of a PAC anti-pass campaign, a gathering of people assembled the police station of the township of Sharpeville. They demanded, they said, to return their passes. If they were arrested, they were prepared to refuse bail; if convicted they would not pay a fine. Similar gatherings occurred in other PAC constituencies. But in Sharpeville, the crowd grew, waiting for several hours. The police nervously called for reinforcements and the tension became palpable. Someone threw a stone. Suddenly a shot rang out, followed by a burst of fire. In a few minutes sixty-nine people lay dead on the ground.

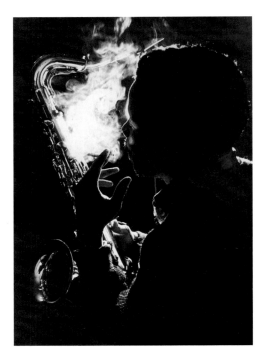

Alf Kumalo
Der Saxophonist Winston Mankunku macht während der Proben zu seinem Album *Yakhal' Inkomo*
eine Pause, 1968
Saxophonist Winston Mankunku taking a break
during a rehearsal of his album *Yakhal' Inkomo*, 1968

The tragedy was to change history. The news rang around the world. A defensive white regime arrested Robert Sobukwe, academic and leader of the PAC, who had gone to hand in his pass book at Orlando Station. He was sent to languish in strict isolation on Robben Island for six years. To contain white panic, Prime Minister, Verwoerd declared a State of Emergency, detained thousands, and swiftly banned both the ANC and the PAC.

There followed a witch hunt of those who went underground, notably Mandela, Sisulu, and others, who remained in touch with the public through press releases and 'Radio Freedom' broadcasts from a secret location. An exodus into exile began. Oliver Tambo was appointed by Luthuli to leave South Africa to head a Mission in Exile to mobilise international support. Sharpeville became notorious and sensitised the world. Chief Luthuli, who had responded to the tragedy with calm and courage, was the first African to be awarded the Nobel Peace Prize in December 1960.

Shortly afterwards, Umkhonto we Sizwe, the 'Spear of the Nation' or MK, was launched, resulting in hundreds, then thousands of men and women leaving the country to acquire military training. The government responded with a Ninety-Day Detention law without trial, then increasing it to 180 days, during which time torture methods became more brutal.

In 1962, Nelson Mandela, underground leader of the ANC, was caught and sentenced to five years' imprisonment on Robben Island.

One year later, the secret headquarters of the ANC in Rivonia Johannesburg (Liliesleaf Farm) were tracked down and leaders arrested. Together with Mandela, their charges carried the death penalty, but in the context of huge international interest, they were eventually sentenced to life imprisonment on Robben Island. Only the one white accused, Denis Goldberg, was incarcerated in Pretoria Central Prison, separated from his comrades because of his colour. A triumphant government declared the ANC to be crushed.

And indeed, for more than a decade, mass protest was absent from the South African landscape. SACTU leaders, who had argued that the class struggle pf black workers could not be unscrambled from the national liberation movement, steadily left the country to join MK. With the absence of labour leaders and political opposition, stability was restored to the regime. Taking advantage of cheap black labour, international investors returned to South Africa. In the remainder of the decade the economy grew by a record 6.5%.

The government resumed its programme of 'grand apartheid', forcibly removing thousands of 'surplus' people from 'black spots' in 'white' towns, to rural camps such as Limehill, Dimbaza, Onverwacht, Sada, and other places, creating centres of poverty, joblessness, and hardship. In the turmoil following Sharpeville, they stealthily imposed passes on black women, first in rural areas, then in the small towns and the cities.

But the Apartheid government's very success in implementing its policies was sowing the seeds of contradiction. Hostels for migrant workers were growing ever larger; a growing black working class was in the making. A new generation of black townspeople was emerging, rebuilding coherent communities in the new ghettoes.

Despite Apartheid's best attempts to reduce the black urban population, there was a growing cohort of youth who knew only city life. In Meadowlands, Soweto, for example, where Sophiatown residents had been moved in the nineteen-fifties, the children might, or might not, know dimly of attempts at resistance, or heard of the existence of a Youth League in earlier years; yet by the early nineteen-seventies, the community was producing artists and musicians as well as activists in civil society. The townships were crudely deprived of community centres, sports fields, shopping centres, and even the most modest infrastructure such as tarred roads, electricity, good street lighting. Yet, social cohesion, vitality, and resourcefulness in the face of adversity survived.

In March 1973, a massive general strike burst spontaneously onto the scene in the industrial areas of Durban and Pinetown in Natal. The event rapidly became infectious and within months was to result in a federation of black trade unions. Black workers, while deprived of the vote and of political representation, had realised an immense power—the ability to stop the economy that had come to rely so heavily on their labour.

By the mid-nineteen-seventies, black workers, and their children, were poised to become a major force for social and economic change in the decades that followed.

1 Albert Luthuli, *Let My People Go* (London, 1962), p. 97.

2 Ibid.

3 JB Vorster, who was to become Minister of Justice, Prime Minister, and then President of the Apartheid state, was fond of pointing out that the racially divided territories of South Africa were no different from the unequal size of each nation state in Europe after 500 years of warfare, conquest, and dispossession.

4 Cited in Luli Callinicos, *Oliver Tambo: Beyond the Engeli Mountains* (London, 2004), p. 161.

5 Trevor Huddleston, *Naught for Your Comfort* (London, 1971).

6 A number of autobiographies graphically relate survival tactics of blacks in the city.

7 Dugmore Boetie with Barney Simon, *Familiarity is the Kingdom of the Lost* (London, 1969).

8 Cited in Luli Callinicos, *A Place in the City* (Johannesburg and Cape Town, 1993), p. 36.

9 Mike Nicol, *A Good-Looking Corpse* (London, 1991).

10 See for example Bloke Modisane, *Blame Me on History* (London, 1963); Casey Motsisis, *Casey & Co: Selected Writings of Casey 'Kid' Motsisi*, ed. Mothobi Mutloatse (Johannesburg, 1978); Todd Matshikiza, *Chocolates for My Wife* (London, 1961, Cape Town, 1982); *The World of Nat Nakasa: Selected Writings of the Late Nat Nakasa*, ed. Essop Patel (Johannesburg, 1971); Can Themba, *The Will to Die* (Portsmouth, 1972); Lewis Nkosi, *Home and Exile* (London, 1965); Miriam Tlali, *Muriel at the Metropolitan* (Johannesburg, 1975); Mtutuzeli Matshoba, *Call Me Not a Man* (Johannesburg, 1979); Don Mattera, *Memory is the Weapon* (Johannesburg, 1987), Anthony Sampson, *Drum* (London, 1958).

11 These included Anton Lembede, Walter Sisulu, Oliver Tambo, AP Mda, and Nelson Mandela, amongst others.

12 Anthony Sampson, *The Treason Cage* (London, 1958).

1950–1976 Apartheid

David Goldblatt
Kinder auf der Grenze zwischen Fietas und Mayfair, um 1949

David Goldblatt
Children on the border between Fietas and Mayfair, Johannesburg, ca. 1949

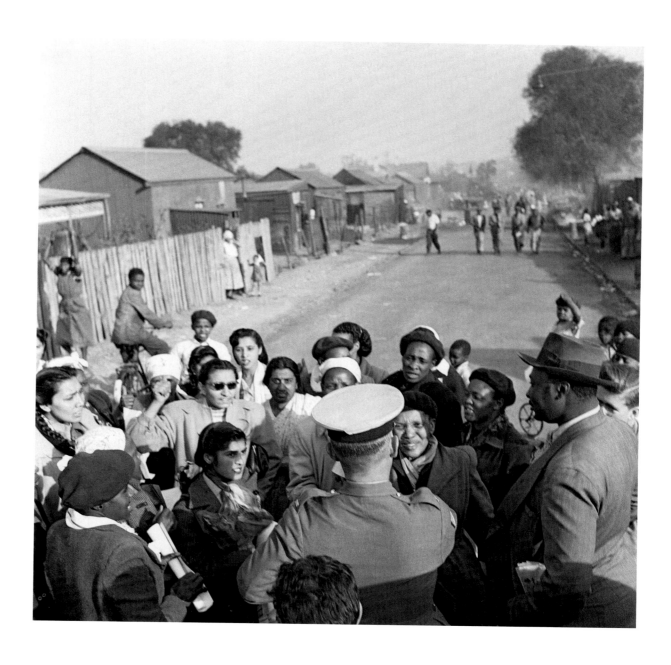

Bob Gosani
Die Geschichte der »Defiance Campaign«, Germiston, Oktober 1952

Die »Defiance Campaign«, die Kampagne zum zivilen Ungehorsam, wurde im Juli 1951 in Johannesburg bei einem Treffen von nichtweißen Führern ins Leben gerufen. Man beschloss, einen gemeinsamen Planungsrat zu gründen, um Schwarze, Farbige und Inder zu koordinieren und sofort eine Massenkampagne zu starten, die die Aufhebung der unterdrückenden Maßnahmen wie die Passgesetze, Gesetze zur Warenbegrenzung, nach Rassen getrennten Stadtvierteln, getrennter Volksvertretung, der Bantu-Verwaltung und zur Unterdrückung des Kommunismus. Der gemeinsame Planungsrat bestand aus J. B. Marks, Dr. Moroka und Walter Sisulu vom ANC. Sie verfassten einen Bericht, der dem ANC vorgelegt werden sollte. Die Regierung sollte aufgefordert werden, die ungerechten Gesetze aufzuheben, und falls sie sich weigerte, sollten Groß-demonstrationen veranstaltet werden, gefolgt von der »Defiance Campaign«.

Bob Gosani
The Story Of Defiance, Germiston, October 1952

The defiance campaign was born in Johannesburg on July 1951, when non-white leaders met and decided to form a Joint Planning Council to co-ordinate Africans, Indians, and Coloureds, and 'to embark upon an immediate mass campaign for the repeal of oppressive measures' which the Council pledged to attack were, and still are, limited to the Pass Laws, Stock Limitations, the Group Areas Act, the Separate Voters, Representation Act, the Bantu Authorities Act, and the Suppression of Communism Act. The Joint Planning Council consisted of J. B. Marks, Dr Moroka, and Walter Sisulu, of the African National Congress. They issued a report, to be put before the African National Congress, the Government should be called on to repeal the unjust laws, if they refused, mass demonstrations were to be held followed by the defiance campaign.

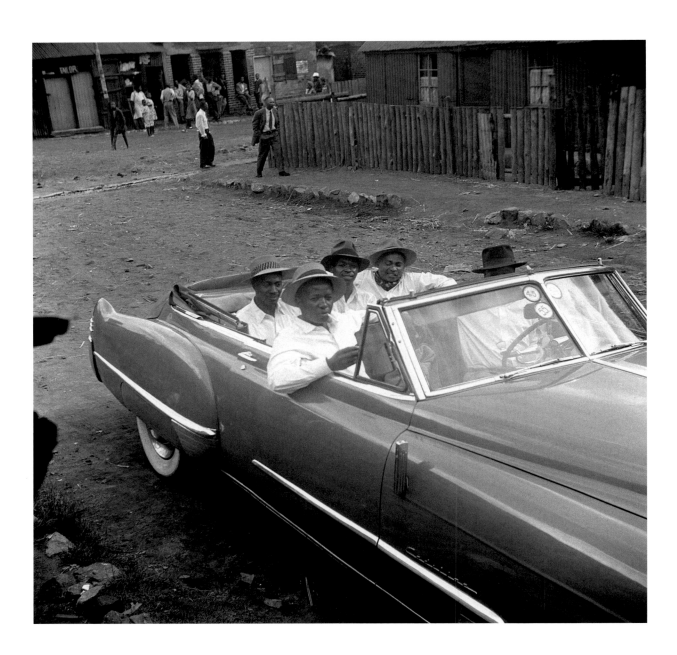

Bob Gosani
Die Americans, 1954

Mr Drum untersucht die berüchtigtste Gang des Minengebietes. Unter der Woche rauben sie Büros aus, indem sie sich als Angestellte in Arbeitskitteln verkleiden. An den Wochenenden hängen sie in der Township herum, tragen schicke amerikanische Klamotten. Nach dem Zweiten Weltkrieg sahen sich die meisten Städte auf der Welt einem anderen Krieg konfrontiert, einem, beim dem sie die Verbrechenswelle, die von den Jugendlichen und den Arbeitslosen ausging, zu stoppen versuchten. In Amerika hieß man es so: Die namenlose Straße, die durch alle Bundesstaaten verläuft. Johannesburg war da keine Ausnahme. Von Sophiatown aus, das man für den Ausgangspunkt aller Verbrechen im Minengebiet hielt, verbreiteten sich mehr Gangs in das Minengebiet als von einer anderen Township. Die Gangs bekämpften sich wegen der Mädchen. Sogar ein Schullehrer mit Hochschulabschluss und ein Student waren ihnen zu Diensten, indem sie ihnen die Liebesbriefe für die anständigen Mädchen, auf denen sie eine Auge geworfen hatten, verfassten. Denn die Americans versuchten respektabel zu sein, wenn sie respektable Leute trafen.

Bob Gosani
The Americans, 1954

Mr Drum investigates the Reefs, a most notorious gang. During the week they rob businesses, disguised as employees in dustcoats. During the weekends, they loaf around the locations, dressed in flashy American clothes. After World War II, most of the worlds big cities had to face another war, trying to stop the crime wave caused by the young and unemployed. America had what was called, 'The street with no name that runs across the States'. Johannesburg was no exception. Sophiatown, generally considered the nucleus of all Reef crimes, spawned on to the Reef more gangs than any other location. There were gang fights over girls. They even had the services of a Bachelor of Arts High school teacher and a matriculated student to write their love letters to the decent girls who drew their fancy. For the Americans tried to be respectable when they met respectable people.

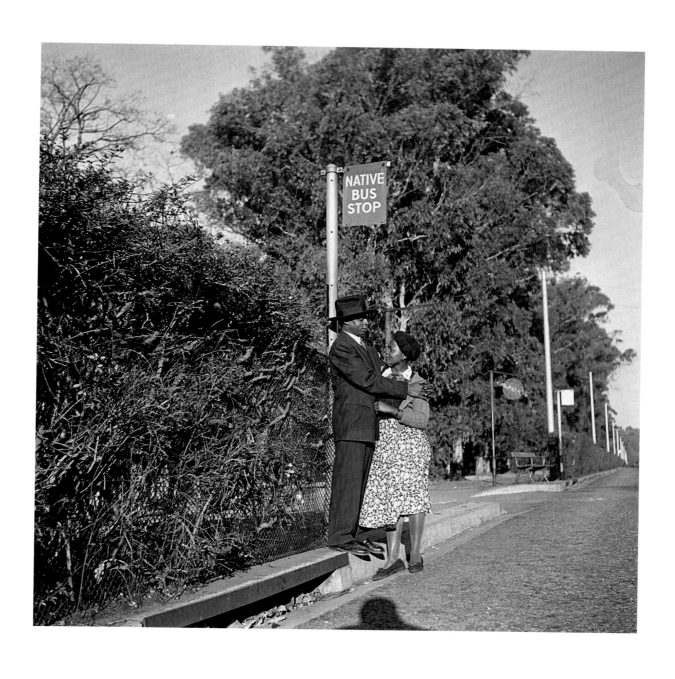

Bob Gosani
Liebesgeschichte, Sophiatown, 1954

Bob Gosani
Love Story, Sophiatown, 1954

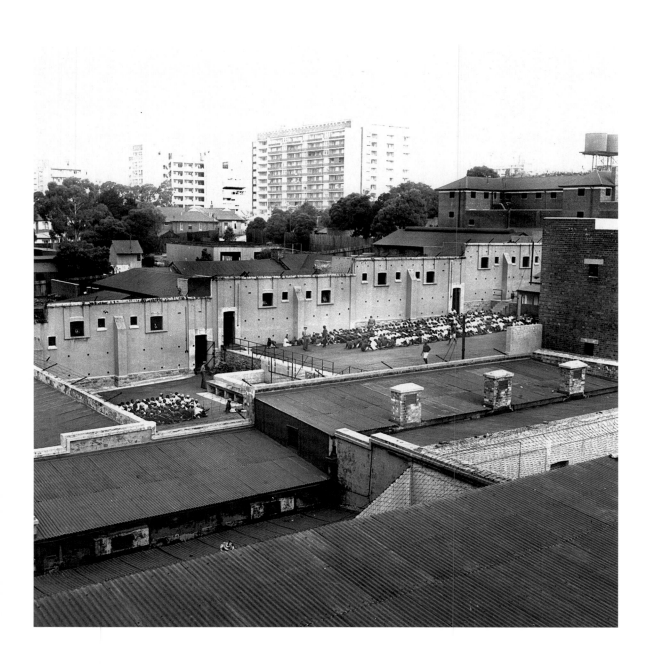

Bob Gosani
Mr. Drum geht ins Gefängnis, 1954

Das Bild zeigt, wie die Gefangenen im Johannesburger Zentralgefängnis und in anderen Gefängnissen des Landes durchsucht werden. Gefangene müssen sich nackt ausziehen und dann in die Luft springen, dabei in die Hände klatschen und den Mund öffnen, und sich dann umdrehen. Dies war bekannt als »Tauza« oder als Zulutanz. Die Verordnung Nr. 388 (b) der Gefängnisverordnung von 1911 besagte: Die Durchsuchung eines Verurteilten soll mit Anstand und respektvoll durchgeführt werden, und die Notwendigkeit, versteckte Gegenstände in der Kleidung oder irgendwo im Körper aufzufinden, soll mit der Schicklichkeit in Einklang gebracht werden. Drum lässt wissen, dass die in den beiden Bildern gezeigte Methode weder auf Anstand noch auf Respekt Rücksicht nimmt und dass sie weder notwendig noch effektiv im Kampf gegen das Schmuggeln ist; deshalb sollte man sie unverzüglich stoppen.

Bob Gosani
Mr Drum Goes to Jail, 1954

This picture shows the method of searching prisoners at Johannesburg Central Jail and in other jails throughout the country. Prisoners are made to strip naked and then to jump up in the air clapping their hands, opening their mouths, and then turn round. This is known as 'Tauza' or as the 'Zulu Dance'. Regulation no 388 (b) of the Prison Regulations of 1911, says: 'The searching of a convict shall be conducted with due regard to decency and self-respect, and in as seemly a manner as consistent with the necessity of discovering any concealed article on or in any part of his body or clothing'. Drum submits that the method of searching shown in these two photographs has no regard whatever to decency or self-respect; that it is neither necessary or even effective in preventing smuggling; and that it should be stopped forthwith.

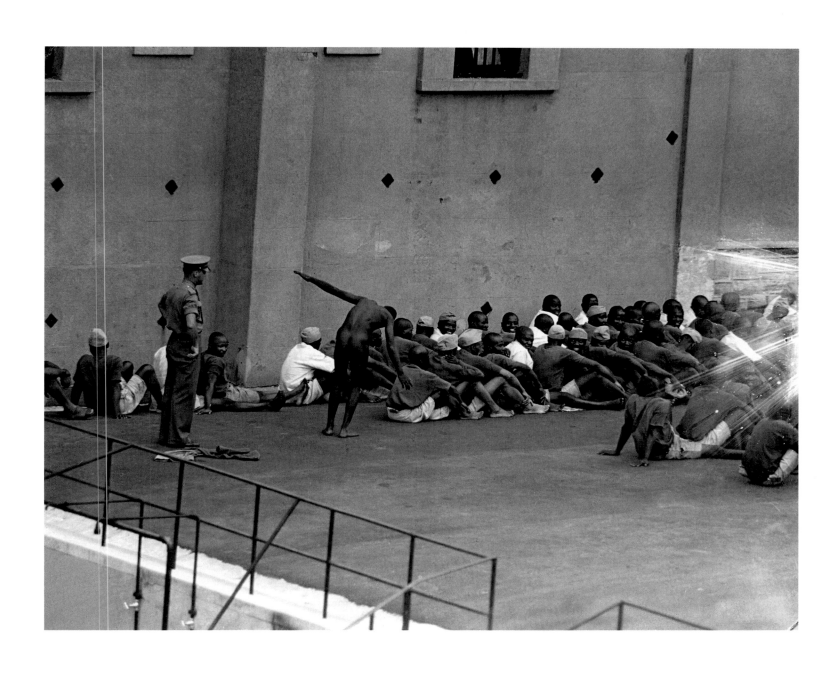

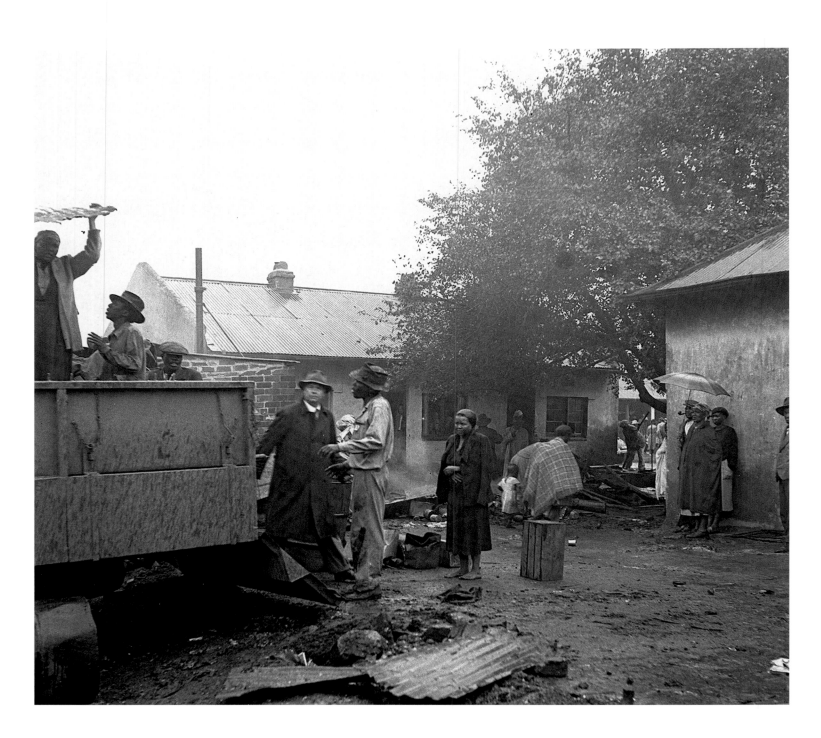

Peter Magubane
Was wird in den Western Areas geschehen, Februar 1955

Die Bewohner von Sophiatown haben zum Umzug gemischte Gefühle. Die ersten
60 Familien in Sophiatown, Johannesburg, haben die Anordnung erhalten, dass sie
ihre Häuser verlassen sollen. Ihnen sind Unterkünfte in der neuen Township
Meadowlands angeboten worden. »Sie werden hiermit gemäß dem Native Resettle-
ment Act 1954 aufgefordert, die Gebäude, in denen Sie wohnen, zu räumen.« Das
erste Datum wird mit 12. Februar angegeben.

Peter Magubane
What will happen in the Western Areas, February 1955

Sophiatown residents show mixed feelings about the move. The first sixty families
in Sophiatown, Johannesburg, have been given orders to leave their houses, and
have been offered accommodation in the new location in Meadowlands. 'You are
hereby required in terms of the Native Resettlement Act 1954 to vacate the premises
in which you are residing'. The first date given is the 12 February.

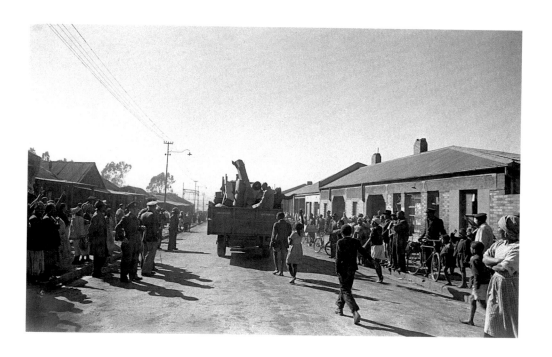

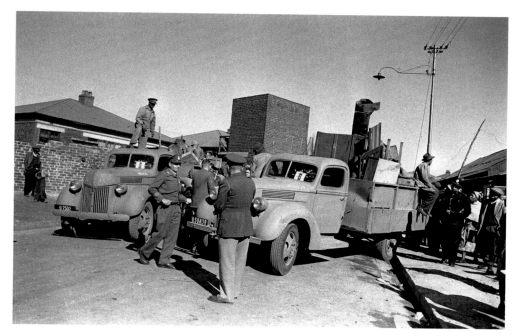

Bob Gosani
Die letzten Tage von Sophiatown, 1955

Große Maschinen und Männer mit Spitzhacken reißen die letzten Mauern von Sof'town ein. Ein letzter Blick und Goodbye. Sophiatown, die Stadt in der Stadt, das fröhliche Paris von Johannesburg, die berüchtigte Casbah-Gang, die kneipigste von allen. Sophiatown macht ihren letzten Atemzug. Ihre Leute mögen es nicht, dass sie ermordet wird, und ich kann sie verstehen, weil sie eine freie Stadt war. Dort gab es Aunt Babes auf der Edith Street. Bright's Place in Tucker und gegenüber das Carlton Hotel mit einem Chinesen als Chef. Sie hatte auch achtbare Bürger. Da waren Dr. A. B. Yuma, der afrikanische Arzt, und Herr J. R. Rathebe, der jedem erzählte, dass er in Amerika gewesen war. Sophiatown konnte sogar mit zwei Herren angeben, die in sie verliebt waren: Anthony Sampson und Pater Trevor Huddleston.

Bob Gosani
Last days of Sophiatown, 1955

Big machines and men with picks are beating down the last walls of Sophiatown. Take a last look and say goodbye. Sophiatown, the city that was within a city, the Gay Paris of Johannesburg, the notorious Casbah gang, the shebeeniest of them all. Sophiatown is now breathing for the last time. Her people do not like the fact that she is being murdered and I sympathize with them because she was a free city. There was Aunt Babes, in Edith Street. Bright's place in Tucker and opposite him the Carlton Hotel, run by a Chinaman. She also had her respectable citizens. There was Dr A. B. Xuma, the African M. D., and Mr J.R. Rathebe, who reminded everybody that he was once in America. Sophiatown will also boast that it built two gentlemen who fell in love with her, Anthony Sampson and Father Trevor Huddleston.

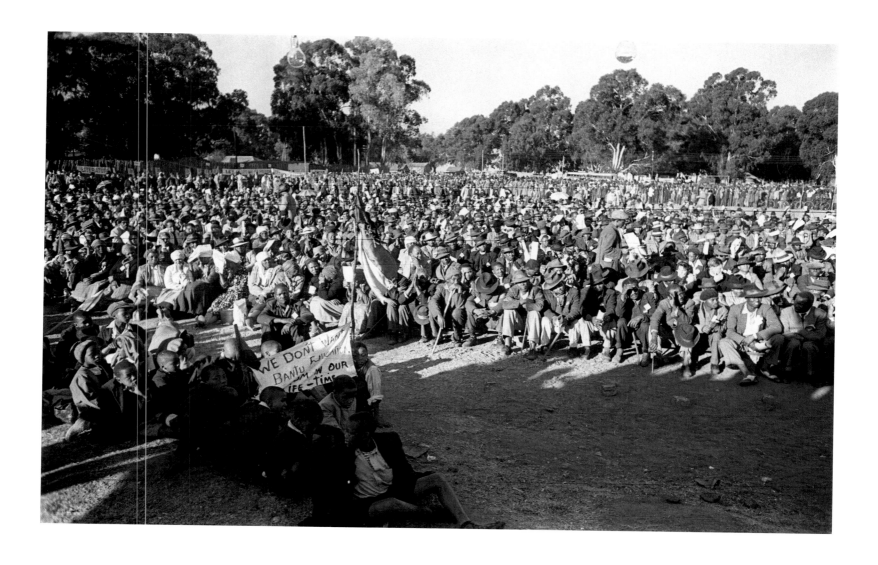

Unbekannter *Drum*-Fotograf
Der 4-in-1-Kongress!, 26. Juni 1955

Zum Volkskongress versammelten sich 3000 Delegierte auf dem Fußballplatz von
Kliptown. Der Volkskongress bestand aus vier Sektionen, dem ANC, dem Indischen
Kongress, der Organisation der Farbigen und dem Kongress der Demokraten. Die
Freiheitscharta, die der Volkskongress am 16. Juni annahm, wurde von den Delegierten
gelesen und unterschrieben. Viele, die zur Freiheitscharta sprachen, ließen die
Hoffnung durchschimmern, dass der Tag nicht weit sei, an dem die Forderungen er-
füllt werden. Der Weg mag lang sein, aber eine vereinte demokratische Front
war die einzige Lösung. ANC-Präsident Albert Luthuli sagte in seiner Botschaft, die
vor dem Kongress verlesen wurde, unten anderem: »Es sollte den Architekten der
Union klar sein, dass sie durch den Ausschluss der Bevölkerungsmehrheit, der Nicht-
weißen, aus der Welt der Demokratie ein falsches Fundament für den neuen Staat
gelegt haben und dass sie die Demokratie verspotten, wenn sie einen solchen Staat
demokratisch nennen.«

Unknown *Drum* Photographer
The 4-in-1 Congress!, 26 June 1955

The Congress of the People meet at the Kliptown football ground with 3000 del-
egates. The Congress of the People were made up out of four member bodies, the
ANC, the Indian Congress, the Coloured People's Organisation, and the Congress
of Democrats. The Freedom Charter, which the Congress of the People adopted on
26 June, was read and signed by the delegates. Many speakers on the Freedom
Charter sounded the note that the day might not be far off when its demands would
be met; the road might be long, but a united democratic front was the only solution.
ANC president Albert Luthuli, in his message read to the Congress, said among other
things that 'it should have been plain to the architects of the Union that by exclud-
ing from the orbit of democracy the majority of the population, the non-whites, they
were laying a false foundation for the new state and making a mockery of democ-
racy to call such a state democratic'.

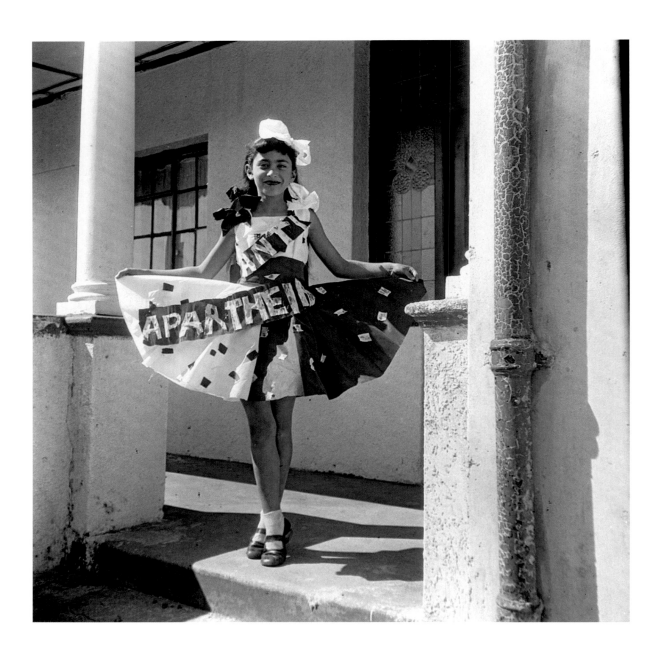

Bob Gosani
Das Anti-Apartheid-Kleid, 1955

Bob Gosani
Anti-Apartheid Dress, 1955

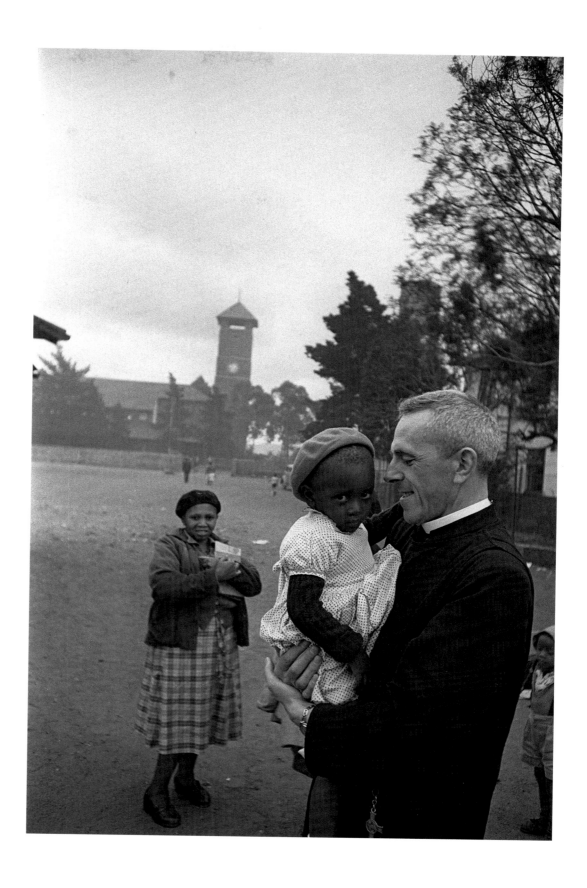

Bob Gosani
Trevor Huddleston, der kämpfende Priester, 1955

In den zwölf Jahren, die Pater Huddleston in Südafrika war, wurde er die wichtigste Figur der Kontroverse. In beiden politischen Lagern entstanden bei den Leuten heftige Debatten darüber, was er über das Rassenproblem sagte. Huddleston arbeitete in der Kirche St. Peter als Provinzial der Auferstehungsgemeinde.

Bob Gosani
Trevor Huddleston, the Fighting Priest, 1955

In the twelve years he was in South Africa, Father Huddleston became the greatest figure of controversy. On both sides of the political fence, people formed violent views about what he said on the race problem. Huddleston worked at St Peter's Priority as Provincial of the Community of the Resurrection.

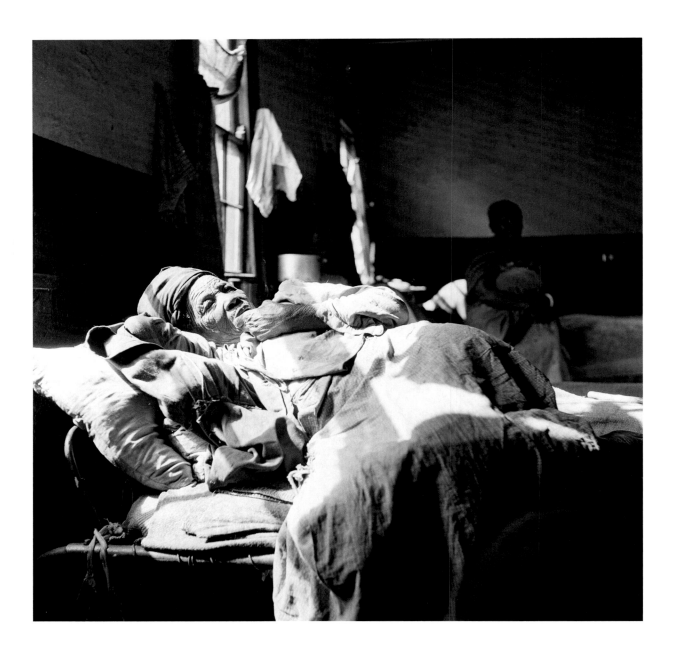

Bob Gosani
Bantu-Heim in Germiston, Das Haus der vergessenen Menschen, 1956

Am Rande von Germiston, zwischen den Abraumhalden der Minen und den Fabriken steht das Bantu-Heim, wo Hunderte von alten Afrikanern auf den Tod warten. Schwachsinnige, Epileptiker und Perverse aalen sich in der Sonne, essen, schlafen und warten ... warten auf den erlösenden Tod. Sie wurden von ihren Angehörigen und Freunden vergessen.

Bob Gosani
Germiston's Bantu Refuge, The House of the Forgotten People, 1956

On the outskirts of Germiston, between mine dumps and factories, stands the Bantu Refuge where hundreds of aged Africans wait to die. Imbeciles, epileptics, and perverts bask in the sun, eat, sleep, and wait ... wait for the blessing of death. They are forgotten by their relatives and friends.

G. R. Naidoo
Norma Naidoo, 1956

Schönheit hängt so oft von der subtilen Eigenschaft einer Frau ab, inwieweit ihr Aussehen und die Persönlichkeit ihres Gesichtes sich mit ihrer Stimmung verändert. Nur wenige Leute wissen, dass das genau das Geheimnis von Norma Naidoos fulminanten Erfolgen bei Schönheitswettbewerben ist. In jeder neuen Situation ist sie eine andere Norma, und jedes Mal ist sie genau die Richtige, dieses schöne Geschöpf von unendlicher Vielfalt. Die 18-jährige Norma Naidoo kommt vom Kap, ist durch und durch Kapmädchen, Gewinnerin von Preisen für die Beste Figur. Kürzlich fügte sie dem noch eine weitere Trophäe hinzu, als sie zur Schönheitskönigin bei einem Wettbewerb im Avalon Theatre, wo die Mädchen im glamourösen Abendkleid auftraten, gekrönt wurde. Norma gewann ihren ersten Titel mit 16.

G. R. Naidoo
Norma Naidoo, 1956

Beauty so often depends upon the subtle quality that a woman may have of changing the hue and personality of her face with her changing excitements. Few people know that this is exactly the secret of Norma Naidoo's sweeping success at beauty competitions. She's a different Norma for every occasion, and at each occasion she's just the right one, this beautiful creature of infinite variety. Petite eighteen-year-old Norma Naidoo is of the Cape, thoroughly Capetonian, winner of the best figure prize in Body Beautiful contests. Recently she added another award to her collection when she was voted Pageant Queen at a competition held at the Avalon Theatre, where girls billowed out in glamorous evening wear. Norma won her first title at the age of sixteen.

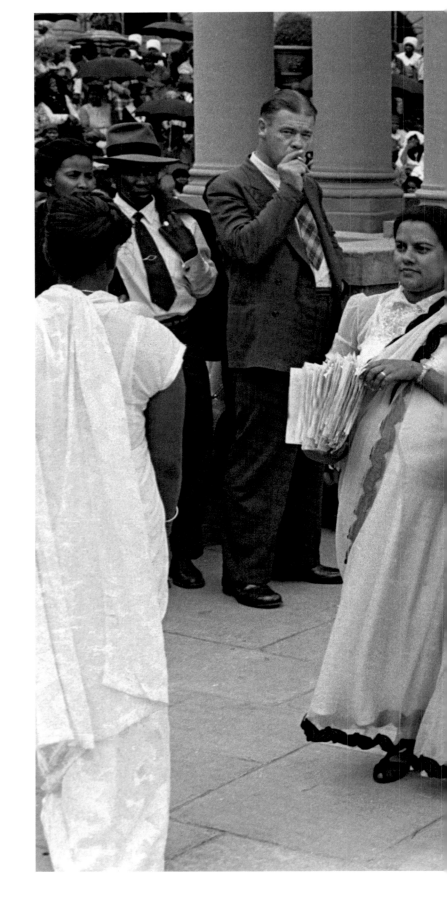

Alf Kumalo
Anti-Pass-Kampagne, 1956

Am 9. August 1956 brachten 20.000 Frauen aller Rassen aus den Metropolen und
Städten, aus den Homelands und aus den Dörfern, manche mit Babys auf dem
Rücken, eine an den Premierminister Strydom gerichtete Petition zum Regierungssitz
in Pretoria. Er war nicht da. Die Petition verlangte, dass die Passgesetze abgeschafft
werden. Lilian Ngoyi, Helen Joseph, Sophie Williams und Radima Moosa – die Delegier-
ten, die die Petition im Büro des Premierminister ablieferten, vor dem Regierungssitz.

Alf Kumalo
Anti-Pass Campaign, 1956

On 9 August 1956, 20,000 women of all races, some with the babies on their backs,
from the cities and towns, from the reserves and villages, took a petition addressed
to the Prime Minister Strydom to the Union Buildings in Pretoria. He was not in.
The petition demanded that the pass laws be abolished. Lilian Ngoyi, Helen Joseph,
Sophie Williams, and Radima Moosa—the delegates to deliver the petition to the
office of the Prime Ministers in front of the Union Buildings.

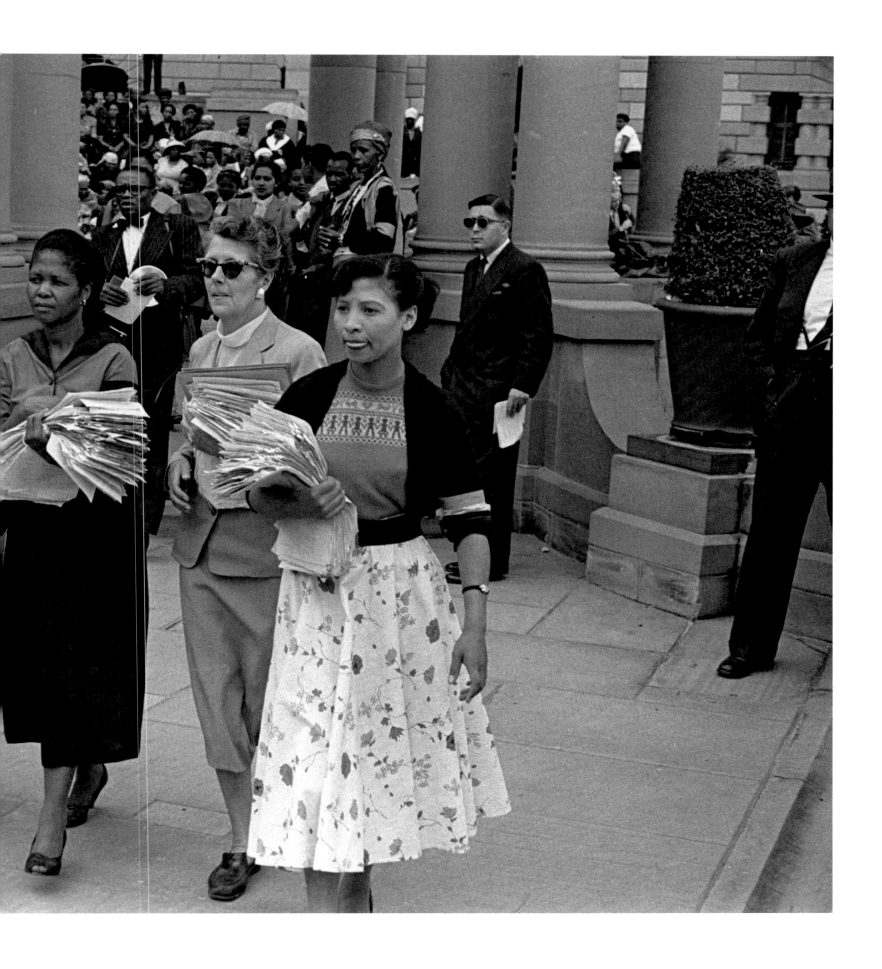

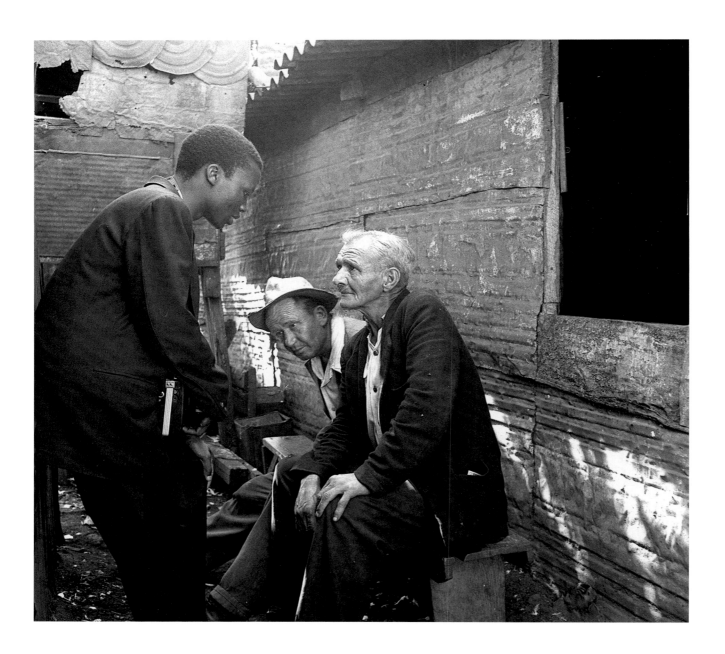

Ranjith Kally
Weiße in den illegalen Kneipen von Cato Manor, Durban, 1957

Bruder Mack (vorne) und Bruder Bill (mit Hut) sitzen vor einer Baracke in Cato Manor in der Sonne (Durban). Wer sagt, dass Cato Manor nicht gut für Weiße ist? Bruder George, Bruder Mack, Bruder Bill und Bruder Baldy mögen es hier. Und sie werden es Ihnen ins Gesicht sagen, Halsabschneider oder nicht, dass die Leute hier genauso Menschen sind wie jeder andere.

Ranjith Kally
Whites in Cato Manor Shebeens, Durban, 1957

Bra Mack (front) and Bra Bill (in hat) sit in the sun outside a Cato Manor shack (Durban). Who said Cato Manor isn't fit for a white to live in? Bra George, Bra Mack, Bra Bill, and Bra Baldy like it there. And they'd tell you to your face that, cut-throats or not, the people there are human just like anybody else.

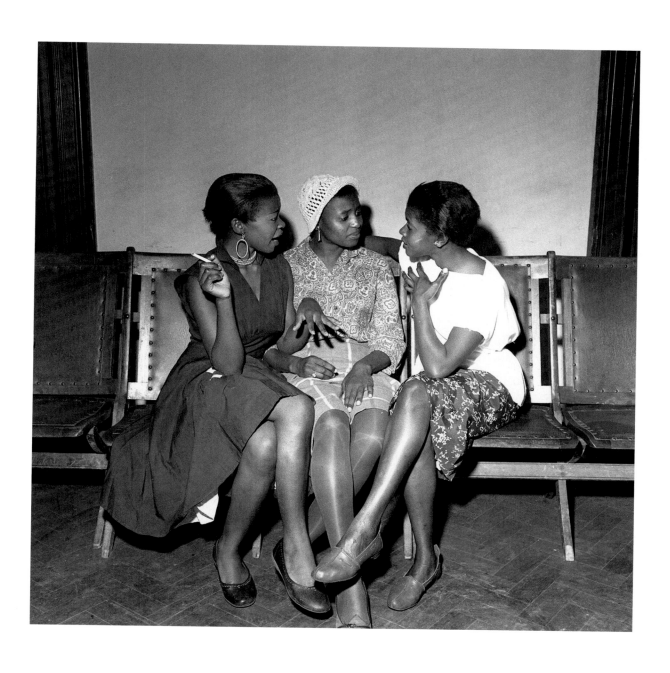

Ranjith Kally
African Jazz, 1957

Miriam Makeba mit zwei Damen.

Ranjith Kally
African Jazz, 1957

Miriam Makeba with two ladies.

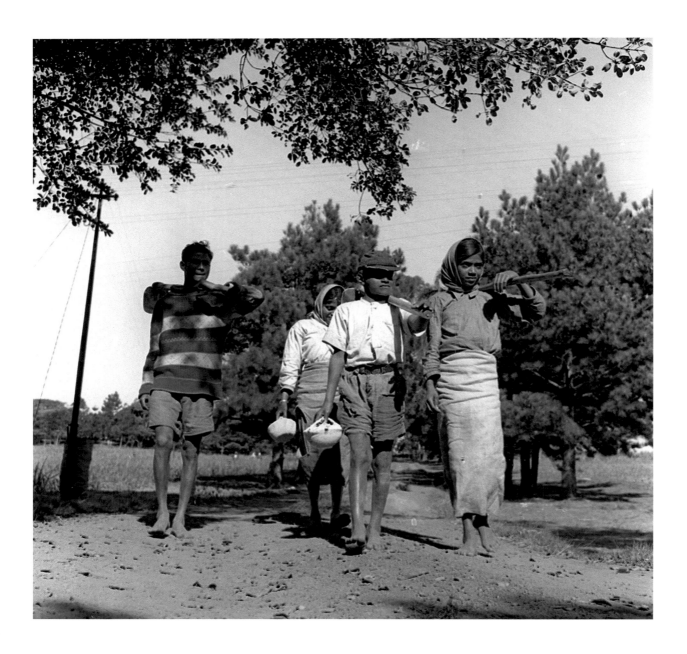

Ranjith Kally
Goldkinder müssen arbeiten, 1957

Mr Drum untersucht die Bedingungen der Kinderarbeit auf den Zuckerrohrfarmen!
Meistens arbeiten indische Kinder auf den Zuckerrohrfarmen! Einige der indischen
Kinder, die auf den Zuckerrohrfarmen in Natal arbeiten, kehren am Wochenende
mit ihrer Hacke und ihrem Essnapf heim. 10 Pence pro Tag für acht Stunden Arbeit.
Das ist es, was die kleinen indischen Kinder auf den Zuckerrohrfeldern in Natal
verdienen, auf den Feldern, auf denen das grüne Gold des Landes gedeiht. Hunderte
von Kindern arbeiten auf den Feldern, pflanzen und düngen das Zuckerrohr und
jäten Unkraut. Einige von ihnen sind noch keine 10 Jahre alt. Und doch machen sie
die Arbeit eines Mannes für die Bezahlung eines Kindes.

Ranjith Kally
Gold's Chillun Gotta Work, 1957

Mr Drum probes conditions of kid labourers on sugar farms! Mostly Indian children
work on these sugar farms! Some of the Indian children working on Natal's sugar
farms return home for the weekend with their hoes and lunch bowls. A penny
farthing an hour; ten pence per day of eight hours. That is what young Indian kids
earn on the Natal sugar fields, the fields on which the country's green gold grows.
Hundreds of children workers are employed in the fields planting, fertilise, and
weeding sugar cane. Some of them are not yet ten years old. Yet, they do a man sized
job for a kid's pay.

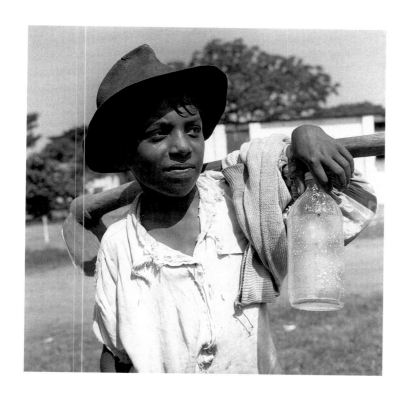
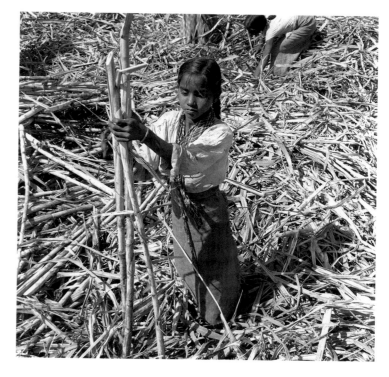

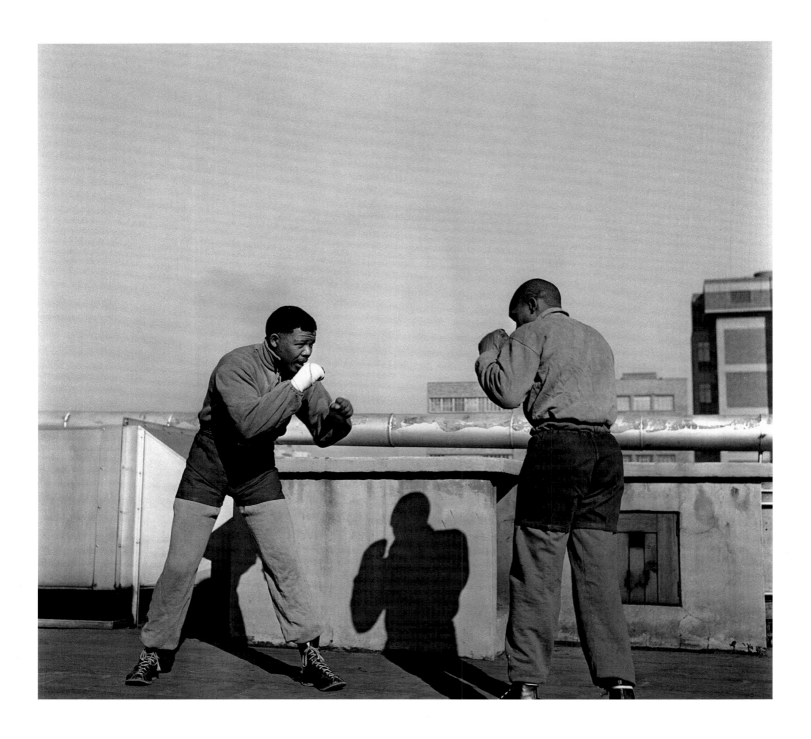

Bob Gosani
Hochverratsprozess: Ende von Runde eins, 1957

Um sich fit zu halten, boxt Nelson Mandela auf dem Dach eines Zeitungsgebäudes in
Johannesburg. Mandela, Rechtsanwalt, war jeden Abend in Jerry Molois Trainingshalle
in Orlando. Sein Sparringspartner ist Moloi (rechts), ein professionelles Leichtgewicht.
Mandela trainierte, um zu entspannen und sich zu erholen, nachdem er den ganzen
Tag auf der Anklagebank gesessen hatte. Als der erste Teil des größten Prozesses in der
Geschichte Südafrikas im August 1957 seinem Ende zuging, rätselte man, wie viele
der 156 angeklagten Frauen und Männer wohl wieder vor Gericht gestellt werden.
Die 156 nationalen Anführer erschienen Ende 1956 zunächst zu einer Voruntersu-
chung wegen Hochverrats in das dafür gebaute Gericht in der Drill Hall, Johannesburg.
Sie standen 1957 die meiste Zeit vor Gericht und wussten, dass das auch die Aus-
sichten für das nächste Kalenderjahr 1958 sein würde, wenn man sie unter Anklage
vor den Obersten Gerichtshof stellen würde.

Bob Gosani
Treason Trial: End of Round One, 1957

To keep fit, Nelson Mandela is boxing on the roof top of a newspaper building in
Johannesburg. Mandela, solicitor, was at Jerry Moloi's boxing gym at Orlando every
evening. He's shadow-sparring with Moloi (right) a professional featherweight.
Mandela used to spar after sitting in the dock all day, for relaxation and recreation.
As the biggest case in South Africa's history lumbered to the end of its first stage
this August 1957, the 156 accused men and women wondered how many of them
would be back in court again. The 156 national leaders had first appeared at a
preparatory examination into treason at the end of 1956, in the specially constructed
court at the Drill Hall, Johannesburg; they had spent their lives in and out of court
for most of 1957; and they could now see the possibility of the same prospect for the
third calendar year, 1958, if they were committed for trial in the Supreme Court.

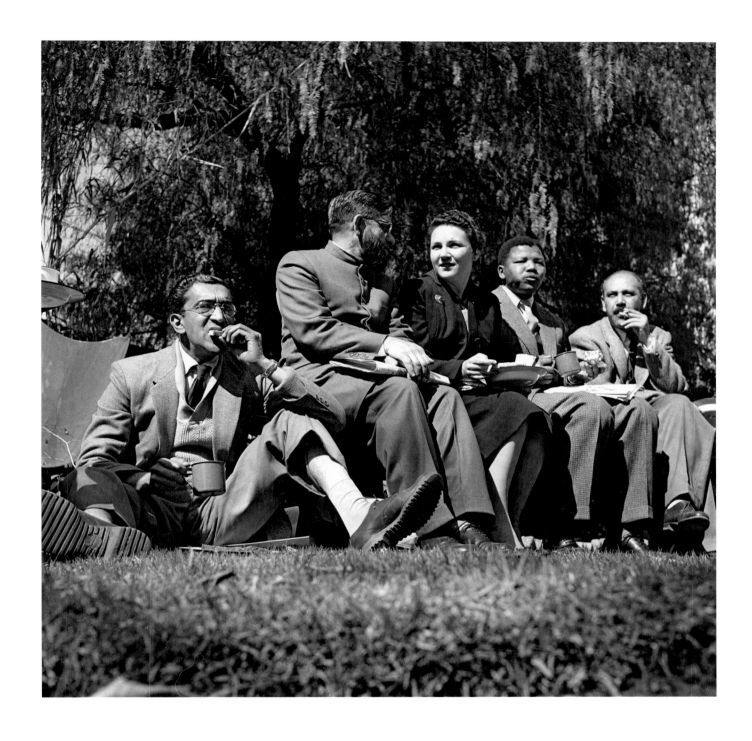

Alf Kumalo
Die Krone gegen 91, September 1958

Der Verrat fängt mit einer Überraschung an. Nelson Mandela während einer Tee-
oder Mittagspause. Der Hochverratsprozess in Pretoria in der alten Synagoge in
der Paul Kruger Street, die in ein Gericht umgewandelt worden war. Die Hungrigen:
die Angeklagten Sonia Bunting und Nelson Mandela essen eine Kleinigkeit, während
die Freunde zuschauen.

Alf Kumalo
The crown versus 91, September 1958

Treason gets off to a surprise start. Nelson Mandela during a tea/lunch break.
Treason trial in Pretoria at the old synagogue in Paul Kruger Street, which was
converted into a court. The Hungry: defendants Sonia Bunting and Nelson Mandela
have a bite while friends look on.

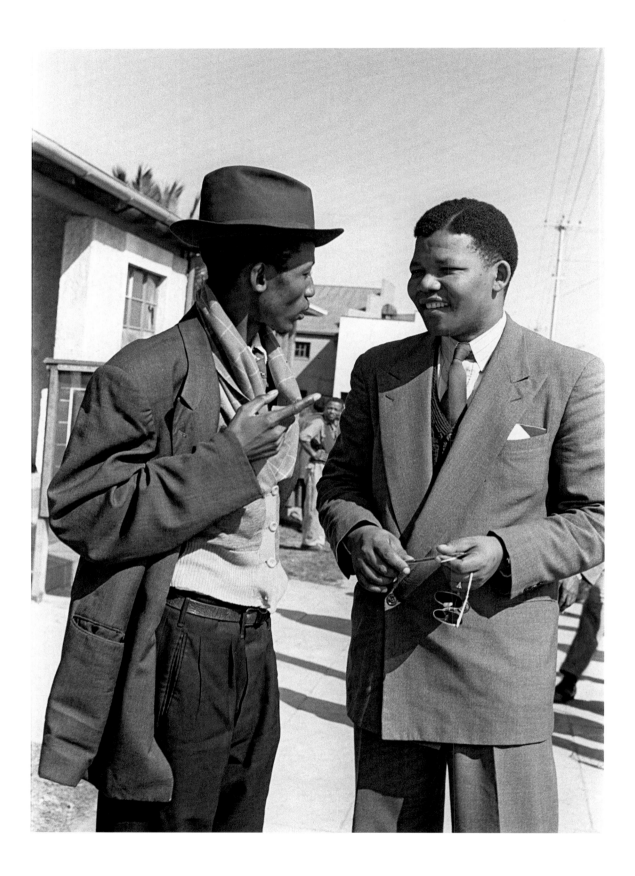

Peter Magubane
Nelson Mandela mit Peter Nthite, einem Führer der Youth League
des ANC bei einer Mittagspause während des Hochverratsprozesses in
Pretoria hinter der Synagoge, 1955

Peter Magubane
Nelson Mandela with Peter Nthite, another Youth League leader in
the African National Congress during lunch break at the Treason Trial
in Pretoria behind the Synagogue, 1955

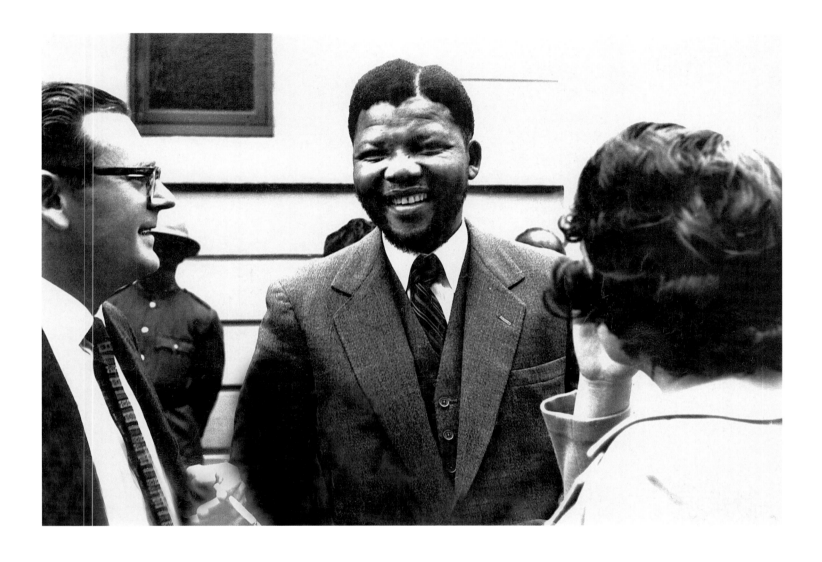

Alf Kumalo
Nelson Mandela (Mitte), Joe Slovo und seine Frau Ruth First während der
Hochverratsprozesses in Pretoria, 1958

Slovo – ein Rechtsanwalt wie Mandela – and First wurden 1956 verhaftet. Beide
waren aktive Mitglieder in der Kommunistischen Partei von Südafrika (SACP). Slovo
war Gründungsmitglied des Kongresses der Demokraten. Er war eines der ersten
Mitglieder des militärischen Flügels des ANC, des Umkhonto we Sizwe, und nahm
regelmäßig an deren Treffen auf der Liliesleaf Farm in Rivonia teil. Er verließ 1963
das Land. Ruth First wurde 1982 durch eine Paketbombe in ihrem Exil in Maputo,
Mosambik, getötet.

Alf Kumalo
Nelson Mandela (middle), Joe Slovo and his wife Ruth First during the
Treason Trial in Pretoria, 1958

Slovo—also a lawyer like Mandela—and First were arrested in 1956. Both were active
members of the South African Communist Party (SACP). Slovo was founding
member of the Congress of Democrats. He was one of the earliest members of the
military wing of the ANC Umkhonto We Sizwe and regularly attended meetings
of its high command at Liliesleaf Farm Rivonia. He left the country in 1963. In 1982,
Ruth First was killed in a parcel bomb explosion in exile in Maputo, Mozambique.

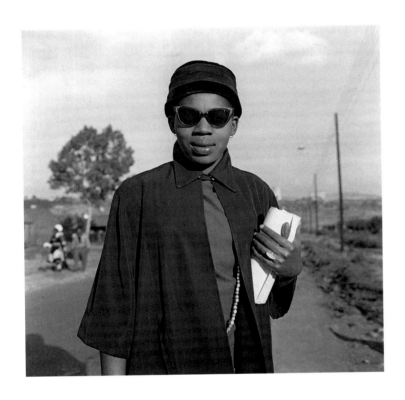

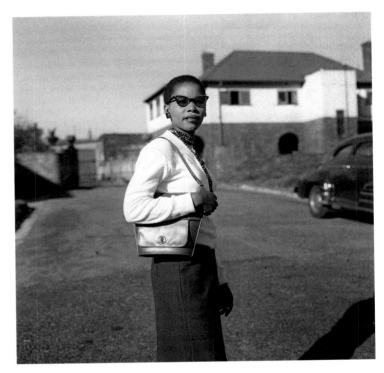

Bob Gosani
Wow! Diese Mädchen wissen sich zu kleiden, 1958

Jo'burgs Fabrikmädchen glauben, dass sie die schärfsten von allen Mädchen sind, wenn es darum geht, sich schick anzuziehen. Hier der Beweis. Nun urteilen Sie, wir trauen uns nicht. Freizeitkleidung bevorzugt.

Bob Gosani
Wow! These girls can sure dress, 1958

Jo'burg's factory girls reckon they're one up on all the other babes when it comes to dressing smartly. Here's their evidence. Now you judge, we're scared to. Casual wear preferred.

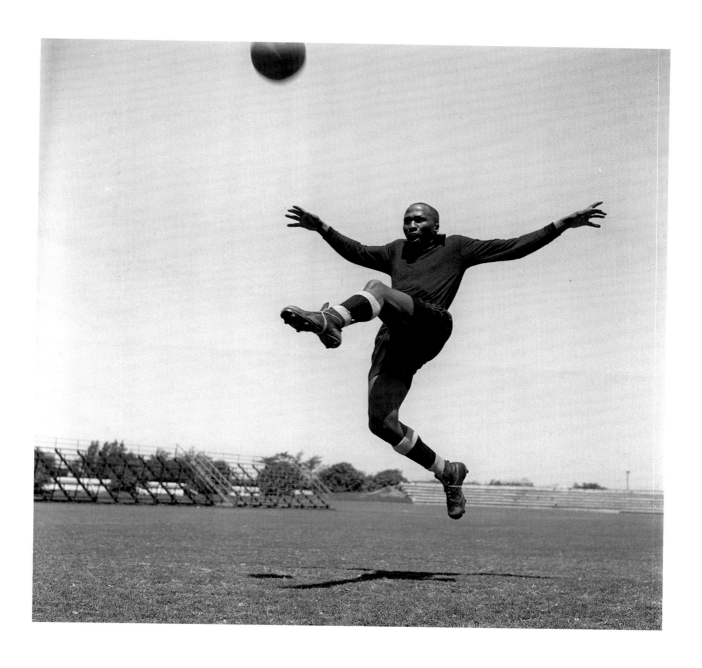

Unbekannter *Drum*-Fotograf
Dieser scharfe Nachtklub-Sänger ist in Wirklichkeit ein … Boxer, Schlagzeuger, Weiberheld und Fußballer, 1958

Lernen Sie Darius Dhlomo kennen, den Mann, den einige den begehrtesten Junggesellen von Durban nennen. Haben Sie schon mal einen Kerl getroffen, deren Talente so vielseitig sind, dass Sie sich wie ein Hinterwäldler vorkommen und Sie meinen, Sie hätten Ihr Leben vergeudet? Er ist Darius Dhlomo, der neue südafrikanische nichtweiße Boxchampion im Schwergewicht. Er spielt im Fußballnationalteam, ist ein Nummer-eins-Athlet, ein Schlagzeuger, ein Bluessänger und ein Junggeselle.

Unknown *Drum* Photographer
This Slick Night Club Singer is Really a … Boxer, Drummer, Ladies Man and Footballer, 1958

Meet Darius Dhlomo, the man some call Durban's most eligible bachelor. Have you ever met one of those guys whose list of talents makes you feel you're a hick from the jungle and have been wasting all your life? He's Darius Dhlomo, the new South African non-white light heavyweight boxing champion. He is also a national soccer player, a number-one athlete, a drummer, a blues singer, and a bachelor.

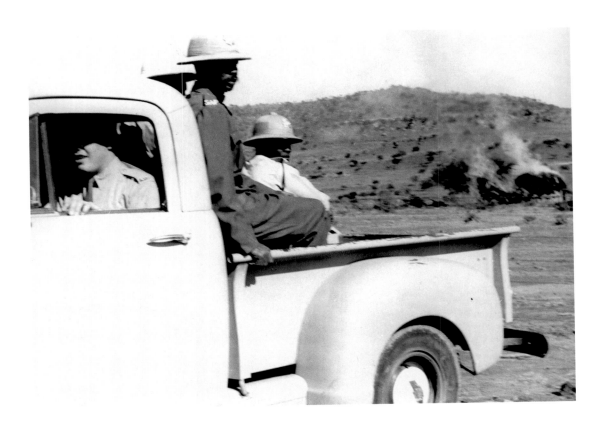

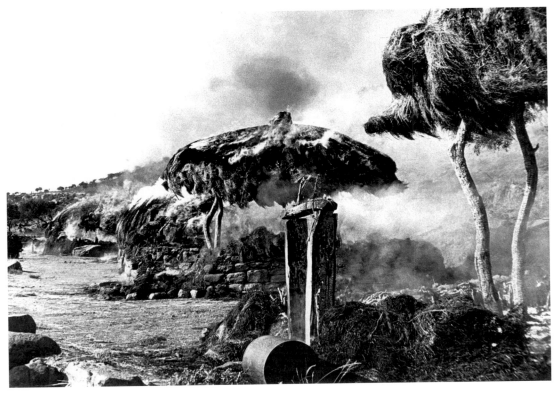

G. R. Naidoo
Wieder Weenen, 1958

Am Ort der Tränen gibt es noch mehr Weinen. Aufflammendes Feuer, eine
Rauchwolke und die Hoffnungen und Teile eines Familienhauses sind zerstört.
Etwa 100 m von einer Straße in Weenen entfernt stochert eine zerbrechlich
wirkende Frau mit einem Stock in den ausgebrannten Ruinen herum, verwirrt,
nicht ganz wissend, was sie tut. Nachdem das Feuer und die Bulldozer die
Hütten ausradiert haben, bleibt nicht mehr übrig als verkohlter Schutt.

G. R. Naidoo
Weenen Again, 1958

There's more weeping at the place of tears. A roar of flames, a cloud of smoke,
and the hopes and part of the home of a family are destroyed. About 100 yards
from a road in the Weenen area a frail looking woman is pecking with a stick
among burnt-out ruins of a hut, dazed, not fully knowing what she is doing.
After the fire and the bulldozers had vanished with the huts there was nothing
left but charred rubble.

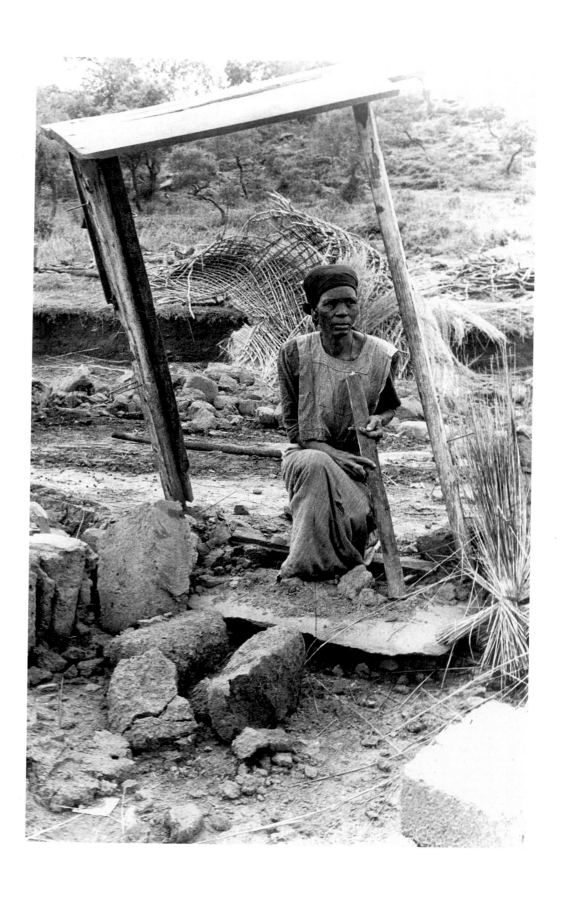

Bob Gosani
Josiah Madzunya, 1959

Was lässt ihn so laut ticken? Einige sagen, dass man sein Blut kochen hört, wenn er sich an einer Straßenecke über das, wofür die Afrikanisten stehen, aufregt, andere sagen, es ist wegen des dicken Mantels, den er sommers wie winters trägt. Warum auch immer, er regt sich ständig über die Schlagzeilen auf, seit die Afrikanisten (PAC) sich 1958 vom ANC abgespalten hat.

Bob Gosani
Josiah Madzunya, 1959

What makes him tick so loud? Some say you can hear his blood boil when he gets worked up on a street corner about what his Africanist group stands for. Others say his blood is boiling because of that overcoat he wears, summer, winter, the lot. Whatever the reason, he has been boiling over into the headlines ever since Africanists (Pan African Congress) split from the African Nationalist Congress (ANC) in 1958.

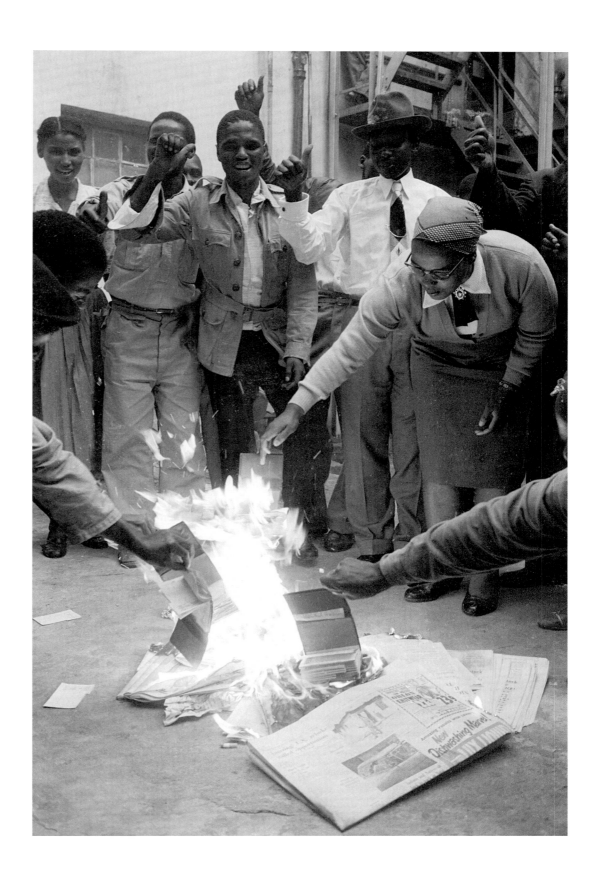

Ranjith Kally
Pässeverbrennung in Durban, 1960

Ranjith Kally
Burning of Passes in Durban, 1960

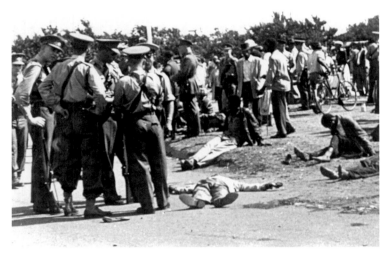

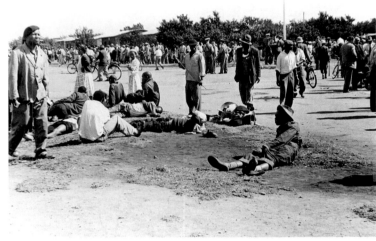

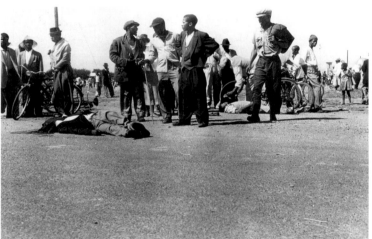

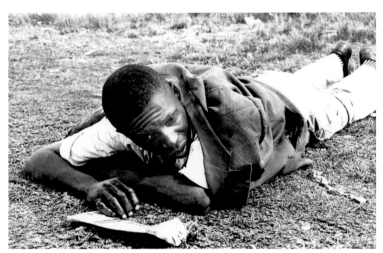

Peter Magubane
Fünf Monate Albtraum, 1960

Sharpeville, wie es begann. Nach dem Protest gegen das Gesetz der Apartheidregierung, nach dem alle Männer und Frauen ein Passbuch bei sich tragen müssen. Nach den Toten von Sharpeville; nachdem 20.000 Menschen verhaftet worden waren. Die Regierung schloss eine weiteres Kapitel in der Geschichte unseres Landes. Es gibt keine Änderung. Apartheid und die weiße Vorherrschaft werden bleiben.

Peter Magubane
Five Months Nightmare, 1960

Sharpeville how it began. After the people's protest against Apartheid government's law that all black South Africans, men and women, must carry pass books. After the Sharpeville killings; after 20,000 people had been detained; the government closed another chapter of our countries history. There was to be no change. Apartheid and baaskap was here to stay.

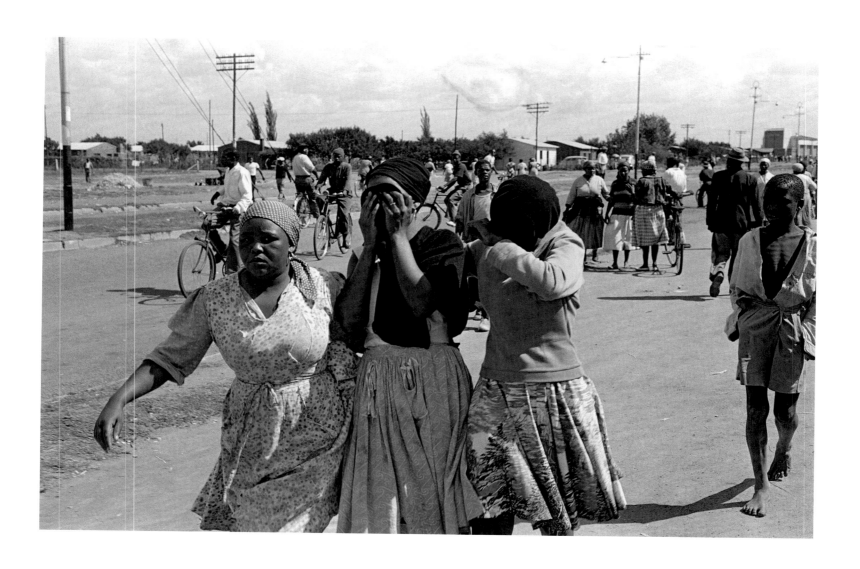

Peter Magubane
Fünf Monate Albtraum, 1960

Zwei trauergebeugte junge Frauen werden nach Hause gebracht, nachdem die Mittlere hat zusehen müssen, wie der Körper ihres Mannes gegenüber der Polizeistation in Sharpeville am 21. März 1960 durch Schüsse der Polizei in ein lebloses Bündel verwandelt worden war.

Peter Magubane
Five Months Nightmare, 1960

Two grief stricken young women being taken home after the one in the middle had viewed her husband's body twisted into a lifeless bulk by police gunfire, opposite the Sharpeville police station, 21 March 1960.

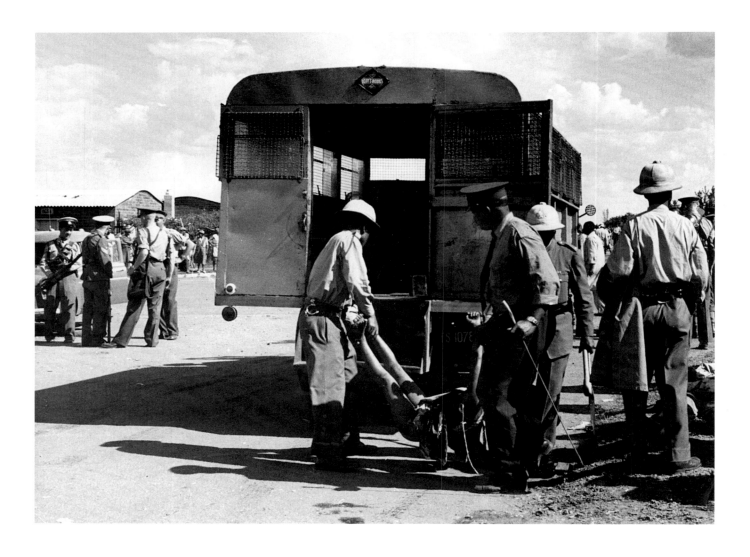

Peter Magubane
Fünf Monate Albtraum, 1960

Die Polizei lädt die Leichen der Opfer des Sharpeville-Massakers am 21. März 1960 in einen Lastwagen.

Peter Magubane
Five Months Nightmare, 1960

Police loading the bodies of victims of the Sharpeville massacre on 21 March 1960.

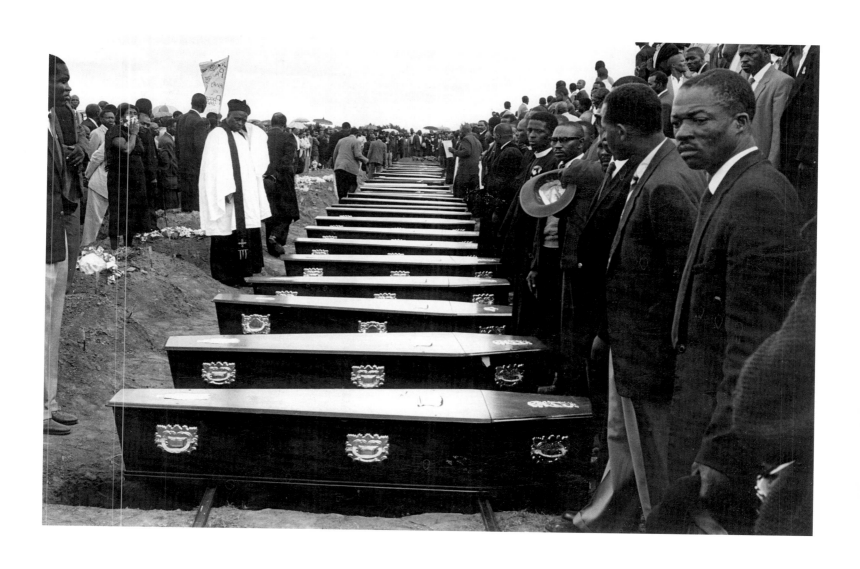

Peter Magubane
Fünf Monate Albtraum, 1960

Verwandte beweinen den Verlust ihrer Lieben, die im Sharpeville-Massaker getötet wurden.

Peter Magubane
Five Months Nightmare, 1960

Relatives mourning the loss of their loved ones killed in the Sharpeville massacre.

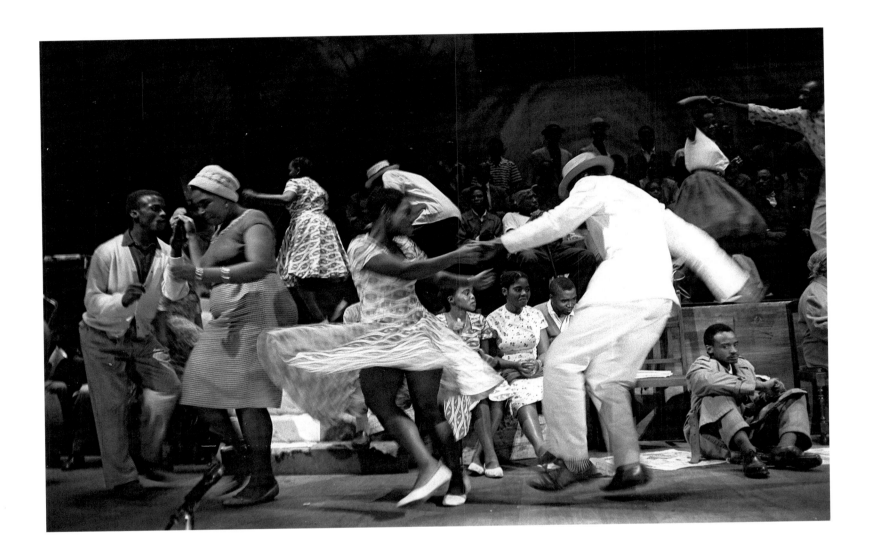

G. R. Naidoo
Hör dir das Musical an, 1960

Es nennt sich *Mkhumbane* und ist in Durban wie der Blitz eingeschlagen. Es ist eine Show über Freude, über Traurigkeit, zwei Stunden klangvolles Vergnügen. »Sehen Sie, wie dunkel es ist, wie still. Kaum einer bewegt sich. Nur einige Frühaufsteher. Nur wenige Busse auf der Straße, die die Frühaufsteher in die Stadt bringen. Von Mkhumbane.« Dies ist Teil des packenden Prologs im Musical *Mkhumbane/Cato Manor* von Alan Paton und Todd Matshikiza, das mitten in den Unruhen und während des Notstands für volles Haus in Durban sorgte.

G. R. Naidoo
Dig This Musical, 1960

It's called *Mkhumbane* and it has just burst like thunder on Durban. It's a show with joy, with sadness, two hours of tuneful, deep-down pleasure. 'See how dark it is, how quiet. Hardly anything is moving. Only some early person. Only some early buses in the street. Taking early persons to the town. From Mkhumbane'. This is part of the haunting prologue to the Alan Paton, Todd Matshikiza musical. Mkhumbane/Cato Manor, which showed to full houses in Durban in the midst of the disturbances and the emergency.

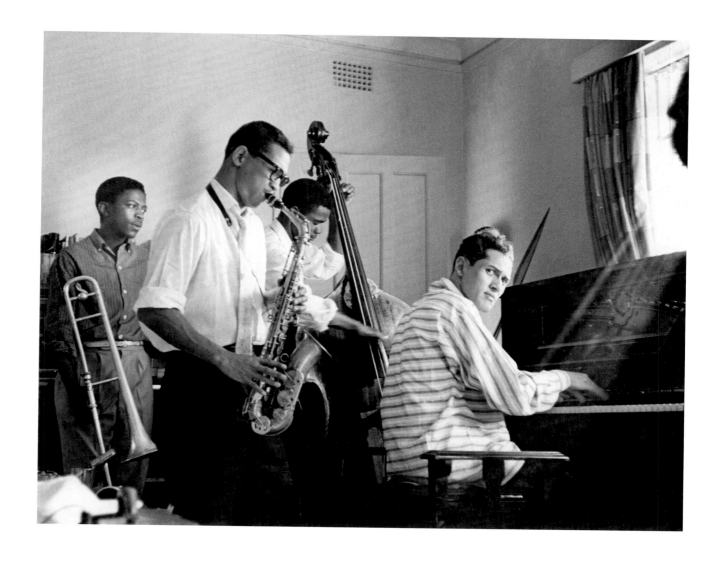

Unbekannter *Drum*-Fotograf
Fringe Country, 1961

Wo es keine Rassenschranken gibt. Kein Ort ist weniger rassistisch als die Jazz-Welt. Die Goodwill-Lounge in Durban war ein gemischtrassiger Veranstaltungsort, so wie das Crescent in Johannesburg. »Fringe Country«, das soziale Niemandsland, wo energiegeladene aufsässige junge Leute aller Rassen zusammenleben und -spielen wie Menschen. Ja, auch unter der rassistischen Sonne Südafrikas.

Unknown *Drum* Photographer
Fringe Country, 1961

Where there is no colour bar. No place is less race conscious than the Jazz world. The Goodwill lounge in Durban was a mixed venue, so was Crescent in Johannesburg. 'Fringe-country', that social noman's land, where energetic, defiant, young people of all races live and play together as humans. Yes, even under the racial skies of South Africa.

David Goldblatt
Shebeen (illegale Kneipe), Highlands, Johannesburg, Mai/Juni 1961

David Goldblatt
Shebeen, Highlands, Johannesburg, May/June 1961

Unbekannter *Drum*-Fotograf
Fussball ist sexy, Kapstadt 1962

Ein dramatischer Augenblick für einige der Mother-City-Mädchen. V.l.n.r.: Denise Layne
(rechts innen), Lorraine van der Horst (rechte Hälfte), Lorraine Johnson (vorne Mitte)
und Patsy Cloete (Torwart). Sie nennen sich die Mother-City-Mädchen – nach
Kapstadts Profiteam Mother City, für die sie die Anheizer spielen. Und obwohl es als
Spaß angefangen hat und sie dort, wo sie nicht hingehörten, ein paar Pfunde
verlieren wollten, sind diese Mädchen heute so wild auf das Spiel, dass sie Wettstreits
mit den Jungen aus der Schule veranstalten.

Unknown *Drum* Photographer
Soccer Goes Sexy, Cape Town 1962

A dramatic moment for some of the Mother City girls. From left to right: Denise
Layne (inside right), Lorraine van der Horst (right half), Lorraine Johnson (centre-
forward), and Patsy Cloete (goalie). They call themselves the Mother City Girls—after
the Cape's professional team, Mother City, for whom they play curtain-raisers.
And though it started out as habit of fun and a good way of keeping the extra inches
off where they weren't wanted, nowadays the girls are so keen on the game they're
issuing challenges to local school boys.

Alf Kumalo
Liliesleaf Farm in Rivonia, ein Tag, nachdem 19 Aktivisten und Anhänger
von Mandela verhaftet worden waren, 1963

1961 kauften Arthur Goldreich und Harold Wolpe die Farm im Norden von Johannes-
burg, um sie zum Hauptquartier der im Untergrund operierenden Kommunistischen
Partei (SACP) und der Aktivisten des ANC (u. a. Walter Sisulu, Dennis Goldberg,
Govan Mbeki, Ahmed Kathrada) zu machen. Nelson Mandela und seine Genossen,
die einen sicheren Ort brauchten, von dem sie aus operieren und wo sie Versammlun-
gen abhalten konnten, lebten hier. Am 11. Juli 1963 führte die Sicherheitspolizei eine
Razzia auf der Farm durch und verhaftete 19 Mitglieder des Untergrunds. Sie und
Mandela wurden im sogenannten Rivonia-Prozess der Sabotage angeklagt und zu
lebenslanger Haft verurteilt. Goldberg, das einzige weiße Mitglied, wurde zu vierfach
lebenslänglich verurteilt. Er wurde nach 22 Jahren freigelassen.

Alf Kumalo
Liliesleaf Farm in Rivonia, the day after the nineteen activists and
fellows of Mandela were arrested, 1963

In 1961, the farm in northern Johannesburg was purchased by Arthur Goldreich and
Harold Wolpe as the headquarter for the underground Communist Party (SACP) and
the African National Congress (ANC) activists (a.o. Walter Sisulu, Dennis Goldberg,
Govan Mbeki, Ahmed Kathrada). Nelson Mandela and his comrades needed a safe
place to operate from, helt meetings, and lived there. On 11 July 1963 security police
raided the farm and captured nineteen members of the underground, charging them
with sabotage, so called Rivonia Trial. The activists and Mandela were sentenced to
life imprisonment. Goldberg, the only white member was sentenced to four terms
life imprisonment at Pretoria. He was released after twenty-two years.

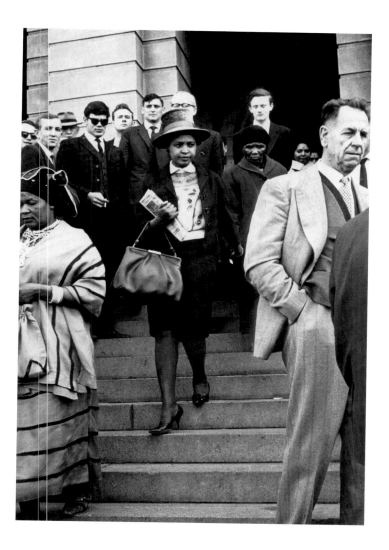

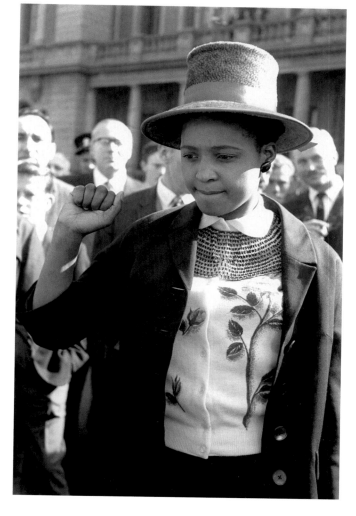

Alf Kumalo
Vor Gericht, Dezember 1963

Winnie Mandela und Mandelas Mutter vor dem Justizpalast während des Rivonia-Prozesses. Die ganze Welt sah zu, als die drei Prozesse u. a. wegen schwerwiegender Sabotage in Pretoria, Kapstadt und Pietermaritzburg begannen. Winnie Mandelas Mann wurde zu lebenslanger Haft verurteilt und auf die Gefängnisinsel Robben Island gebracht.

Alf Kumalo
On Trial, December 1963

Winnie Mandela and Mandela's mother outside the Palace of Justice during the Rivonia Trial. The whole world was watching when the three major sabotage trials started in Pretoria, Cape Town, and Pietermaritzburg. Winnie Mandela's husband was sentenced to life imprisonment on Robben Island.

David Goldblatt
Die Innenstadt von Johannesburg von Südwesten, Januar 1964

David Goldblatt
Johannesburg city from the southwest, January 1964

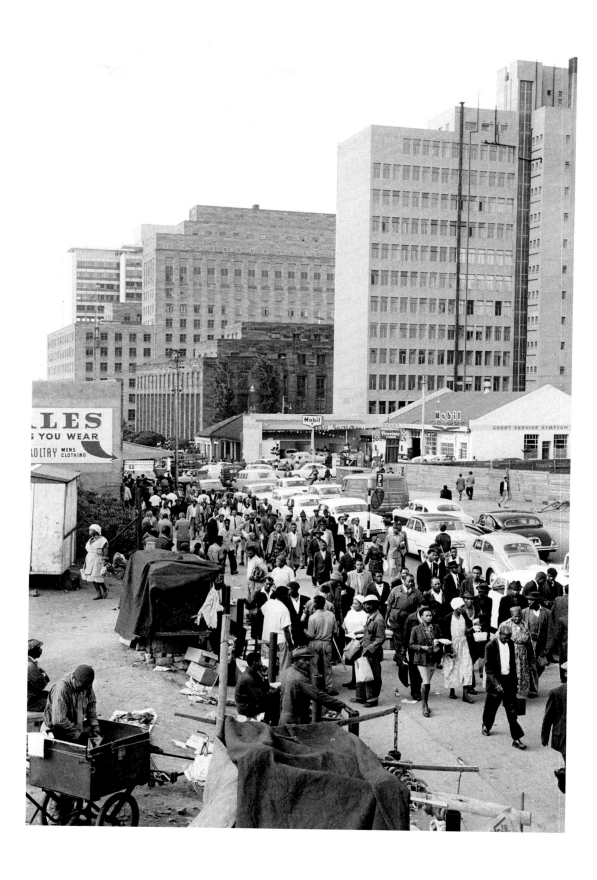

David Goldblatt
Am Abend strömen die Schwarzen zum Westgatebahnhof, wo die Züge nach Soweto abfahren, die Weißen sitzen in ihren Autos und fahren in die nördlichen Vorstädte, Johannesburg, 1964.

David Goldblatt
In the evening exodus from the city, blacks stream to Westgate station for trains to Soweto; whites, in their cars, head for the Northern Suburbs, Johannesburg, 1964.

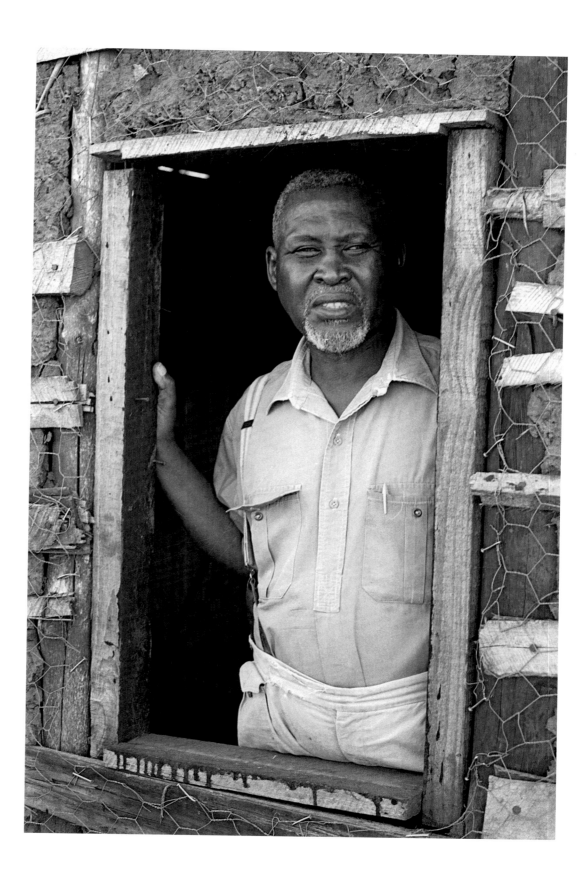

Ranjith Kally
Chief Albert Luthuli, früherer ANC-Präsident, Rektor der Glasgow University und 1960 Träger des Friedensnobelpreises, April 1964

Von der Regierung mundtot gemacht, weil er nichts mehr in diesem Land veröffentlichen durfte, wurde er unter Hausarest gestellt und durfte sein Haus in der Nähe von Stanger in Natal nicht verlassen.

Ranjith Kally
Chief Albert Luthuli, former President General of the African National Congress, Rector of Glasgow University, and 1960 Nobel Peace Prize winner, April 1964

Gagged by the Government from having any of his words published in this country, being under house arrest he was confined to a small area around his home near Stanger in Natal.

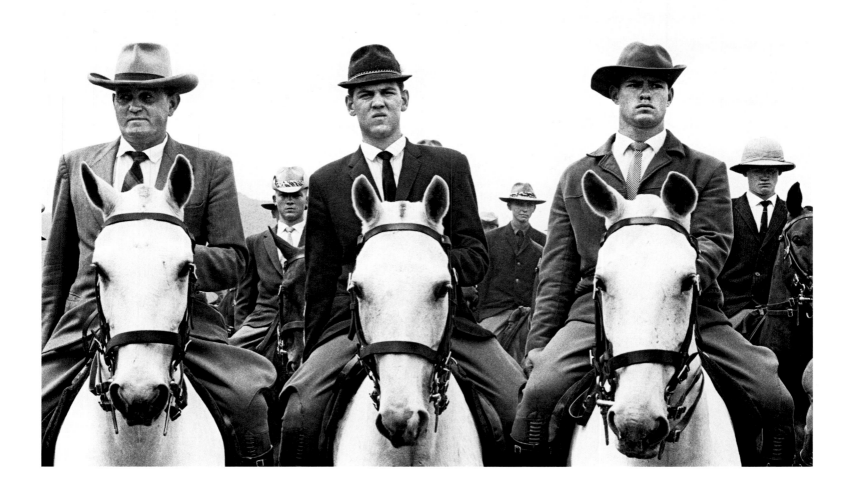

David Goldblatt

Das Kommando der Anhänger der Nationalen Partei, die den Premierminister und den Vorsitzenden der Nationalen Partei Hendrik Verwoerd und seine Frau Betsie zur Feier anlässlich des 50-jährigen Bestehens der Partei in De Wildt begleitet, Oktober 1964

Der Mann in der Mitte der vorderen Reihe ist Leon Wessels, der spätere stellvertretende Minister für Gesetz und Ordnung in der Regierung der Nationalen Partei. Er war das erste ältere Mitglied der Partei, das sich für die Apartheid entschuldigt hat.

David Goldblatt

The commando of National Party stalwarts which escorted Prime Minister and National Party leader, Hendrik Verwoerd and his wife Betsie, to the party's fiftieth anniversary celebrations at De Wildt, October 1964

The man in the middle of the front row is Leon Wessels who later became Deputy Minister of Law and Order in the National Party government. He was the first senior member of that party to apologise for Apartheid.

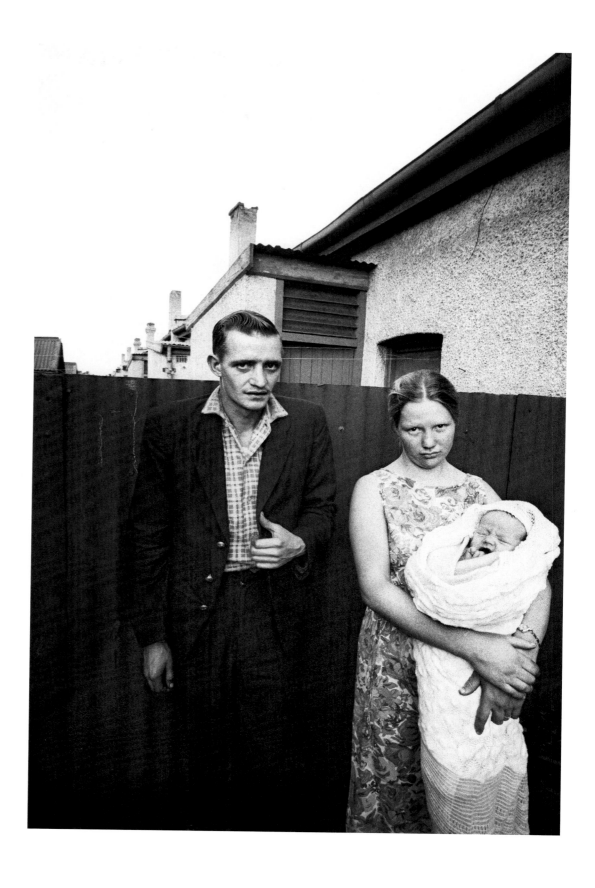

David Goldblatt
Ein Eisenbahner und seine Familie im Hinterhof ihres Hause in den
»Dubbeldekkers«, Bloemfontein 1965

Er und seine Frau war sehr religiös. Sie glaubten nicht daran, dass der eine Glaube
wahrer ist als der andere, deshalb gingen sie jeden Sonntag in eine andere Kirche.

David Goldblatt
A railwayman and his family in the backyard of their home in the 'Dub-
beldekkers', 1965

Both he and his wife were deeply religious; they did not believe that one faith was
'more true' than another, so each Sunday they attended a different church,
Bloemfontein.

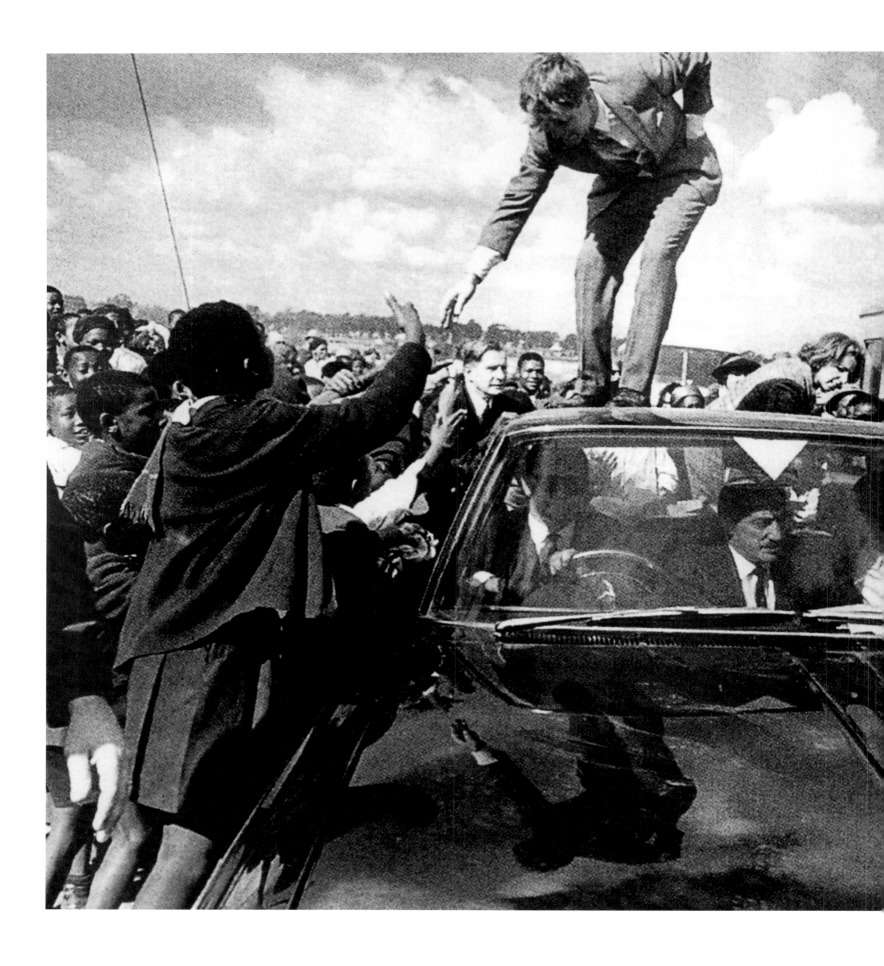

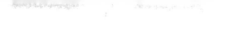

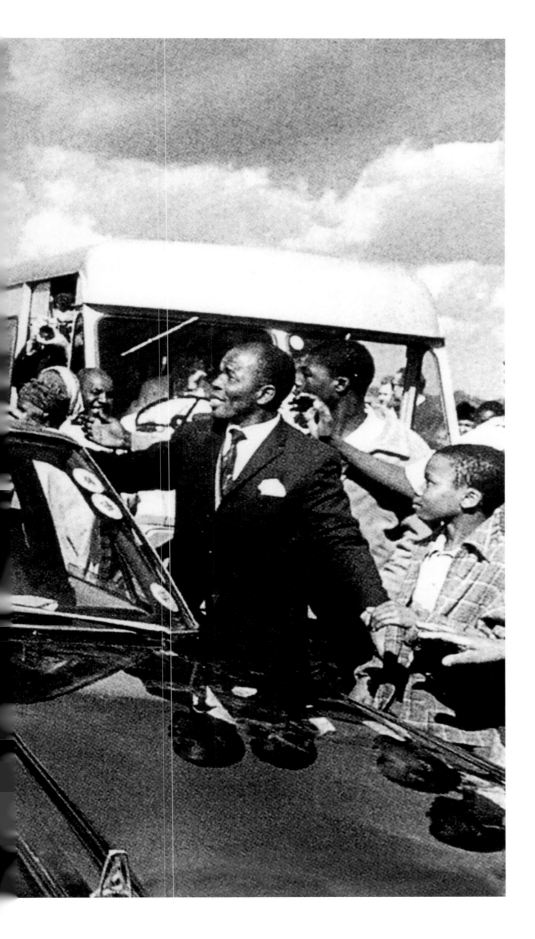

Alf Kumalo
Robert Kennedy zu Besuch in Soweto, 1966

Hier sieht man ihn auf dem Dach eines Autos vor der katholischen Kirchen Regina Mundi, wo er mit den Bewohnern betete. Senator Kennedys Besuch in Südafrika im Juni 1966 war einer der wichtigsten Besuche eines Amerikaners in Südafrika, weil er während der schlimmsten Jahre der Apartheid stattfand. Der Architekt der Apartheid, Dr. Verwoerd, war Premierminister, während Nelson Mandela, Chief Albert Luthuli und andere Führer der Opposition im Gefängnis auf Robben Island saßen, unter Hausarrest standen oder im Exil waren. Mit wenigen Ausnahmen befand sich die gesamte Opposition, das ganze Spektrum vom schwarzen und weißen Südafrika – politische Parteien, Universitäten, Kirchen, Künsten und Medien – unter fester Kontrolle der Nationalen Partei und ihrer militärischen, bürokratischen und ideologischen Maschinerie. Kein Weißer hat je so einen überschwänglichen Empfang erhalten wie die Kennedys in Soweto. Tausende jubelten ihnen zu, als sie die ungepflasterten Straßen entlangfuhren – die meiste Zeit auf dem Dach ihres Autos –, Schulen und die Kirche Regina Mundi besuchten sowie spontan das bescheidene Heim von Mrs. Zondi in Swoeto.

Alf Kumalo
Robert Kennedy visiting Soweto, 1966

Here he is seen on the roof of a car outside the Regina Mundi Catholic Church where he prayed with local residence. Senator Kennedy's visit to South Africa in June 1966 remains the most important visit an American made to South Africa because it took place during the worst years of Apartheid. The architect of Apartheid, Dr Verwoerd, was Prime Minister, while Nelson Mandela, Chief Albert Luthuli, and other opposition leaders were in prison on Robben Island, put under house arrest, or were in exile. With rare exception, all opposition across the spectrum of black and white South African political parties, the universities, the churches, the arts, and the media were living under the tight control of the National Party and its military, bureaucratic and ideological machinery. No white people had ever received the kind of exuberant reception the Kennedys received in Soweto. Thousands of people cheered them as they travelled the unpaved roads—much of the time on the roof of their car—and visited schools, the Regina Mundi Church and a spontaneous visit to the modest Soweto home of Mrs Zondi.

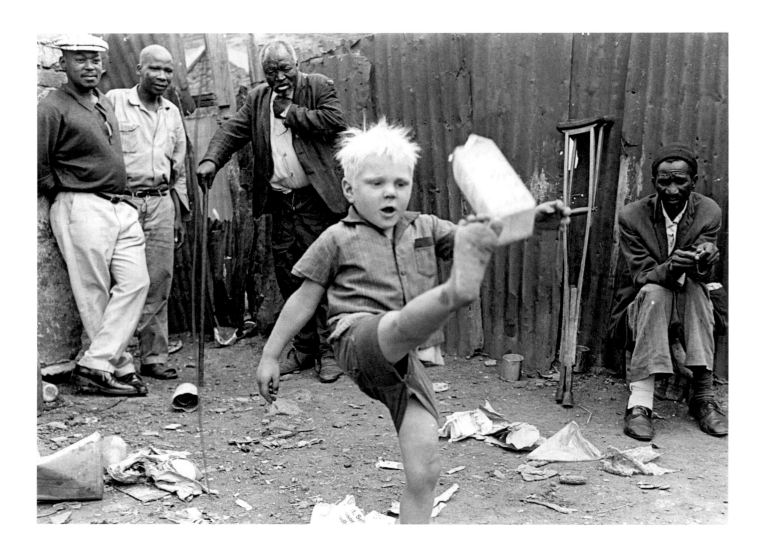

Ubekannter *Drum*-Fotograf
V steht für Vrededorp – und Verbrechen, 1969

Jeder leere Maismehlkarton ist für jeden Jungen ein guter Fußball. In Vrededorp gibt es keine Rassenschranken. Der Penner aus dem Joubert Park oder die Hausfrau aus Meadowlands. Jeder mit einer Liebe für Barberton kann bei diesem Spaß mitmachen. Aber der alte Mann im Hintergrund wird Ihnen erzählen, dass das kein Platz für Kinder ist.

Unknown *Drum* photographer
V is for Vrededorp—and Vice, 1969

Any empty carton of maize is a good football for any boy. There are no race barriers in Vrededorp. Joubert Park hobo or Meadowlands housewife. Anyone with a taste for Barberton can join in the fun. But the old man in the background will tell you it's not really a place for kids.

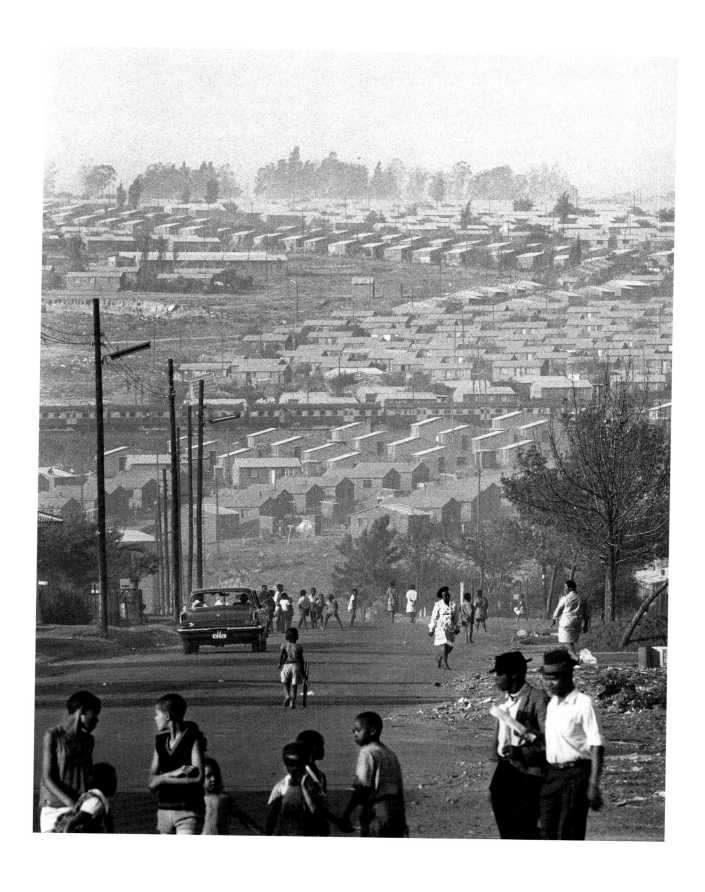

David Goldblatt
Meadowlands von Mofolo aus, Soweto, Johannesburg, September 1972

David Goldblatt
Meadowlands from Mofolo, Soweto, Johannesburg, September 1972

Das Wiederaufleben des Kampfes und das Ende der Apartheid: 1976–1994

Andries Walter Oliphant

Einleitung

Um die südafrikanische Fotografie zu verstehen, oder gar die ästhetischen und sozialen Dimensionen vollständig zu erfassen, ist es notwendig, so glaube ich, für den politischen und historischen Kontext, in dem die Bilder stehen, sensibel zu sein sowie dafür, wie sie über die Zeit hinweg kommunizieren. Daher soll dieser Beitrag skizzieren, in welchem Kontext die für diese Ausstellung ausgewählten Fotografien ursprünglich entstanden sind.

Wie die Kunst des Augenblicks, so wird das fotografische Bild, auch wenn es inszeniert, stilisiert oder abstrahiert ist, aus den rastlosen Fängen der Zeit geschnappt. In diesem Sinne hat es viele Gemeinsamkeiten mit dem flüchtigen, momentanen und zufälligen Charakter der Aktualität. Während die Geschichtsschreibung immer eine ausgewählte Rekonstruktion der Vergangenheit ist, fangen Fotografien den tatsächlichen Moment in Echtzeit ein. Aus der heutigen Sicht, als künstlerische Manifestationen, bieten sie einen visuellen Zugang zur Vergangenheit.

Im Großen und Ganzen umschließt die Zeit von 1950 bis 1994 den Aufstieg und Fall der Apartheid. Die Jahre von 1994 bis 2010 bilden den Übergang zur Demokratie und die Herausforderungen ihrer Konsolidierung. Jede Stufe dieser epischen Betrachtung ist durch ihre eigenen kritischen Momente, entscheidende Ereignisse, Helden, Schurken, Opfer und Menschenmassen, aus denen eine fotografische Perspektive entsteht, visuell erfasst. Es geht hier um die letzten drei Jahrzehnte der Minderheitsregierung in Südafrika.

Black Consciousness (Schwarzes Bewusstsein) und die Wiedergeburt des Kampfes 1976–1980

Alle Anti-Apartheid-Organisationen verboten und deren Führer entweder im Gefängnis oder im Exil, gab es in der zweiten Hälfte der 1960er-Jahre keinen offenen Widerstand gegen die Apartheid. Unterdrückt in Südafrika, in den Untergrund getrieben oder ausgewiesen, begannen die Freiheitsorganisationen im Exil den mühsamen Prozess der Umgruppierung unter den neuen Bedingungen der Illegalität. Der African National Congress (ANC) entwickelte mit seinen Verbündeten, der Kommunistischen Partei Südafrikas (SACP) und dem südafrikanischen Kongress der Gewerkschaften (SACTU), mit viel größerer Wirkung als sein Rivale, der Panafrikanische Kongress (PAC), eine neue mehrgleisige Strategie. Diese bestand aus dem bewaffneten Aufstand gekoppelt mit der wirtschaftlichen, kulturellen, sportlichen und diplomatischen Isolierung der Apartheidregierung.

Die Stille und scheinbare Nachgiebigkeit innerhalb Südafrikas im Gefolge der Niederlage der Kampagnen zum zivilen Ungehorsam der 1950er-Jahre trugen in den späten 1960er-Jahren Früchte, kamen aber in den frühen 1970er-Jahren zu einem Ende. Der angestaute Groll der Mehrheit der Bevölkerung, bedingt durch das Leben unter der Knute eines triumphierenden rassistischen Regimes, war wie ein Pulverfass, das zu explodieren drohte. In seiner Verblendung, es sei allmächtig, ging die Apartheidregierung im kulturellen Bereich zu weit, als sie aus bildungspolitischen Gründen Afrikaans als Unterrichtssprache in den schwarzen Schulen einführte. Dies geschah, obwohl sich die Buren an ihren eigenen Sprachenkampf gegen den britischen Imperialismus, der ihnen die englische Sprache aufzwang, hätten erinnern können. Im Lichte der Apartheidideologie war dies wieder eine überstürzte Maßnahme im gesamten verbrecherischen Projekt der »Bantu Education« als Mittel der Versklavung der Schwarzen.

Während die Einführung von Afrikaans als Unterrichtssprache der sprichwörtliche Tropfen war, der das Fass zum Überlaufen brachte, gab es eine Reihe weiterer Faktoren, die den Aufstand in Soweto anstachelten und die Südafrika reif für eine erneute Revolte machten. Die Unterdrückung Andersdenkender, die erdrückenden, ausbeuterischen und menschenverachtenden Bedingungen, unter denen Schwarze leben mussten, wurden Anfang der 1970er-Jahre unerträglich. Dies führte zu Streiks, anfangs nur mit dem Ziel, die Arbeitsbedingungen in den Fabriken zu verbessern. In deren Verlauf führte es weiter zu Turbulenzen und Unruhen in der südafrikanischen Gesellschaft, von denen die Kolonialherren dachten, sie hätten sie beruhigt.

Es gab noch eine weitere Zutat zu dieser explosiven Mischung. Dies war das Auftauchen der Black-Consciousness-Bewegung innerhalb einer neuen Generation von radikalen Intellektuellen und Aktivisten. Obwohl diese Bewegung bereits seit 1966 aktiv war, erreichte sie die historische Bühne, als die südafrikanische Studentenorganisation (SASO) 1969 gegründet wurde. Die SASO, die ihre Basis an schwarzen Universitäten hatte, trennte sich von der älteren National Union of South African Students (NUSAS), die vornehmlich an englischsprachigen Universitäten für Weiße mit liberalen Grundsätzen zu Hause war.

Diese neue, von schwarzen Studenten unterstützte Bewegung, in der Steve Biko der führende Theoretiker war, bezog ihre revolutionären Ideen von Frantz Fanon, Aimé Césaire, Leopold Senghor und der Black-Power-Bewegung in den USA. Man versuchte, die mentalen und psychologischen Bedingungen der Angst und der Minderwertigkeit unter den Schwarzen mit schwarzem Stolz und afrikanischem Selbst-

bewusstsein zu begegnen. Die Bewegung wurde unterstützt und gestärkt durch die Studentenrevolten 1968 in Europa und dem Zusammenbruch der portugiesischen Kolonien Angola und Mosambik 1974.

Unter Berufung auf die Wurzeln der christlichen und afrikanischen humanistischen Traditionen füllte Black Consciousness das Vakuum, das die Repressionen in den 1960er-Jahren erzeugt hatten. Sie standen dem weißen, englisch geprägten südafrikanischen Liberalismus kritisch gegenüber. Verärgert über die herablassende und abweisende Haltung gegenüber Schwarzen wurde Biko nicht müde darauf hinzuweisen, dass Weiße, gleich ob liberal oder konservativ, kein Monopol auf die Wahrheit hätten. Er sah die Aufgabe der Black-Consciousness-Bewegung zweigeteilt. Einmal sollten die Afrikaner befreit werden von der Klassifizierung als »Nicht-Weiße« und von den negativen sprachlichen, kulturellen und ideologischen Zwängen des Kolonialismus. Zweitens sollte ein Frontalangriff gegen die Komplizenschaft der nach außen liberalen und anti-rassistischen, englisch sprechenden weißen Südafrikaner mit den rassistischen Buren gestartet werden. Ihm ging es darum, die Masken von diesen zwei Gesichtern des Kolonialismus herunterzureißen.

Das zentrale Anliegen der Black-Consciousness-Bewegung ist der christliche Grundsatz der Gleichheit aller Menschen als Schöpfungen eines gütigen Gottes verbunden mit den Geboten des afrikanischen Humanismus, der den Menschen als Wert an und für sich achtet. Aus diesem Grunde war es für die unterdrückte schwarze Bevölkerung essenziell, dass jeder Kampf für die Freiheit zum Ziel haben musste, den Zustand der Machtlosigkeit, der den Afrikanern durch entmutigende Maßnahmen der Kolonialherrschaft aufgezwungen wurde, zu verändern. Es war eine Gegenbewegung, die sich gegen das Bewusstsein der Weißen und den damit verbundenen Rassismus und gleichzeitig auf eine Wiederherstellung des schwarzen Selbstbewusstseins richtete. Sie stützte sich auf psychologische Bedingungen der Umwälzung, die die Strategien des zivilen Ungehorsams aus den frühen 1950er-Jahren ausbauten. Anfangs wurde die Bewegung von vielen missverstanden. Schwarze und antirassistische Weiße waren skeptisch, weil sie sie für eine Form schwarzer Exklusivität und schwarzen Rassismus hielten. Umgekehrt begrüßten weiße und schwarze Rassisten die Bewegung aus dem Missverständnis heraus, dass ihre Ideologie der Rassentrennung geteilt würde. Daher war die Universität von Fort Hare, der ältesten Universität für Schwarze in Südafrika, die erste, die SASO als Studentenvertretung anerkannte auf der Grundlage, dass sie keine Gefahr für den Status quo der Apartheid bedeutete.

Biko wies bei mehreren Gelegenheiten darauf hin, dass schwarz sein und Afrikaner sein nicht eine Frage der Hautfarbe, sondern des Bewusstseins sei. Er argumentierte, entweder sei es einem bewusst, dass man unterdrückt und gering geachtet wird oder nicht. Wenn man sich dessen bewusst ist, könnten radikale Aktionen geplant und die Bedingungen geändert werden. Sich nicht dessen bewusst zu sein, heißt, dass man die Behauptung akzeptiert, die Unterlegenheit der Schwarzen sei naturgegeben und unveränderbar und nicht eine Form der Unterdrückung, dazu geschaffen, um Menschen auszubeuten. Black Consciousness im Sinne von Biko bedeutet, dass Schwarze und Weiße friedlich zusammenleben, und zwar auf der Grundlage, dass jedem Gleichheit, Freiheit und Respekt zugestanden werden. Der Aufstand von 1976 muss in diesem historischen und politischen Kontext gesehen werden.

Der Aufstand ging von einer Gruppe von Schülern der unteren und oberen Klassen aus, die am Morgen des 16. Juni 1976 am Orlando Stadion in Soweto zusammengekommen waren. Nur bewaffnet mit Transparenten, die die »Bantu Education« und Afrikaans als die Sprache der Unterdrücker ablehnten. Wie schon zuvor in Sharpeville 1960 schoss die Polizei auf die unbewaffneten Schüler, als sie sich versammelten. Die ersten Opfer waren Hasting Ndlovu und der 12-jährige Hector Pieterson.

Eine Aufnahme von Sam Nzima zeigt das Bild von Mbuyiswa Makhubu, einem 18-jährigen Schulkameraden, sein von Qualen gezeichnetes Gesicht, mit Pietersons erschlafftem Körper auf dem Arm. Pietersons Schwester, die 17-jährige Antoinette, läuft neben Makhubu, schreiend vor Entsetzen. Sie laufen auf den Fotografen zu, auf seinen Wagen, der nicht zu sehen ist, in einem verzweifelten Versuch, Pieterson in ein Krankenhaus zu bringen. Bei der Ankunft im Krankenhaus wurde nur noch der Tod festgestellt, das Foto ging um die Welt. Es ist und bleibt eine Ikone, die die Brutalität der Apartheid festhält.

Der Aufstand breitete sich schnell in andere Teile des Landes aus. Um den Aufstand zu unterdrücken, wurde ein zweiter Notstand ausgerufen. Wie in den 1960er-Jahren verbot die Regierung alle Versammlungen und verhängte eine Ausgangssperre, errichtete Straßenblockaden an den Zufahrten zu den schwarzen Townships und führte eine Zensur ein, um den Medien die Veröffentlichung von Berichten und Fotos über die Unruhen zu verbieten. Über Monate kämpften die Sicherheitskräfte gegen Steine werfende Jugendliche und streikende Arbeiter auf den Barrikaden und versuchten, die Kontrolle über das in Flammen stehende Land zu erlangen.

Am 12. September 1977 wurde Steve Biko in Polizeigewahrsam ermordet. Im Oktober desselben Jahres wurden alle Organisationen, die mit der Black-Consciousness-Bewegung in Verbindung standen, einschließlich der studentischen, kulturellen und religiösen Organisationen sowie den Zeitungen *The World* und *The Weekend World*, die der schwarzen Stadtbevölkerung über die Unruhen berichteten, als rechtswidrig erklärt. Genau wie 1963 war Ende 1977 das Feuer der Unruhen, bekannt als der Soweto-Aufstand, gelöscht.

23 Menschen starben am ersten Tag, darunter zwei Weiße. Nach offiziellen Angaben starben 700 Menschen in Soweto. Es wird allerdings geschätzt, dass 1000 Kinder in Soweto und Hunderte in anderen Teilen des Landes getötet wurden. International geächtet verteidigte man sich wie bereits 1960 damit, dass die gewaltsame Unterdrückung eines Volksaufstandes ein legitimes Mittel gegen die Bedrohung des Kommunismus sei. Den Weißen wurde versichert, dass die Ordnung wiederhergestellt und die Macht der Minderheit unberührt geblieben sei. Doch still und heimlich nahm man davon Abstand, Afrikaans in Schulen für Schwarze einzuführen. Man überlegte neue Maßnahmen, wie man fortan Widerstände brechen und die Macht der Minderheit sichern könne.

Der ANC war auf dem Wege der Wiedererstarkung. Im Exil hatte er Fuß gefasst und war bereit, die Apartheidregierung mit noch größeren strategischen Fähigkeiten und noch höherem Einsatz herauszufordern. Im Zuge der staatlichen Unterdrückung flohen viele Jugendliche aus dem Land und schlossen sich Widerstandsbewegungen an. Weiterhin war der Aufstand von Soweto der öffentliche Beweis, dass die furchtlose und heroische Kampfbereitschaft einer neuen Generation den Süden mit den radikalen Ideen von Biko durchsetzte.

Von 1978 an war die Minderheitsregierung im Belagerungszustand. Was als Aufstand gegen die Sprachenpolitik des Bantu-Bildungsgesetzes gestartet war, war nun eine Bewegung gegen das gesamte System der rassistischen Vorherrschaft. Als Konsequenz daraus befand sich der Apartheidstaat in einer permanenten Krise und war nicht länger in der Lage, die Mehrheit der Bevölkerung zu kontrollieren. Er ging seinem Niedergang entgegen.

Die demokratische Massenbewegung und der Niedergang der Apartheid 1980–1990

Die letzte Phase im Kampf um die Freiheit Südafrikas wurde am 14. Juni 1983 mit der Gründung der United Democratic Front (UDF) eingeleitet. Dies geschah unter der Führung des Kirchenmannes Dr. Allan Boesak.

Black Consciousness legte den Schwerpunkt auf die Unabhängigkeit der Schwarzen und war gegen die Zusammenarbeit mit weißen Organisationen. Die UDF hingegen übernahm die alle Gruppen einbeziehende Politik der Kongressbewegung der 1950er-Jahre.

Diese Bewegung entstand als Reaktion auf eine Politik der gemäßigten Reformen, die ihren Anfang damit nahmen, dass der Apartheidstaat das Dreikammersystem einführte, um auf diesem Wege die Gruppen unterschiedlicher Herkunft, die Farbigen und die Inder, die nicht in Homelands angesiedelt waren, politisch einzubinden. So wurde die parlamentarische Vertretung auf diese Gruppen ausgeweitet. Das System bestand aus drei Parlamentskammern und getrennte Wahlverfahren, die Macht allerdings blieb in den Händen der Weißen.

Die Ausgrenzung der Afrikaner, die die überwältigende Mehrheit der Bevölkerung ausmachten, brachte viele zu der UDF. Dadurch verschmolzen die Gruppen der Zivilgesellschaft, Gewerkschaften, Kirchen, Frauenorganisationen und Kriegsdienstverweigerer ebenso wie Sportorganisationen und Kultureinrichtungen zu einer mächtigen Front im entscheidenden Kampf gegen die Macht der Minderheit.

Zur selben Zeit begann der ANC aus dem Exil heraus von seinen Basen im südlichen Afrika den bewaffneten Aufstand zu verstärken. Polizeistationen und Militäreinrichtungen wurden bombardiert. Mit Ausnahme einiger weniger Fälle, in denen undisziplinierte Einzelgänger agierten, wurden keine Zivilisten angegriffen, denn das hielt man für Terrorismus. Gleichzeitig wurden die Verbindungen zur UDF verstärkt, die de facto zum inländischen Arm des ANC wurde.

In Südafrika wurden zunehmend Massendemonstrationen, Mieterstreiks, Studentenrevolten und Arbeiterstreiks auf den Straßen sichtbar. Dies waren »rollende Massenaktionen«. Dabei wurden die Apartheid-Fahnen verbrannt, während die verbotenen Fahnen des ANC und der SACP unter den Augen von Polizei und Armee entrollt wurden. Auf internationaler Ebene weitete sich die Kampagne »Freiheit für Mandela« aus, eine Parole, die erstmals am 11. Oktober 1963 von der UN-Generalversammlung als Antwort auf den Rivonia-Prozess übernommen wurde. Von 1983 an wurde der Druck auf die weiße Regierung verstärkt.

Mit zunehmenden Unruhen wurde das Land unregierbar und schlitterte auf einen Bürgerkrieg zu, als die schwarzen Gemeinden angegriffen wurden und sich rächten. Der dritte Notstand wurde 1985 erklärt.

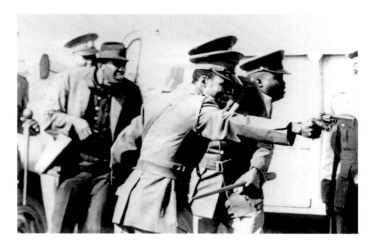

Sam Nzima
Polizisten schießen auf unbewaffnete Schüler, Soweto, 16. Juni 1976
Police shooting at armless students, Soweto, 16 June 1976

Trotz der Behauptung, Südafrikas Wandel zur Demokratie wäre friedlich verlaufen, muss man feststellen, dass zwischen 1983 und 1993 mehr als 15.000 Menschen in einem Kleinkrieg gegen die Bevölkerung von einer sterbenden Ideologie und ihren Stellvertretern getötet wurden. Diese blutige Ära wurde offensichtlich beim Sebokeng-Massaker am 27. Juli 1990, als die Polizei mit scharfer Munition auf Demonstranten schoss, zwölf Menschen tötete und Hunderte verletzte.

Hinter den Gewaltszenen zeigte sich ein strategisches Drama. Angeregt durch Mandela begann der Staat, zu der Zeit von P. W. Botha geführt, geheime Gespräche mit ihm zu führen. Es sollte zunächst herausgefunden werden, ob es genügend Konsens zwischen den widerstreitenden Parteien zu Schlüsselfragen wie die Mehrparteiendemokratie, freie Marktwirtschaft, Minderheitenschutz, Aufhebung des Verbots der Freiheitsbewegung und die Freilassung politischer Gefangener gibt, bevor die Gesprächspartner öffentlich ihre Bereitschaft zu Verhandlungen erklärten.

Um die Vertraulichkeit der ersten Treffen zu gewährleisten, wurden Nelson Mandela, Walter Sisulu und Andrew Mlangeni von Robben Island zum Pollsmoor Gefängnis nach Kapstadt gebracht. Sie wurden in einem von den anderen Gefangenen abgetrennten Bereich untergebracht, damit keiner etwas von diesen Gesprächen erfuhr. Ahmed Kathrada kam später zum Trio dazu. Govan Mbeki, ein marxistischer Hardliner, der gegen jede Verhandlung mit der Minderheitsregierung war, war nicht dabei. Von 1985 bis 1989 gab es eine Reihe von Gesprächen zwischen Mandela und hohen Regierungsvertretern. Es wurde auch mit dem ANC im Exil Kontakt aufgenommen, zuerst geheim, dann offen, um die öffentliche Meinung zu testen.

Eine verhandelte Demokratie 1990–1994

1989 begannen die Dinge sich zu bewegen. Um die öffentliche Meinung und Reaktion zu testen, wurden acht Gefangene freigelassen, darunter Sisulu, Mbeki, Mhlaba und Mlangeni. Mandela entschied sich, im Gefängnis zu bleiben, weil er befürchtete, dass es als Verrat gedeutet werden könnte, wenn er entlassen werde, bevor das Verbot der Freiheitsbewegung aufgehoben ist und alle politischen Gefangenen freigelassen sind.

Am 3. Februar 1990 hielt De Klerk seine historische Rede bei der Eröffnung des Parlamentsjahres. Er kündigte an, alle Freiheitsbewegungen wieder zuzulassen und die politischen Gefangenen einschließlich Mandela freizulassen. Am 11. Februar 1990 ging Mandela, begleitet von seiner Frau Winnie Mandela, durch das Tor des Gefängnisses in

Paarl, wo er zum Ende seiner Haftzeit in einem Wärterhaus untergebracht war und wo er diverse Besucher empfangen hatte, unter anderem in Vorbereitung seiner Freilassung.

Führende Funktionäre kamen aus dem Exil zurück, und politische Gefangene kamen frei. Offene Verhandlungen begannen vorsichtig am 4. Mai 1990 mit der Unterzeichnung des Groote-Schuur-Protokolls in der Residenz des Staatspräsidenten in Kapstadt. Es unterstrich die Absicht der beiden Parteien, für ein Ende der Gewalt einzutreten und Hürden abzubauen, die weiteren Verhandlungen im Wege sein könnten. Am 6. August 1990 unterzeichnete die Regierung im Protokoll von Pretoria die Amnestie für alle Exilanten, und im Gegenzug sagte sich der ANC vom bewaffneten Kampf los.

Es dauerte ein Jahr, bis alle anderen 27 Parteien in Südafrika am 14. September 1991 die nationale Friedenserklärung unterzeichnet hatten. Dies machte den Weg frei für den Verfassungskonvent, dem Convention for a Democratic South Africa (CODESA). Zur ersten Versammlung traf sich der Konvent am 20. Dezember 1991 im World Trade Centre in Kempton Park.

Mehr und mehr wurde die Nationale Partei von unzufriedenen Wählern angegriffen und verlor zwischen 1991 und 1992 drei Nachwahlen an konservative weiße Parteien. Im Gegenzug hielt De Klerk 1992 ein Referendum unter der weißen Bevölkerung ab und erhielt 68,7 % Zustimmung zur Fortsetzung der Verhandlungen. Diese endeten abrupt am 17. Juni 1993, als bewaffnete Kämpfer der IFP (Independent Freedom Party, die Partei der Zulus) in die Township Boipatong einmarschierten und über 40 Menschen töteten. Der ANC beschuldigte die Regierung der Mitverantwortung für diese Morde, und Mandela sagte in einem Brief an De Klerk weitere Gespräche ab. Der ANC war misstrauisch gegenüber den bewaffneten Kräften der Apartheidregierung und war überzeugt, diese spielten eine verdeckte Rolle bei diesen und anderen Morden. Nach dem Rückzug aus den Verhandlungen begannen der ANC und seine Allianzpartner Massendemonstrationen

zu organisieren, eine Taktik, die die UDF schon in den 1980er-Jahren angewendet hatte.

Am 7. September 1992 wurde in Bisho, der Hauptstadt des »unabhängigen« Homeland Ciskei eine Demonstration abgehalten, bei der gefordert wurde, das Gebiet wieder in Südafrika zu integrieren. 28 Demonstranten wurden getötet, als die Ciskei-Verteidigungseinheit, eine militärische Polizeieinheit, das Feuer auf die Demonstranten eröffnete. Die aufgeheizte Stimmung kühlte etwas ab, als De Klerk am 23. März 1993 erklärte, man wolle die acht geheim entwickelten Atombomben entschärfen und vernichten.

Der Verhandlungsprozess wurde ein weiteres Mal gestört, als der populäre Militärkommandeur des ANC, Chris Hani, von rechtsgerichteten paramilitärischen Agenten am 10. April 1993 getötet wurde. Mandela sprach im Fernsehen. Er verurteilte die Ermordung, die nichts anderes zum Ziel habe, als die Gespräche zu stören, und er forderte die ANC-Anhänger auf, keine Vergeltung zu verüben. Ein Blutbad wurde vermieden, und die Ermordung verfehlte ihr Ziel.

Eher komisch war eine andere Aktion der äußersten Rechten, um die Gespräche zu torpedieren. Am 25. Juni 1993 zerstörten etwa 3000 Mitglieder der Afrikaner Weerstandsbeweging (AWB), unter der Führung des kürzlich ermordeten Eugene Terre'Blanche, den Glaseingang des World Trade Centre in Kempton Park mit einem gepanzerten Fahrzeug, während dort die Verhandlungen stattfanden. Dies wird heute als absurdes, rechtsextremes Kabinettstückchen gewertet. Die Hauptverhandlungspartner erkannten, dass die Ermordung Hanis und Aktionen wie diese die Gespräche vereiteln würden, wenn sie weiter so verschleppt werden.

Zur allgemeinen Erleichterung der Mehrheit der Südafrikaner wurde von den Verhandlungsparteien am 18. November 1993 um Mitternacht eine vorläufige Verfassung unterschrieben und ein Datum für die Wahl festgesetzt. Nicht eine Minute zu früh.

Am 27. April 1994 gingen Millionen Südafrikaner das erste Mal nach 500 Jahren kolonialer Herrschaft in öffentlichen Wahllokalen im ganzen Land wählen. Die Wahlen fanden ohne Zwischenfälle statt. Es war die Geburtsstunde der ersten nicht-rassistischen demokratischen Regierung mit Nelson Mandela als Staatspräsident und mit De Klerk und Thabo Mbeki, dem Sohn von Govan Mbekis, als seine Stellvertreter in einer Regierung der Nationalen Einheit.

Am 10. Mai 1994 wurde Mandela, den seine früheren Widersacher begrüßten, im Amphitheater der Union Buildings in Pretoria, der Zitadelle weißer Vorherrschaft, in sein Amt eingeführt. Das Buch der Geschichte der Kolonisierung Südafrikas wurde geschlossen. Am selben Tage wurde ein neues Buch aufgeschlagen.

Fazit

Die Verhandlungen, die zur Demokratie in Südafrika geführt haben, und die Jahre, die diese Ausstellung umfasst, sind ausführlich dokumentiert. Es handelt sich um ein umfangreiches Archiv von Fotografien, Audiodokumenten und Plakate sowie andere Erinnerungsobjekte.

Einige dieser Bilder wurden im *Drum*-Magazin abgedruckt, das als Fenster für schwarze soziale, politische und kulturelle Entwicklungen in den 1950er-Jahren fungierte und eine Plattform für die Fotografen Alf Kumalo, Peter Magubane, Jürgen Schadeberg, Bob Gosani und andere darstellte. Ebenso wurden dort Werke von Schriftstellern und Journalisten wie Es'kia Mphalele, Lewis Nkosi, Henry Nxumalo, Bloke Modisane und Can Themba veröffentlicht.

In den 1970er-Jahren verbreitete das *Staffrider*-Magazin die Arbeiten der Fotografen Paul Weinberg, Omar Badsha, Cedric Nunn, David Goldblatt, Santu Mofokeng und anderen. Künstler, Schriftsteller und Fotografen erkannten mehr und mehr die Macht von Bildern und Worten im Kampf um die Mobilisierung der Opposition gegen die Apartheid. Ende der 1970er-Jahre hatte sich eine bemerkenswerte visuelle und grafische Ästhetik entwickelt, die sich um die soziale Gegenwart Südafrikas bemühte.

Die Bilder dieses Archivs sind lebendige Beweise einer komplexen, konfliktbeladenen und sich wandelnden Geschichte Südafrikas. Die soziale und ästhetische Bedeutung dieser Bilder, die von der Notwendigkeit des Überlebens, der Freiheit und der Gerechtigkeit geprägt sind, wird gerade mit den Fotografien aus dieser Epoche deutlich.

Africa Research Group, *Race to Power: The Struggle for Southern Africa*, New York 1974.

Steve Biko, *I Write What I Like*, London 1979.

T. R. H. Davenpoort, *South Africa: A Modern History*, London 1993.

Francis Meli, *A History of the ANC: South Africa Belongs to Us*, Harare 1988.

Peter Magubane, *June 16, 1976: Never, Never Again*, Braamfontein 1986.

Robert Price und Carl Rosberg (Hrsg.), *The Apartheid Regime: Political Power and Racial Domination*, Johannesburg 1980.

Anthony Sampson, *Mandela: The Authorised Biography*, Johannesburg 1999.

South African Democracy Trust, *The Road to Democracy in South Africa: 1970–1980*, Pretoria 2006.

Weinberg, Paul, *Then and Now: Eight South African Photographers*, Johannesburg 2008.

Renewal of Struggle and the Demise of Apartheid: 1976–94

Andries Walter Oliphant

Introduction

To make sense, let alone fully grasp the aesthetic and social dimensions of South African photography, I think, requires attentiveness to the political and historical context to which the images belong as well as to how they communicate over time. Hence, this essay is tilted towards sketching the contexts in which the photographs, selected for this part of the exhibition, were originally produced.

As the art of the instant, the photographic image, even when it is staged, stylized, or abstracted, is always an image snatched from the rushing jaws of time. As such it has much in common with the fleeting, momentary, and haphazard nature of actuality. Where written narratives of history are always selective reconstructions of the events, photographs capture actual moments experienced and lived in real time. Viewed from the present, as artistic manifestations, they provide visual access to the past.

Broadly speaking, the period from 1950 to 1994 is the epoch of the rise and fall of Apartheid. The years from 1994 to 2010 constitute the transition to democracy and the challenges of its consolidation. Every stage of this epic narrative is populated by its own critical moments, decisive events, heroes, villains, casualties, and crowds, which form a photographic perspective, has been visually captured. The concern here is with the last three decades of minority rule in South Africa.

Black Consciousness and the Revival of Struggle: 1976–80

With all anti-Apartheid organisations banned and the leaders either in jail, in hiding or in exile, the second half of the nineteen-sixties saw no open resistance to Apartheid. Repressed within South Africa, driven into the underground and expelled, the exiled liberation movements began the arduous process of regrouping under the new conditions illegality The African National Congress (ANC) and its allies, the South Africa Communist Party (SACP), and the South African Congress of Trade Unions (SACTU) with much greater effect then their rival, the Pan Africanist Congress (PAC), embarked on a new multi-pronged strategy. It consisted of armed insurrection coupled to economic, cultural, sport, and diplomatic isolation of the Apartheid government.

The silence and apparent acquiescence inside South Africa, following in the wake of the defeat of the Defiance campaigns of the nineteen-fifties, having incubated in the late 1960, was however coming to an end in the early nineteen-seventies. The accumulated grievances of the majority of the population, living under the brutal yoke of a triumphant racist regime, was a veritable powder keg waiting to explode.

Deluded as all-powerful, the Apartheid government had over-reached itself on the cultural front when it adopted an educational policy making Afrikaans the medium of instruction in black schools. This was done against the memory of the Afrikaners own language struggles and revolt against British imperialism bent on imposing English on them. Viewed in the light of Apartheid ideology this was yet another precipitous decision rooted in the outrageous project of Bantu Education conceived as a means for the enslavement of blacks.

While the imposition of Afrikaans as the medium of teaching in black schools was the proverbial straw that broke the camels back, the Soweto Uprising was also fuelled by other factors that made South Africa ripe for renewed revolt. The repression of dissent, the oppressive, exploitive, and abusive conditions under which blacks lived had reached had become unbearable in the early nineteen-seventies. This led to labour strikes initially directed to improve working conditions on the factory floor. In the process, it injected turbulence and unrest into South African society whose colonial rulers thought they had pacified.

There was also another explosive ingredient to this mix. This was the emergence of the Black Consciousness Movement among a new generation of radical intellectuals and activists. Although in gestation since 1966, it arrived on the historical stage when the South African Students Organisation (SASO) was launched in 1969. Based at black universities, it broke away from the older National Union of South African Students (NUSAS) housed at white English-speaking universities with liberal credentials.

This new black-based student movement, of which Steve Biko was the main theorist, drew on the revolutionary theories of Frantz Fanon, Aimé Césaire, Leopold Senghor, and the Black Power Movement in the United States. It sought to counter the mental and psychological conditions of fear and inferiority fostered among the oppressed by advocating black pride and an African self-awareness. It was further emboldened by the 1968 student revolts in Europe and the collapse of Portuguese colonies in Angola and Mozambique in 1974.

Stepping into the vacuum left by the repression of the nineteen-sixties, the Black Consciousness had its roots in Christian and African humanist traditions. It was critical of white South African English liberalism. Resenting its patronizing, condescending, and dismissive attitudes towards blacks, Biko never tired of pointing out, that whites, liberal or conservative, had no monopoly on truth. He saw the task of Black

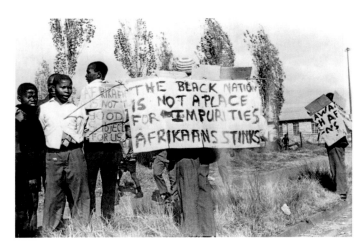

Peter Magubane
Afrikaans soll als Unterrichtssprache eingeführt werden – der Tropfen, der
das Fass in den Townships zum Überlaufen brachte, 1976
Afrikaans enforced as a medium of instruction—the spark that lit South
African townships in 1976

Consciousness as two-fold. Firstly, to unshackle Africans, classified as 'non-whites', from the negative linguistic, cultural and ideological chains of colonialism. Secondly, to launch a frontal attack on the complicity of ostensibly liberal and anti-racist white English speaking South Africans with racists Afrikaner rule. His strategy, was to strip the masks from these two faces of colonialism in South Africa.

The central tenet of Black Consciousness are rooted in the Christian principle of the equality of human beings, as creations of a benevolent God blended with the precepts of African humanism which values human beings in and for themselves. Thus, for the oppressed black people to mount and lead any struggle for freedom required that the state of powerless imposed on Africans by the debilitating strategies of colonial rule be cast-off. As such it was a counter-movement directed both at white consciousness and the racism it spawned as well as on the restoration of black selfhood. It focussed on cultivating the appropriate psychological conditions for revolt that would take the defiance strategies of the nineteen-fifties further.

It was initially misunderstood by many. Blacks and whites committed to non-racialism frowned on it as a form of black exclusivity and racism. Conversely, white and black racists welcomed it, on the misunderstanding that shared ideologies of racial segregation. Hence, the University of Fort Hare, the oldest university for blacks in South Africa, was the first to accord official recognition to SASO, as a student representative body on the basis that it was not a threat to the Apartheid status quo.

Biko pointed out on several occasions that blackness and being African are not matters skin-colour but of consciousness. He argued, one is either conscious that you are oppressed and treated as lesser being by white racism, or not. Being conscious of this makes it possible to take radical action to change this affairs. Not being conscious of this results in accepting the claims of black inferiority as something

natural and unalterable and not as an oppressive human design in the service of economic exploitation. Black consciousness as Biko conceived it, envisaged blacks and whites living together peacefully provided everyone enjoyed equality, freedom, and respect. The revolt of 1976 must be seen in this historical and ideological context.

It was set in motion by a group of primary and high school children who converged on the Orlando Stadium in Soweto on the morning of 16 June 1976. Armed with nothing but placards scrawled with slogans denouncing 'Bantu Education and rejecting Afrikaans' as the 'language of the oppressor'. As previously at Sharpeville in 1960, the police fired at the unarmed students as the scattered up their arrival. The first casualties were Hasting Ndlovu and the twelve-year-old Hector Pieterson.

A photograph taken by Sam Nzima, captures the image of Mbuyiswa Makhubu, an eighteen-year-old fellow student. His face contorted in agony, running with Pieterson's limp body in his arms. Pieterson's seventeen-year-old sister, Antoinette, runs next to Makhubu, screaming in horror. They are running into the frame of the photographer towards his car, in a desperate attempt to get Pieterson to a hospital. Pronounced dead on arrival at a local clinic, the photograph was relayed around the world. It is and remains the iconic image capturing the brutality of Apartheid.

The revolt spread rapidly to other parts of the country. To quell it, a second State of Emergency was declared. As in the nineteen-sixties, the government banned all public gatherings and imposed a curfew, set up roadblock at the entrances of the black townships, and subjected the media to censorship prohibiting the publication of reports and photographs of unrest. For months, the security forces battled stone-throwing youths and striking workers at barricades in an attempt to take control of a country on fire.

On 12 September 1977, Steve Biko was murdered in police custody. In October that year, all organisations associated with the Black Consciousness, including students, cultural, and religious organisations along with the newspapers *The World* and *The Weekend World* which covered the unrest for black urban readers were declared unlawful. As was the case in 1963, by the end of 1977, the fires of revolt known as the Soweto Uprising were extinguished.

Twenty-three people died on the first day, including two whites. Official reports gave the final death toll of 700 in Soweto. It is, however,

estimated that 1000 children were killed in Soweto and hundreds more in other parts of the country. Condemned internationally, the defended labelled it violent suppression of the popular insurrection, as done in 1960, as justified action in the fight against the threat of communism. Reassuring whites that order had been restored and that the minority power was unshaken. They nevertheless quietly backed-off from imposing Afrikaans on black schools and began thinking of new ways to contain popular dissent and preserve white minority power.

By now, the ANC was well on the way to recovery. Finding its feet in exile, it was ready to take on the Apartheid government with greater strategic skill and determination. In the wake of state repression, large numbers of youths fled the country swelling the ranks of the liberation movements. Furthermore, the Soweto Uprising publicly dramatised the fearless and heroic militancy of a new generation imbued with Biko's radical ideas instilling uneasiness in the south.

So, from 1976 onwards, the minority government was besieged. What started as an uprising against the language policies of Bantu education escalated into a revolt against the entire system of racist rule. Consequently, the Apartheid state in a permanent crisis, no longer able to control the majority of the population, was headed towards its fall.

The Mass Democratic Movement and the Demise of Apartheid: 1980–90

This final phase in the struggle to free South Africa was launched on 14 June 1983 under the auspices of the United Democratic Front (UDF), led by the clergyman, Dr Allan Boesak. Black Consciousness stressed black independence and opposed collaboration with white organisations. The UDF revived the inclusive politics of the Congress Movement of the nineteen-fifties.

It came into existence as a reaction to the limited reforms introduced by the Apartheid state's proposed tri-cameral system that sought to co-opt people of mixed decent, the so-called, 'coloureds' and 'Indians', not accommodated in the homelands dispensation. It extended parliamentary representation to these communities. It consisted of three chambers and segregated voting, with power remaining in the hands of whites.

The exclusion of Africans, that is, the overwhelming majority of the population, was grist on the mills of the UDF. It galvanised civic, trade union, church, women's, conscientious objectors as well as sport and cultural organizations into a formidable front propelled in the final push to topple minority rule.

Simultaneously, the exiled ANC stepped up it's armed insurrection from bases in Southern Africa. Working with members operating in the underground inside the country, police stations and military installations were bombed. With a few exceptions by ill-disciplined mavericks, civilians were not targeted: this was considered terrorism. In addition, close links were forged with the UDF which eventually became the de facto internal wing of the ANC.

In South Africa, mass demonstrations, rent, boycotts, student revolts, and labour strikes became regular sights on the streets. This was 'rolling mass action'. At these demonstrations the Apartheid flag was burnt while the flags of the banned ANC and SACP were defiantly unfurled in full view of the police and army. Internationally, the Release Mandela Campaign, first adopted by the General Assembly of the UN on 11 October 1963, in response to the Rivonia Trial, expanded. From 1983 onwards, it put further pressure on the white government.

As unrest spread, the country became ungovernable and slid towards civil war as black communities came under and retaliated. A third State of Emergency was declared in 1985.

Although it is claimed that South Africa's transition to democracy was peaceful, it is estimated that from 1983 to 1993 over 15,000 people were killed in the low intensity war waged on the population by a dying ideology and its proxies. This bloody period is punctuated by the Sebokeng massacre of 27 July 1990; when police opened fire on a crowd of demonstrators, twelve protestors were killed and hundreds wounded.

Behind these scenes of violence, a strategic drama was unfolding. Prompted by Mandela, the state, then led by P.W. Botha, began secret talks with him. Explorative, the talks sought to establish whether there was sufficient consensus between the adversaries on key issues, such as multi-party democracy, a free market economy, the protection of minorities, the unbanning of the liberation movements, and the release of political prisoners, before either party would publicly commit to negotiate for a peaceful settlement.

To secure the confidentiality of the initial meetings, Mandela, Walter Sisulu, and Andrew Mlangeni, were taken from Robben Island to Pollsmoor Prison in Cape Town. They were held in a separate section away from other prisoners, so that the talks could go on undetected. Ahmed Kathrada later joined the trio. Notably, Govan Mbeki, a hardline Marxist, who opposed any talks with the minority government, did not join them. From 1985 to 1989, a series of meetings took place between Mandela and senior government officials. Contact was also made with the ANC in exile, first secretly and later openly, to test the public opinion.

A Negotiated Democracy: 1990–94
In 1989 things began to move. Concerned to test the public opinion and its reaction, the Apartheid government released eight prisoners, including Sisulu, Mbeki, Mhlaba, and Mlangeni. Mandela decided to remain in prison, since he was concerned that his release may be perceived as selling out should he be freed before the liberation movement when unbanned and all political prisoners would be released.

On 3 February 1990, De Klerk delivered his historic speech at the opening of parliament. He announced the unbanning of all the liberation movements, the release of all political prisoners including Mandela. On 11 February, Mandela, accompanied by Winnie Mandela, walked out the gates of the prison in Paarl where, towards the end of his prison term, he lived in a warden's house and was able to receive a range of visitors in preparation of his impending release.

Exiled leaders began to return and political prisoners were freed. Open negotiations began tentatively on 4 May 1990, with the signing of *Groote Schuur Minute* at the presidential residence in Cape Town. It expressed the commitment of both parties to work towards ending violence and removing all hurdles that could impede negotiations. On 6 August 1990, the government undertook to indemnify all returning exiles from prosecution in the Pretoria Minute. In turn, the ANC pledged to suspend the armed struggle.

Despite this, it took a year before twenty-seven other parties in South Africa signed the *National Peace Accord* on 14 September 1991. This paved the way for the Convention for a Democratic South Africa (CODESA). It met on 20 December 1991 at the World Trade Centre in Kempton Park for it first session.

Increasingly, attacked by disgruntled white voters, the National Party lost three by-elections to conservative white parties between 1991

and 1992. In response, De Klerk held a white referendum in February 1992 and received the support of 68.7% to proceed with the negotiations. But the talks broke down, when, on 17 June 1993, armed IFP supporters invaded the Township of Boipatong killing over forty people. The ANC held the government responsible for the killings and Mandela wrote to De Klerk calling off the negotiations.

The ANC, suspicious of the Apartheid government's armed forces, believed they played a hidden role in these and other killings. Withdrawing from the negotiations, the ANC and its alliance partners embarked on mass demonstrations, a tactic used by the UDF in the nineteen-eighties.

On 7 September 1992, a demonstration was held in Bisho, the capital of the 'independent' Homeland of the Ciskei to demand the territory's reincorporation into South Africa. It resulted in the killing of twenty-eight demonstrators when the Ciskei Defence Force fired at the demonstrators. The tense atmosphere was somewhat relaxed when De Klerk announced on 23 March 1993, that his government had secretly developed eight nuclear bombs but has decided to dismantle and destroy them.

The negotiation process experienced another crises when the popular ANC military commander, Chris Hani was assassinated by right-wing paramilitary agents on 10 April 1993. Mandela appeared on TV. Condemning the assassination, which he said was aimed at derailing the talks and he urged ANC supporters to refrain from retaliation. A bloodbath was averted and the assassination missed the point.

More comical, another attempt to derail the talks was made by the far-right. On 25 June 1993, some 3000 members of the Afrikaner Weerstands Beweging (AWB) under the leadership of the recently murdered Eugene Terre'Blanche, smashed an armoured vehicle through the glass doors of the World Trade Centre in Kempton Park where negotiators were in session. This is now seen as a piece of absurd right-wing stunt. The main negotiating parties realised that the slaying of Hani and other such incidents could scupper the negotiations if they dragged on.

To the relief of the majority of South Africans, an Interim Constitution, setting the date of elections, was signed by the leaders of the negotiating parties at midnight on 18 November 1993. It was not a minute too soon.

On 27 April 1994, millions of people of South Africa, for first time in five hundred years of colonial rule, assembled in public places all over the country, to vote. Voting passed without incident and so gave birth to the first non-racial democratic government in South Africa with Nelson Mandela as President and De Klerk and Thabo Mbeki, the son of Govan, as deputies, in a government of national unity.

On 10 May 1994, Mandela, saluted by his former captors, was inaugurated in the amphitheatre of the Union Buildings in Pretoria, the citadel of white supremacy. This closed the book on colonialism in South Africa. A new book was opened on the same day.

Conclusion

The negotiations which led to democracy in South Africa and the years spanning this exhibition, are fully documented. It is a vast archive of photographic images, audio and graphic texts as well as other mnemonic objects.

Some of these images printed in the *Drum* magazine which served as an outlet for black social, political, and cultural developments in the nineteen-fifties. It provided platforms for photographers such Alf Kumalo, Peter Magubane, Jürgen Schadeberg, Bob Gosani, and others. It also published the work of writers and journalist such as Es'kia Mphahlele, Lewis Nkosi, Henry Nxumalo, Bloke Modisane, and Can Themba.

In the nineteen-seventies, *Staffrider* magazine disseminated the work of photographers such as Paul Weinberg, Omar Badsha, Cedric Nunn, David Goldblatt, Santu Mofokeng, and others. Artist's, writers, and photographers increasingly came to grasp the power of images and writing in the struggle to mobilize opposition against Apartheid. By the end of the nineteen-seventies, a remarkable visual and graphic aesthetic engaged with the social actualities of South Africa had been established.

The images in this archive are vivid montages of the complex, conflict-ridden and shifting historical narrative of South Africa The social and aesthetic significance of the images, inscribed with the necessity of survival, freedom, and justice, are visible in the photographs of this epoch.

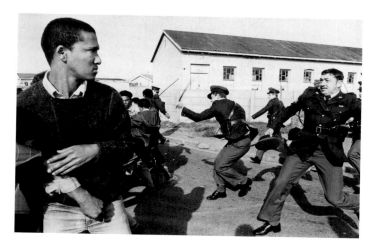

Gideon Mendel
Polizisten greifen Demonstranten der UDF an, 1985
Police Charging United Democratic Front Protesters, 1985

Africa Research Group, *Race to Power: The Struggle for Southern Africa* (New York, 1974)

Steve Biko, *I Write What I Like* (London, 1979)

T. R. H. Davenpoort, *South Africa: A Modern History* (London, 1993)

Francis Meli, *A History of the ANC: South Africa Belongs to Us* (Harare, 1988)

Peter Magubane, *June 16, 1976: Never, Never Again* (Braamfontein, 1986)

Robert Price and Carl Rosberg, eds. *The Apartheid Regime: Political Power and Racial Domination* (Johannesburg, 1980)

Anthony Sampson, *Mandela: The Authorised Biography* (Johannesburg, 1999)

South African Democracy Trust, *The Road to Democracy in South Africa: 1970–1980* (Pretoria, 2006)

Paul Weinberg, *Then and Now: Eight South African Photographers* (Johannesburg, 2008)

1976–1994 Struggle

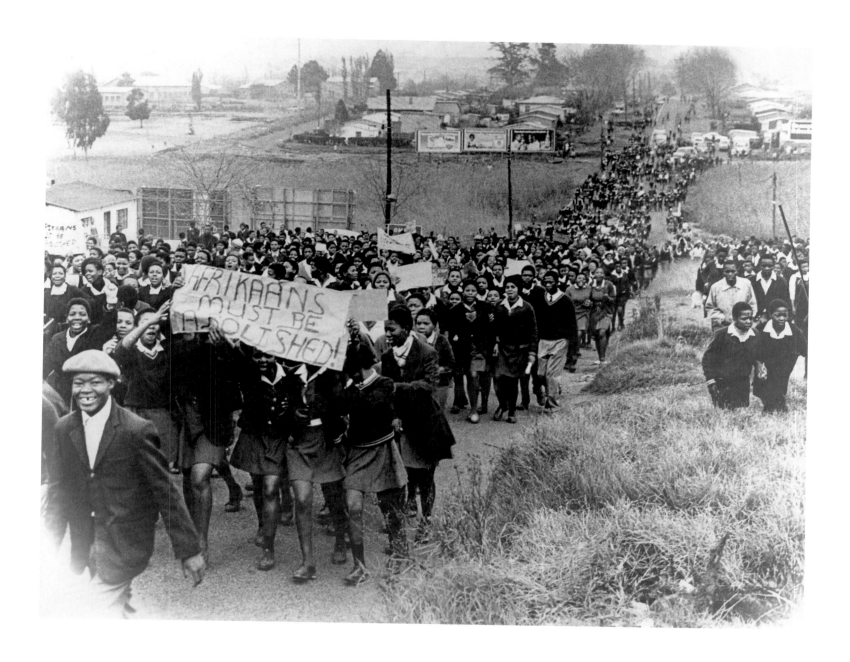

Sam Nzima
Schüler protestieren gegen Afrikaans als Unterrichtssprache, Soweto,
16. Juni 1976

Sam Nzima
Students march against Afrikaans as a medium of instructions, Soweto,
16 June 1976

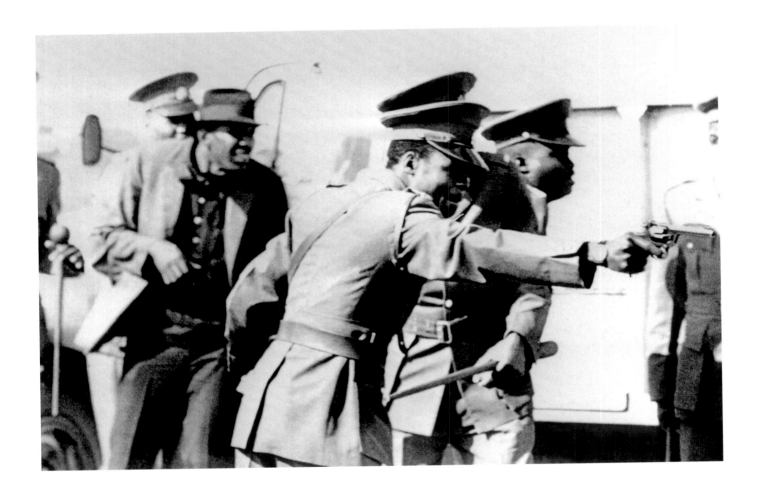

Sam Nzima
Polizei schießt auf unbewaffnete Schüler, Soweto, 16. Juni 1976

Sam Nzima
Police shooting at armless students, Soweto, 16 June 1976

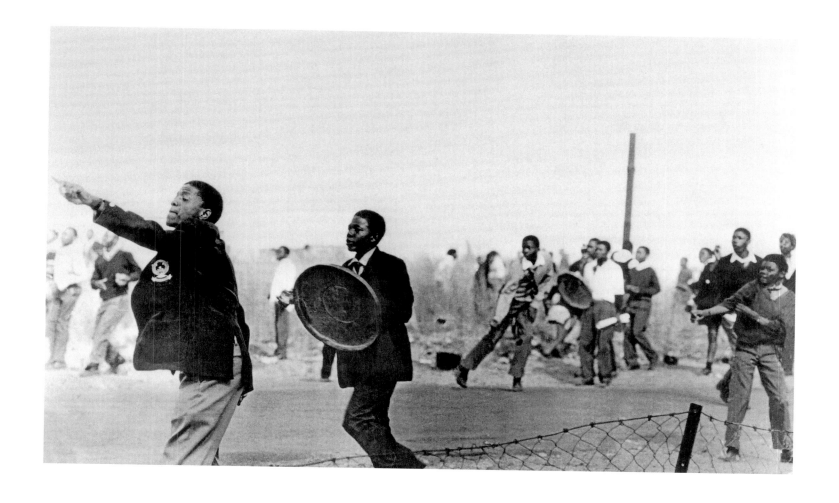

Sam Nzima
Schüler verteidigen sich gegen die schießende Polizei, Soweto,
16. Juni 1976

Sam Nzima
Students defending themselves from the shooting police, Soweto,
16 June 1976

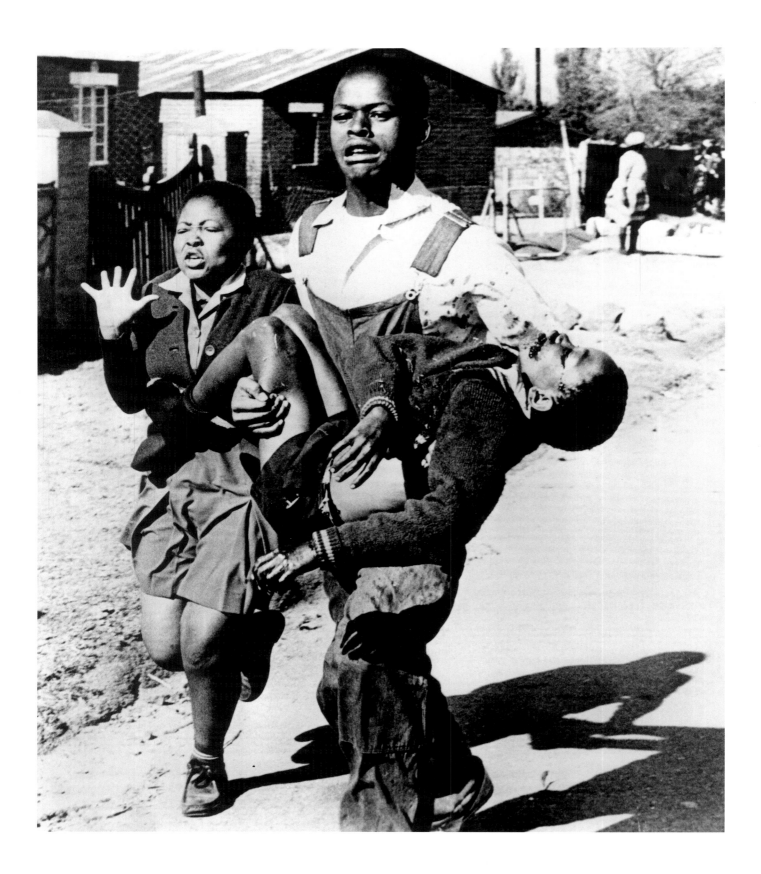

Sam Nzima
Mbuyiswa Makhubu trägt den verwundeten Hector Pieterson, gefolgt von dessen Schwester Antoinette, Soweto, 16. Juni 1976

Sam Nzima
Mbuyiswa Makhubu carrying wounded Hector Pieterson followed by his sister Antoinette, Soweto, 16 June 1976

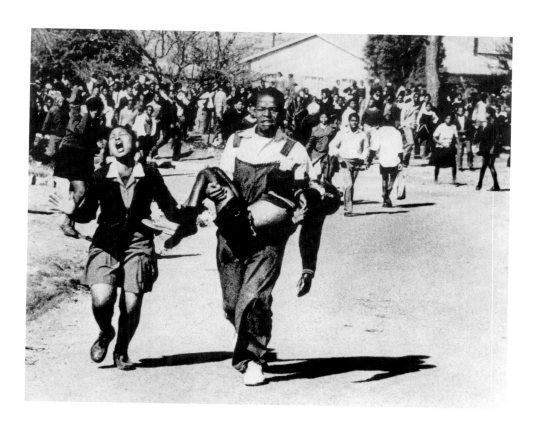

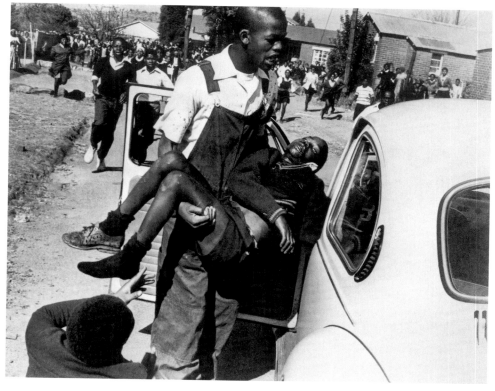

Sam Nzima
Antoinette, Hector Pietersons Schwester, und andere Schüler schreien
vor Entsetzen, als sie sehen, dass ihr Bruder in den Armen von Mbuyiswa
Makhubu stirbt, Soweto, 16. Juni 1976

Sam Nzima
Letzter Atemzug von Hector Pieterson, Soweto, 16. Juni 1976

Sam Nzima
Antoinette, sister of Hector Pieterson, and other students crying
hysterically when seeing her brother going to die in the arms of
Mbuyiswa Makhubu, Soweto, 16 June 1976

Sam Nzima
Last breath of Hector Pieterson, Soweto, 16 June 1976

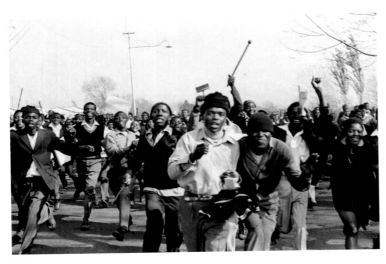

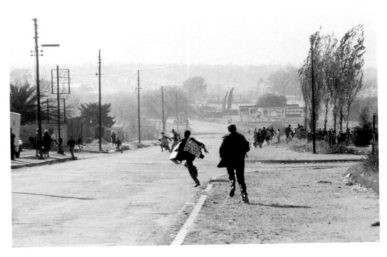

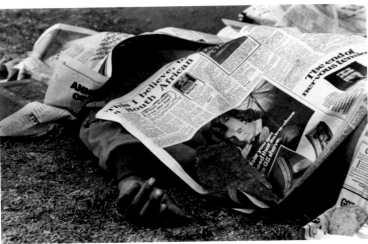

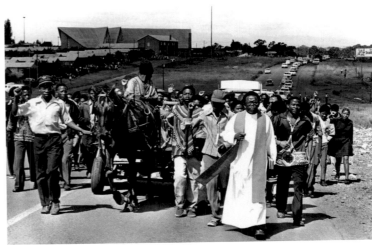

Peter Magubane

»Die jungen Löwen«. Trubel in Soweto vor Ausbruch der Gewalt am
16. Juni 1976

Schlagzeile: »Daran glaube ich, von einem Südafrikaner… Für was
würden Sie Ihr Leben geben?« Ein durch eine Kugel zerstörtes Leben in
Soweto, 16. Juni 1976.

Peter Magubane

'The Young Lions'. The excitement in Soweto before the violent storm
on 16 June 1976

Headline news: 'This I believe, by a South African … What would you
die for?' A life smothered with a bullet in Soweto, June 1976

Peter Magubane

Ein junger Demonstrant flieht vor der Polizei in Soweto, 1976

Father Buti Tlhagale führt den Trauerzug der Opfer des Soweto-Auf-
standes an, 1976

Peter Magubane

A young protester flees from police in Soweto, 1976

Father Buti Tlhagale leads a funeral procession of victims of the
Soweto Uprising, 1976

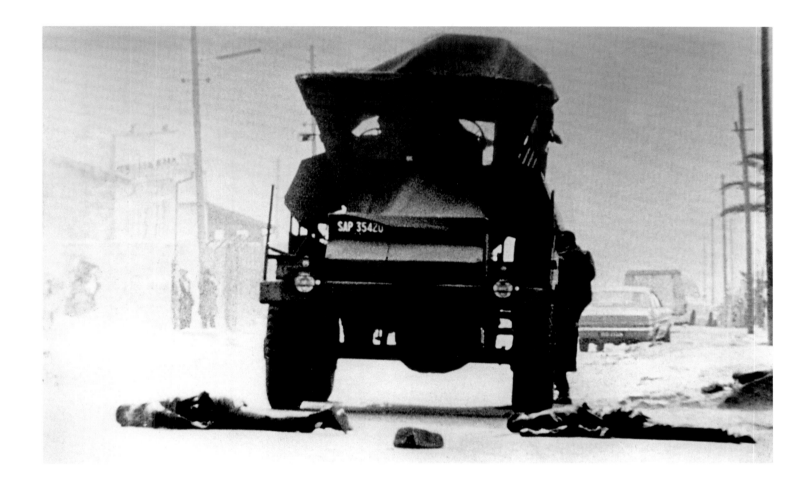

Alf Kumalo
Soweto-Aufstand, 1976

Leichen liegen vor einem Armeefahrzeug in der Nähe von Mzimhlophe, wenige Tage nach dem 16. Juni 1976. Die Polizei hat den Befehl ausgegeben, dass der Widerstand mit aller nötigen Gewalt niedergeschlagen werden soll. Und so geht das Töten weiter.

Alf Kumalo
Soweto Uprising, 1976

Dead bodies lie in front of an army vehicle near Mzimhlophe, just days after 16 June 1976. The police had been instructed to squash the resistance using whatever force was necessary and so the killings continued.

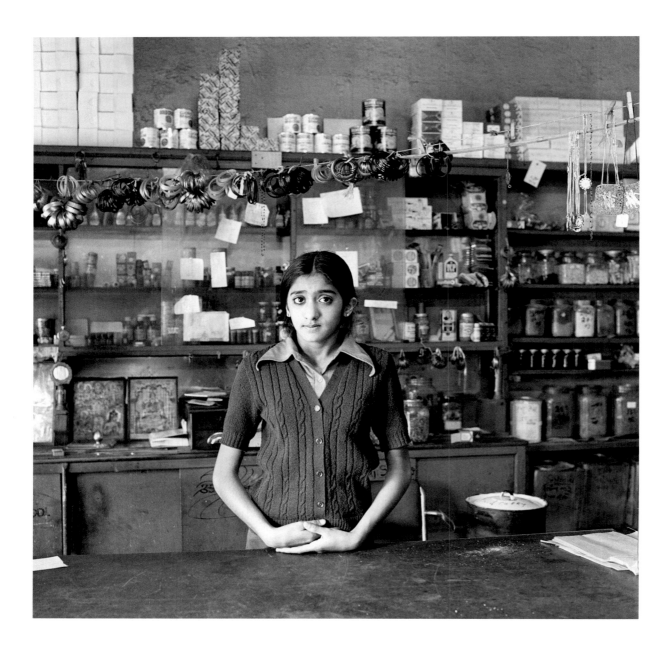

David Goldblatt
Yaksha Modi im Laden ihres Vaters, Chagan Modi, bevor er auf Grundlage
des Group Areas Act zerstört wurde, 17 Street, Fietas, 1976

David Goldblatt
Yaksha Modi in the shop of her father, Chagan Modi, before its
destruction under the Group Areas Act, 17 Street, Fietas, 1976

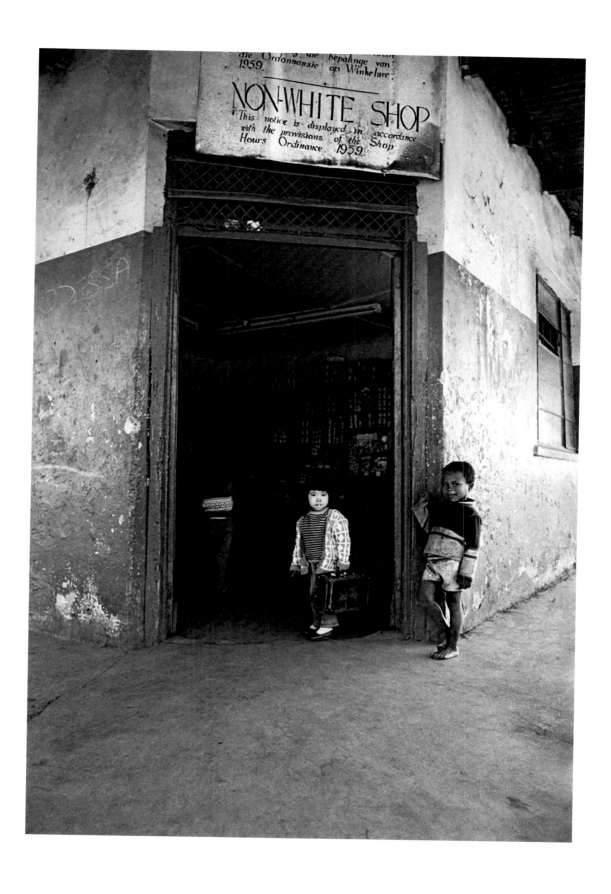

Paul Weinberg
Eine junge Chinesin im Laden ihrer Eltern, Kliptown, Soweto, Juni 1980

Paul Weinberg
A young Chinese girl in her parents' shop, Kliptown, Soweto, June 1980

Paul Weinberg
P. W. Botha nimmt die Militärparade in Pretoria ab, 1980

Paul Weinberg
P. W. Botha takes the salute at a military parade in Pretoria, 1980

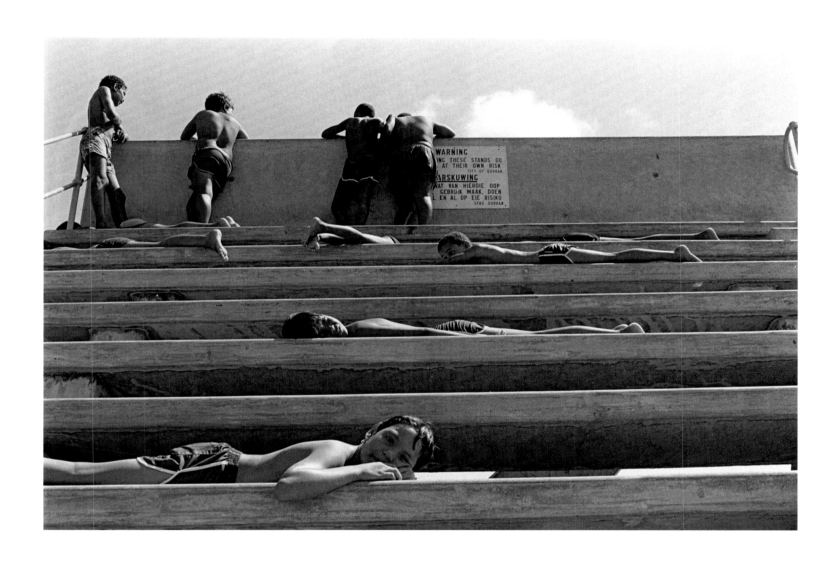

Cedric Nunn
Schwimmbad für Farbige, Durban, 1982

Cedric Nunn
Swimming pool for coloureds, Durban, 1982

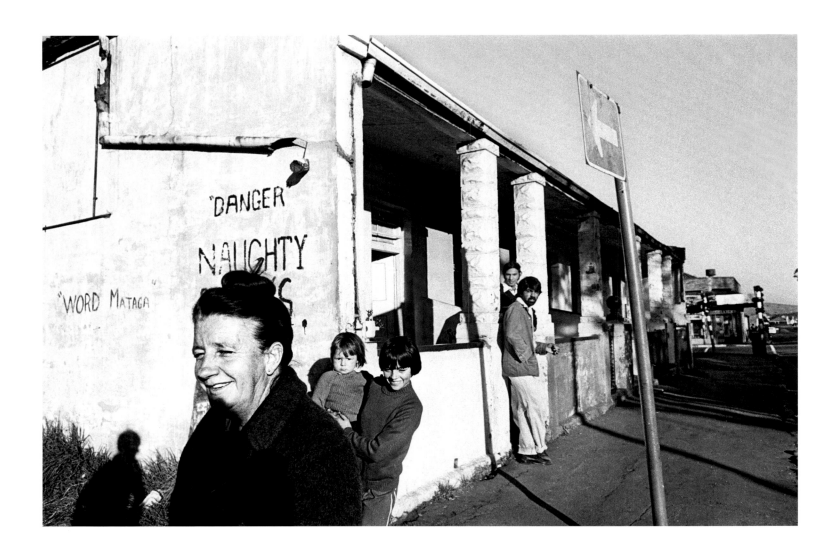

Paul Weinberg
Nachbarn, Pageview, Johannesburg, zur Zeit der Apartheidräumungen,
Juni 1982

Paul Weinberg
Neighbours, Pageview, Johannesburg, time of Apartheid removals, June 1982

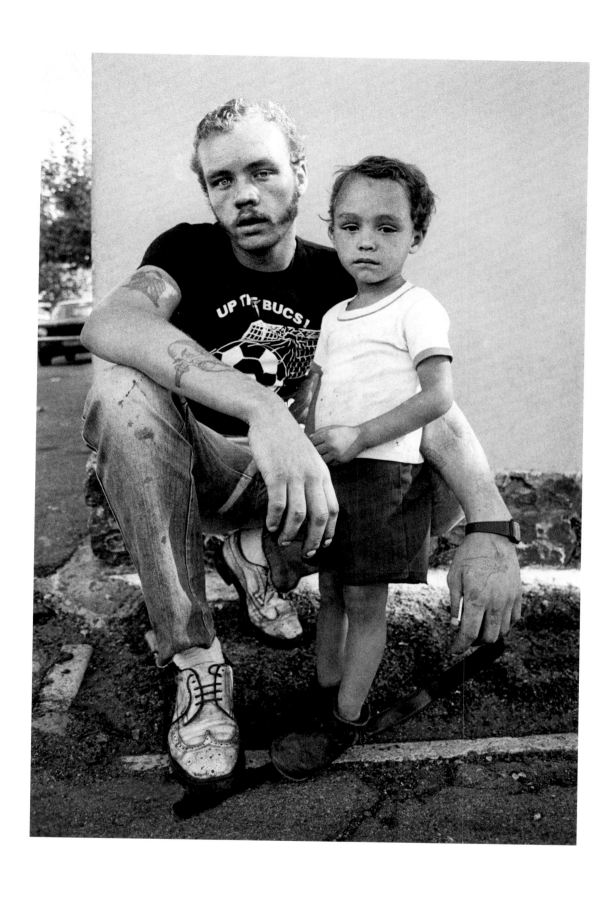

Paul Weinberg
Vater und Sohn, Mai 1983

Paul Weinberg
Father and son, May 1983

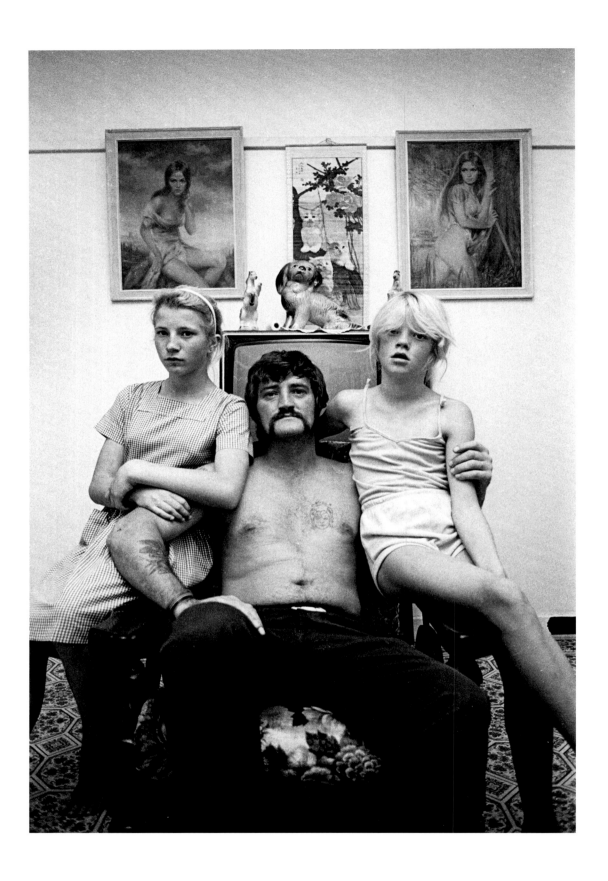

Paul Weinberg
Vater und Töchter, Juni 1983

Paul Weinberg
Father and daughters, June 1983

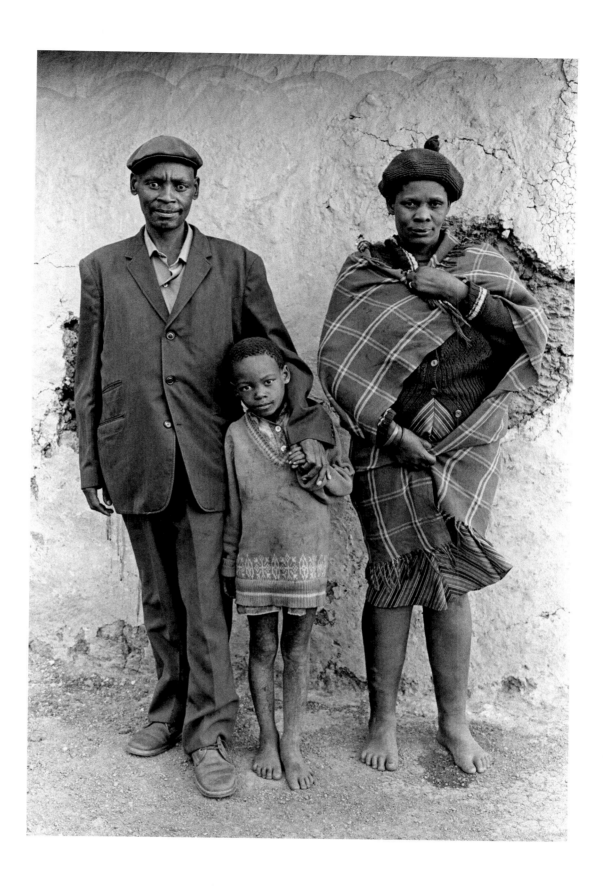

Cedric Nunn
Farmarbeiter mit Familie, iXopo, KwaZulu-Natal, 1983

Cedric Nunn
Farm worker and family, iXopo, KwaZulu-Natal, 1983

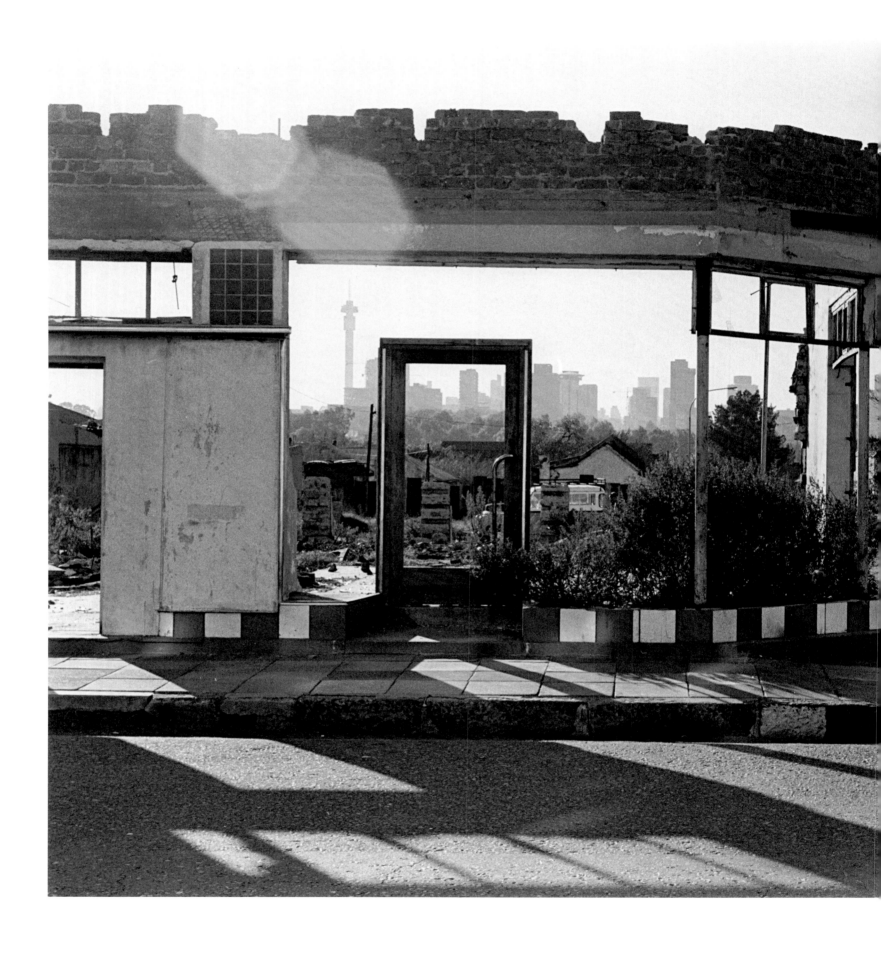

Cedric Nunn
Pageview fällt der getrenntrassigen Stadtentwicklung und der Zwangs-
räumung zum Opfer, Johannesburg 1983

Cedric Nunn
Pageview falls prey to separate development and forced removal,
Johannesburg 1983

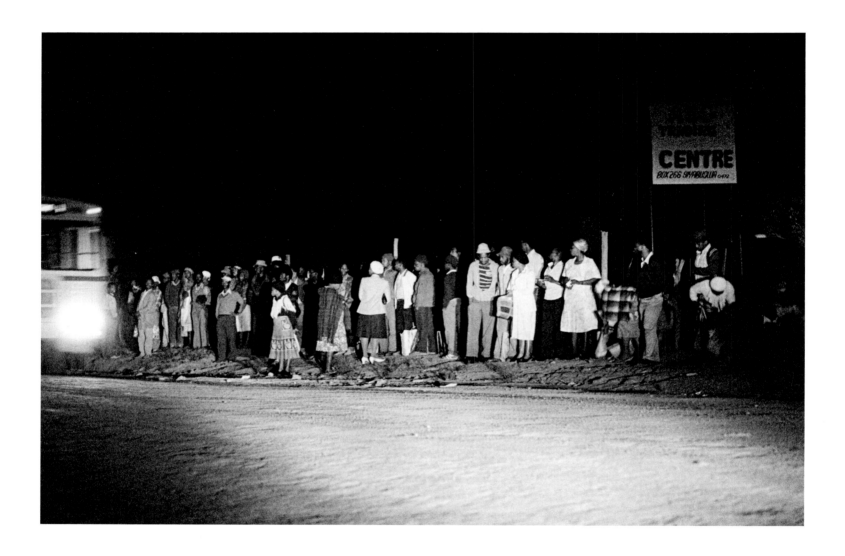

David Goldblatt
Auf dem Weg zur Arbeit, Mathysloop, Februar 1984

Arbeiter stehen in KwaNdebele Bantustan um 2:40 Uhr für den ersten Bus des Tages, der sie an ihre Arbeitsplätze nach Pretoria bringt, Schlange. Die Fahrt dauert fast drei Stunden. Vielen müssen dann noch bis zu einer Stunde weiterfahren, um gegen 7 Uhr bei der Arbeit zu sein. Es gab nur wenige Arbeitsplätze dort, was früher KwaNdebele Bantustan war.

David Goldblatt
Going to work, Mathysloop, February 1984

Workers in the KwaNdebele bantustan queue at 2:40 am for the first bus of the day to take them to their workplaces in Pretoria. The journey will take nearly three hours. Many will then take further transport of up to an hour in order to be at work by 7:00 am. There were very few employment opportunities in what was the KwaNdebele bantustan.

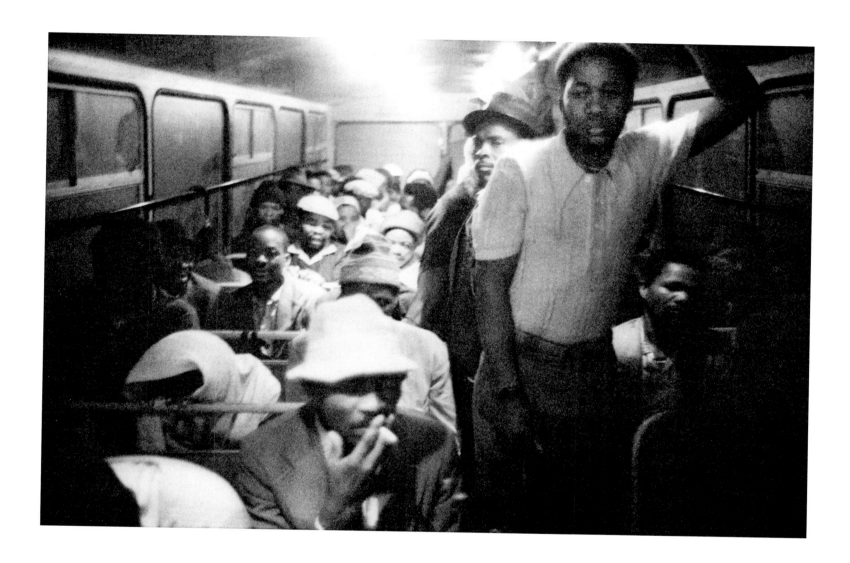

David Goldblatt
Auf dem Weg zur Arbeit, 1984

Arbeiter aus KwaNdebele Bantustan im ersten Bus des Tages. Die Fahrt dauert drei
Stunden. Diejenigen, die stehen, werden bald auf dem Boden sitzen und versuchen,
etwas Schlaf zu ergattern.

David Goldblatt
Going to work, 1984

Workers from the KwaNdebele bantustan on the first bus of the day. The journey will
take nearly three hours. Those standing will soon sit on the floor of the bus and try
to find some sleep.

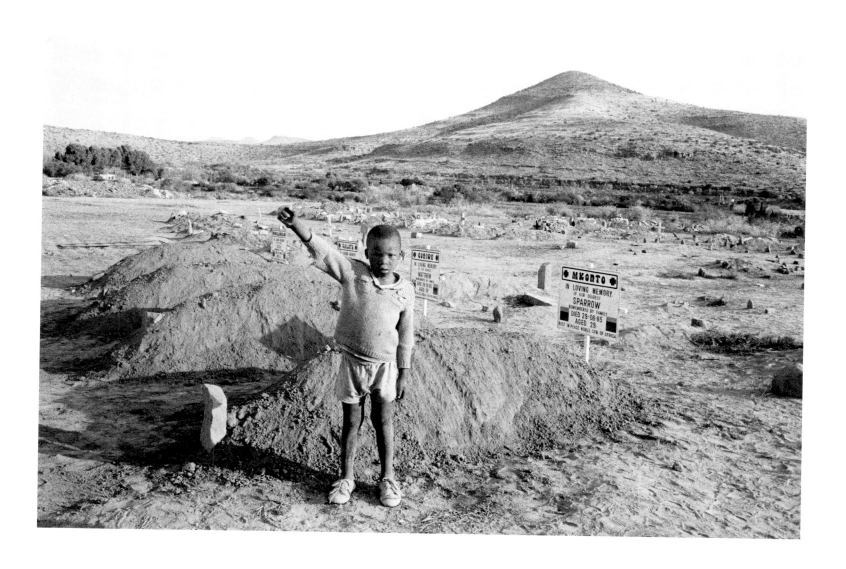

David Goldblatt
Nach der Beerdigung der Vier aus Cradock salutiert ein Kind vor ihnen, 1985

Vier jung Gemeindearbeiter wurden von der südafrikanischen Sicherheitspolizei am 20. Juli 1985 in Cradock ermordet.

David Goldblatt
After their funeral, a child salutes the Cradock Four, 1985

Four young community workers were assassinated by the South African Security Police, Cradock, on 20 July 1985.

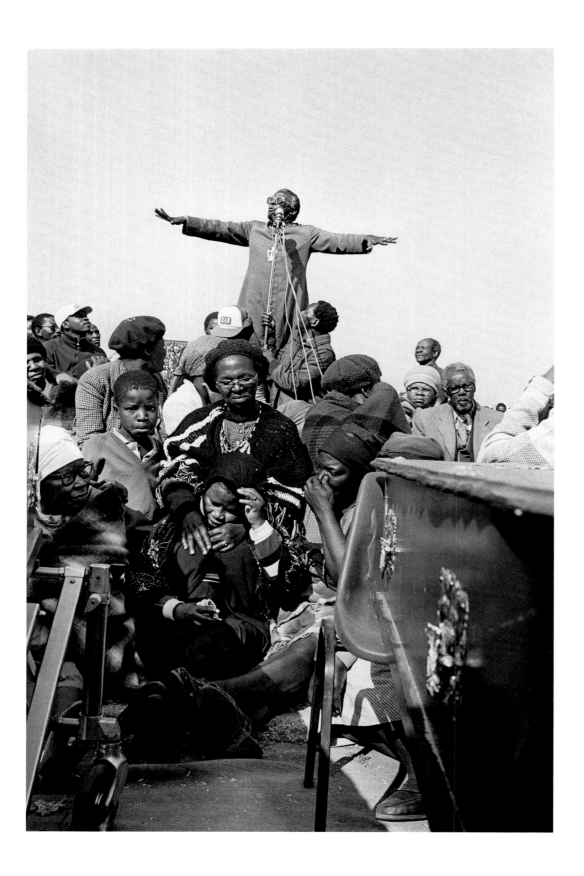

gille de vlieg
Bischof Desmond Tutu spricht zu den Teilnehmern einer Massen-
beerdigung in KwaThema, Ekhuruleni, 1985

gille de vlieg
Bishop Desmond Tutu addresses the participants at a mass funeral in
KwaThema, Ekhuruleni, 1985

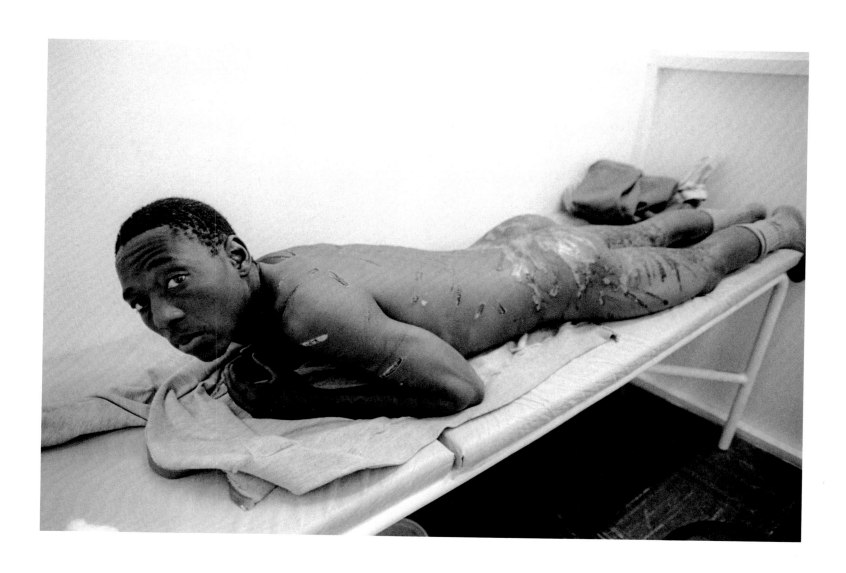

gille de vlieg
Paulos Mohobawne zusammengeschlagen von der Bürgerwehr, die vom
örtlichen Rat angeheuert worden war, Thabong, Welkom, Juni 1986

gille de vlieg
Paulos Mohobane beaten by vigilantes hired by the local councillors,
Thabong, Welkom, June 1986

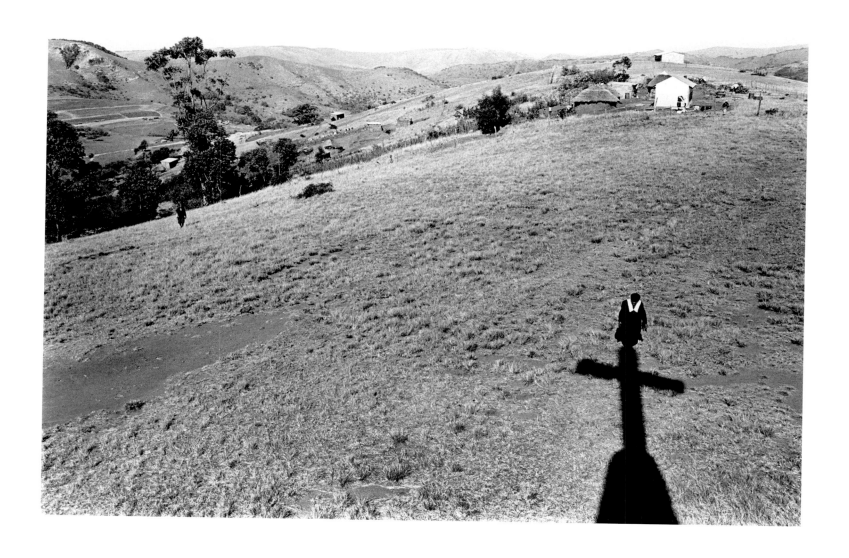

Cedric Nunn
Ankunft bei einer örtlichen Kirche, Mahlatini, KwaZulu-Natal, 1986

Cedric Nunn
Arriving at the local church, Mahlatini, KwaZulu-Natal, 1986

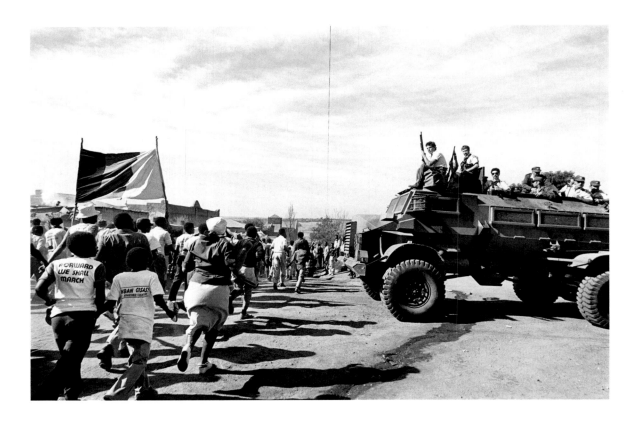

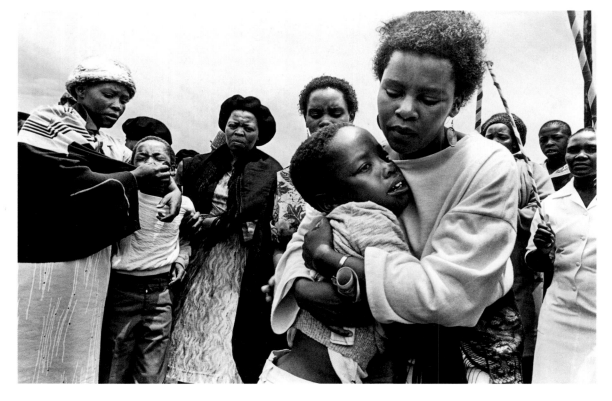

Gideon Mendel
Trauerzug für von der Polizei getötete Schüler, 1986

Bewaffnete südafrikanische Polizei in einem gepanzerten Caapir-Fahrzeug beobachten
den Zug der Trauernden, die die verbotene Fahne des ANC bei einem Gemein-
schaftsbegräbnis für die Schüleraktivisten, die von der Polizei in Alexandra Township,
Johannesburg, erschossen wurden, tragen.

Trost für die Söhne eines Mannes, der von der Polizei getötet wurde, 1986

Familienangehörige trösten die Zwillinge beim Begräbnis ihres Vater in Munsieville
Township, in der Nähe von Krugersdorp. Ihr Vater, ein Krankenpfleger, wurde von der
Polizei an einer Straßensperre erschossen.

Gideon Mendel
Funeral procession for students killed by police, 1986

Armed South African police, on an armoured Casspir vehicle, watch the procession
of mourners carrying the banned African National Congress flag at the mass funeral
of student activists shot by the police in Alexandra Township, Johannesburg.

Comforting sons of man shot by police, 1986

Family members console twin brothers during their father's funeral in Munsieville
Township near Krugersdorp. Their father who had been a nurse was shot by police
at a roadblock.

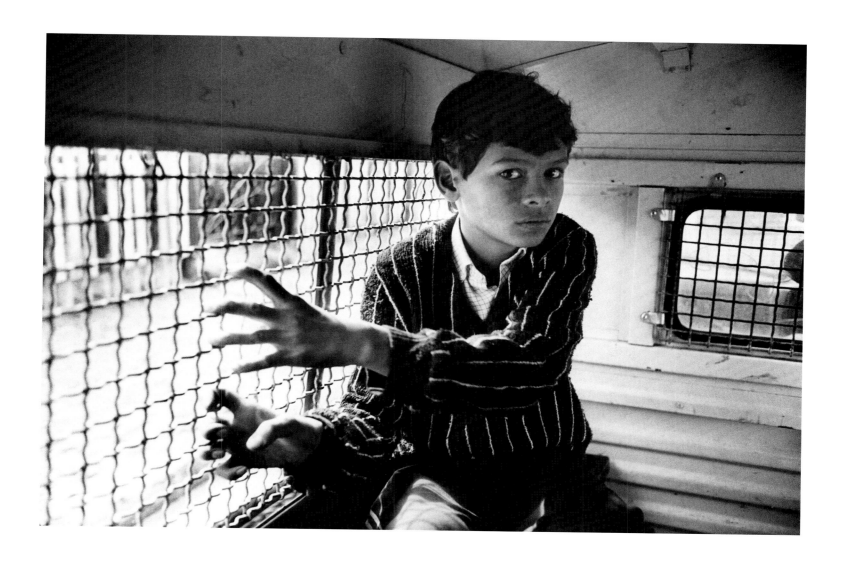

Gideon Mendel
Junge in einem Polizeifahrzeug, 1986

Ein Junge hinten in einem Polizeifahrzeug, nachdem er im Zusammenhang mit den Unruhen in Athlone in Kapstadt, in denen Schüler und Polizei verwickelt waren, verhaftet worden ist. Wegen der Einschränkungen während des Notstandes war es illegal, Demonstrationen zu fotografieren. Und so befand sich der Fotograf auch im hinteren Teil des Polizeifahrzeuges, nachdem er verhaftet worden war.

Gideon Mendel
Teenage boy in a police vehicle, 1986

A teenage school boy in the back of a South African police vehicle after being arrested during a riot involving students and police in Athlone in Cape Town. Due to emergency restrictions it was illegal to photograph demonstrations, and the photographer was in the back of the police car after being arrested as well.

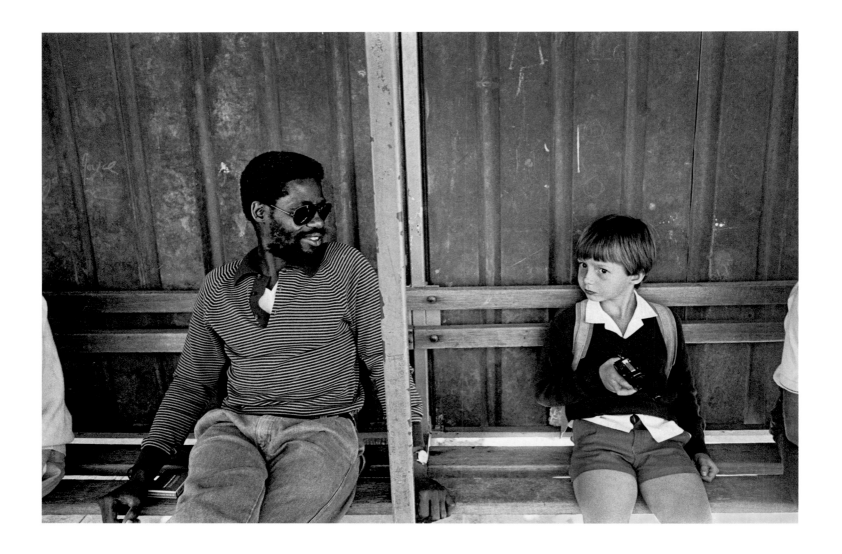

Paul Weinberg
Warten auf den Bus während der Apartheid, Juni 1986

Paul Weinberg
Waiting for a bus during the times of Apartheid, June 1986

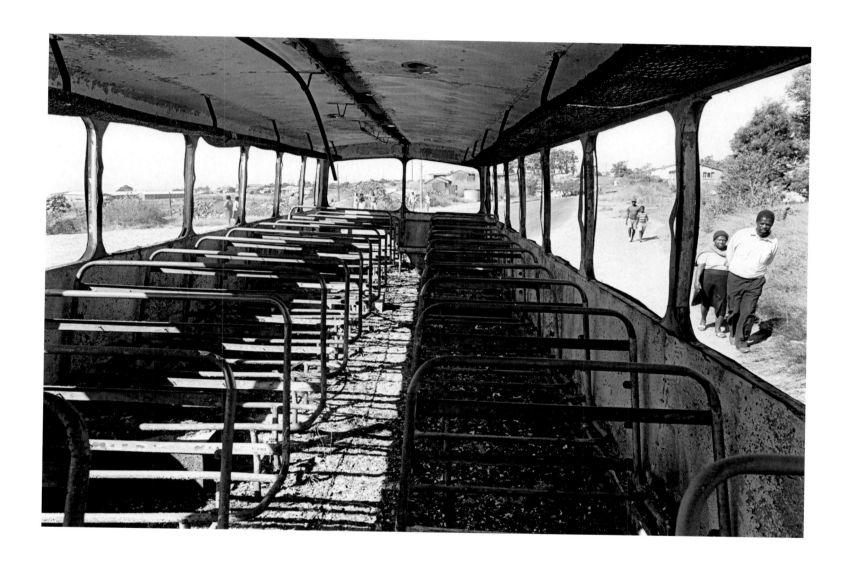

Cedric Nunn
Bei der »Wegbleiben«-Aktion ausgebrannter Bus, KwaMashu Township, Durban, 1987

Cedric Nunn
Bus torched in Stay Away mass action, KwaMashu township, Durban, 1987

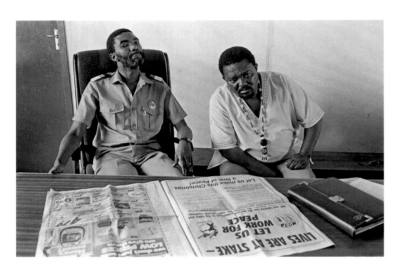

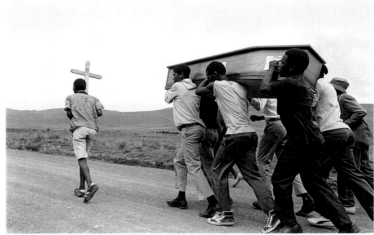

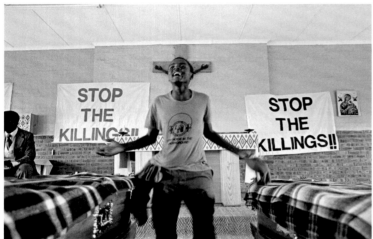

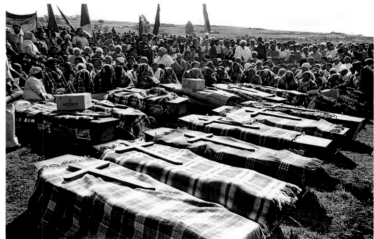

Cedric Nunn

Führer der Inkatha Freedom Party halten eine Pressekonferenz in Taylors Halt ab, Pietermaritzburg, KwaZulu-Natal, 1987

Begräbnis zweier Jugendlicher, die im Natalkrieg entführt und ermordet wurden, Mpophomeni, KwaZulu-Natal, 1987

Cedric Nunn

Begräbnis zweier jugendlicher Kameraden, die im Natalkrieg entführt und ermordet wurden, Mphophomeni, KwaZulu-Natal, 1987

Inkatha-Mitglieder begraben ihre Toten des Natalkrieges, Midlands, KwaZulu-Natal, 1987

Cedric Nunn

Inkatha Freedom Party leaders at a press conference in Taylors Halt, Pietermaritzburg, KwaZulu-Natal, 1987

Funeral of two youths abducted and killed in the Natal War, Mpophomeni, KwaZulu-Natal, 1987

Cedric Nunn

Funeral of two comrade youths abducted and killed in the Natal War, Mphophomeni, KwaZulu-Natal, 1987

Inkatha members bury their dead in the Natal War, Midlands, KwaZulu-Natal, 1987

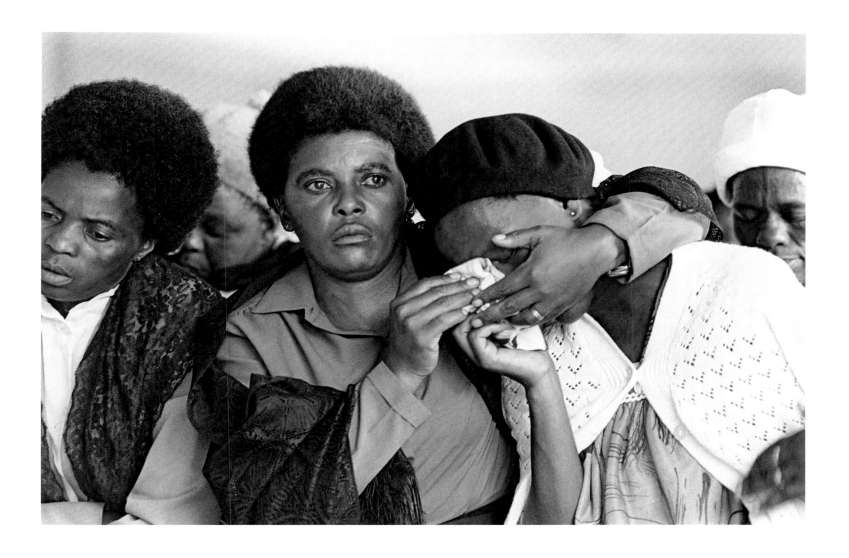

Cedric Nunn
Trauernde beim Begräbnis zweier Jugendlicher von der United Democratic Front, die im Natalkrieg entführt und ermordet wurden, Mpophomeni, KwaZulu-Natal, 1987

Cedric Nunn
Mourners at the funeral of two United Democratic Front youths who were abducted and murdered in the Natal War, Mpophomeni, KwaZulu-Natal, 1987

Cedric Nunn
Kinder in Arniston toben in den Wellen an der Küste vom Westkap, 1989

Cedric Nunn
Arniston kids body surfing off the Western Cape coast, 1989

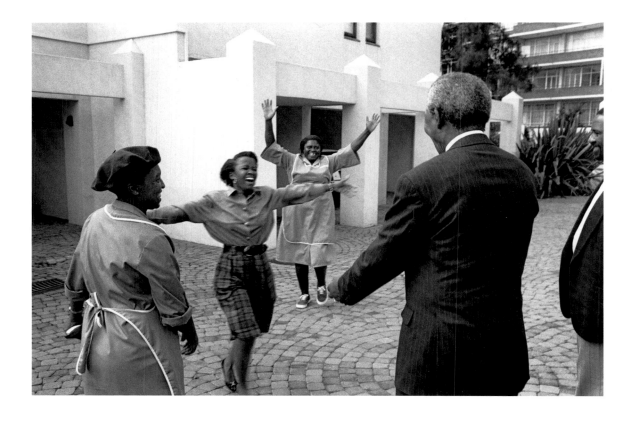

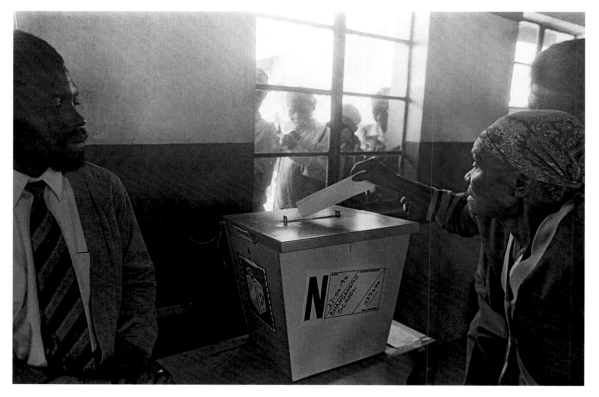

George Hallett
Mandela, erste Begegnung, Johannesburg 1994

Cedric Nunn
Südafrikas erste demokratische Wahl, Bangonomo, Kwazulu-Natal, 1994

Die erste freie Wahl in Südafrika im April 1994 steht für das Ende der Apartheid.
Mehr als 19 Millionen Menschen standen im Lande Schlange, um an den drei Wahltagen
ihre Stimme abzugeben.

George Hallett
Mandela, First Encounter, Johannesburg 1994

Cedric Nunn
South Africa's first democratic elections, Bangonomo, Kwazulu-Natal,
1994

The first free election in South Africa in April 1994 marks the end of Apartheid.
More than nineteen million people queued in lines all over the country to vote over
a three days voting period.

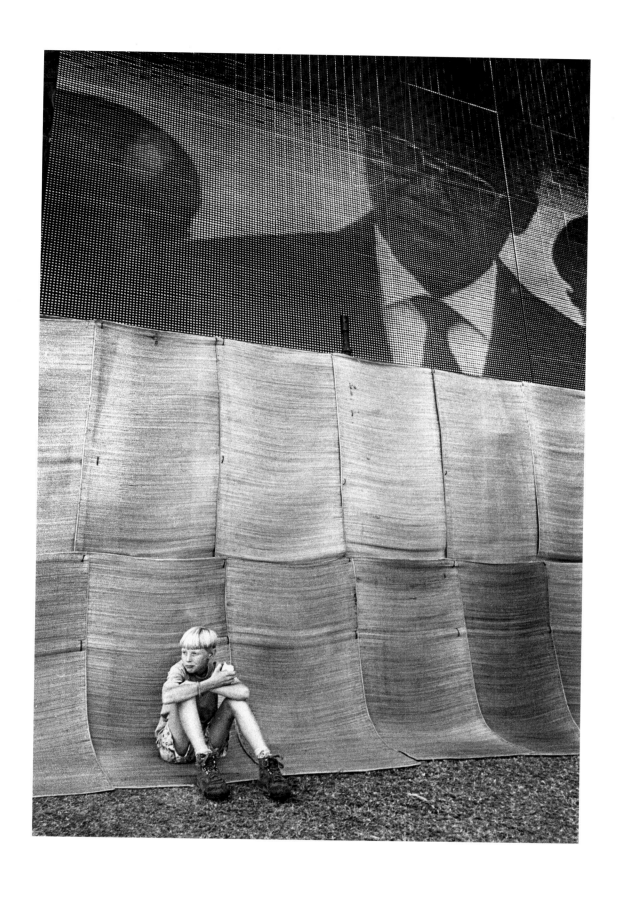

Paul Weinberg
Ein Junge bei der Amtseinführung von Nelson Mandela, Mai 1994

Paul Weinberg
A young boy at the inauguration of Nelson Mandela, May 1994

Nähe durch Ferne

Wiebke Ratzeburg

Die Fotografie ist ein Medium der Entfremdung. Zunächst trennt der Vorgang des Fotografierens den Fotografen von den fotografierten Dingen und Menschen. Die Entfernung zum Objekt wird dann noch größer, wenn wir als Betrachter Welten sehen, von denen wir räumlich, sozial und zeitlich sehr weit entfernt sind. Dieser Abstraktionsprozess ermöglicht dem Betrachter – und da schließe ich mich als europäisch verortete Autorin explizit ein – den Zugang zum Fremden und Beunruhigendem in einer kontrollierten Form, die sowohl die Reflexion der Verhältnisse als auch Empathie erlaubt.

Die südafrikanische Fotografie bezieht ihre Bedeutung unter anderem aus dieser politischen Dimension. Sie hat über viele Jahre das Apartheidregime in seinen menschenverachtenden Ritualen und seinen katastrophalen Folgen der Weltöffentlichkeit vor Augen geführt. Mit dem Ende der Apartheid 1994 ist zwar eine neue Ära der Demokratisierung in Südafrika angebrochen, die gesellschaftlichen Verwerfungen sind aber noch lange nicht überwunden. So bleibt für engagierte Fotografen weiterhin viel zu tun.

Angesichts der Vielzahl der gesellschaftlichen Probleme, ihren komplexen Ursachen und dem Mangel an einfachen Lösungsmöglichkeiten hat sich die Bildsprache der Fotografen gewandelt. Es gibt nicht mehr das eine politische Unrechtsregime, das sich mit seinen sichtbaren Herrschaftsinstrumenten zeigen und bloß stellen lässt. Der Gegner scheint verschwunden, die Auswirkungen der Jahrhunderte langen Ausbeutung und Kolonialisierung haben jedoch eine Eigendynamik entwickelt, die nicht rückgängig zu machen ist. Die Hoffnung auf eine schnelle Erholung der Gesellschaft von diesen Auswirkungen – so zeigen die aktuellen Bilder deutlich – ist auch nach über 20 Jahren der Demokratisierung nicht eingelöst.

Santu Mofokeng – Billboards

Stattdessen sehen wir Fotografien einer durch und durch modernen – entfremdeten – Lebenswirklichkeit. Im postmodernen Patchwork stehen in Santu Mofokengs Bildern riesige Billboards einer artifiziellen Warenwelt in Mitten von tristen Township-Straßenlandschaften, teilweise bevölkert von einzelnen Passanten. Das nicht »gestylte« Erscheinungsbild dieser echten Menschen und die funktionale Ödnis der Orte bilden einen krassen Gegensatz zu den geschönten Werbewelten der Plakate. Mofokeng verdeutlicht hier die chimäre Gestalt der Fotografie in der postmodernen Konsum- und Werbegesellschaft: Einerseits werden Bilder von glatten, sauberen und perfekten Menschen und Dingen fotografisch erzeugt und aggressiv platziert. Neben ihnen muss die Wirklichkeit wie eine triste Einöde erscheinen. Ande-

rerseits kann das gleiche Medium in einer Arbeit wie von Mofokeng diese schöne Werbewelt als Illusion entlarven. Zur Wirkungsmacht der Billboards in den Townships sagt Mofokeng, dass sie während der Apartheid als Herrschaftsinstrumente eingesetzt wurden, in dem sie Gesetze und Verbote verkündeten.[1] Ihre heutige, übergroße Erscheinungsform als Werbetafeln, ganz auf den Autoverkehr ausgerichtet, schwebt vom realen Leben darunter scheinbar völlig losgelöst, auf einer eigenen Bedeutungs- und Bildebene, die jedoch eine suggestive Wirkungsmacht besitzt.

Pierre Crocquet – Enter Exit

Die große Stärke der traditionellen Dokumentarfotografie – auf gesellschaftliche, politische und soziale Missstände aufmerksam zu machen und diese damit auch aktiv bekämpfen zu können – erzeugt heute beim Betrachter eine manchmal gefährliche, weil vereinfachende Erwartungshaltung: Im Bild wird automatisch nach den »kritischen Punkten« und über das Bild hinaus nach den Verantwortlichen für diese vermeintlichen Missstände gesucht. Die Bilder von Pierre Crocquet aus seiner Serie *Enter Exit* zeigen Porträts von Einwohnern eines kleinen Ortes in Südafrika. Die Menschen verschiedener ethnischer Herkunft sind in ihrer Wohn- und Arbeitsumgebung festgehalten. Das Fehlen von neuen, industriell gefertigten Konsumgütern in den Bildern erzeugt beim Betrachter sofort die reflexartige Assoziation: Hier handelt es sich um die Dokumentation von Armut, von »Randexistenzen und einfachen Leuten«, die vom gesellschaftlichen Leben ausgeschlossen sind, denn in der modernen Konsumgesellschaft entsteht »soziale Isolation durch Armut«.[1] Auf den zweiten Blick steht dieser Interpretation entgegen, dass die Personen als Individuen und nicht als Vertreter ihrer Klasse oder Ethnie dargestellt sind. Sie sind keineswegs als Opfer oder leidend inszeniert, sondern treten dem Betrachter würdevoll entgegen.

Nun heißt es aber, nicht in das gegenteilige Wahrnehmungsklischee zu verfallen und die Lebensumstände dieser Menschen – angesichts ihrer scheinbaren Zufriedenheit – zu romantisieren. Doppelt fatal wäre diese Interpretation, weil sie das koloniale Trugbild vom »glücklichen Wilden«, der ohne Zivilisationsballast sein Leben lebt, auf die heutige Zeit projizieren würde. Die Stärke von Crocquets Fotografie liegt gerade darin, dass sie sich beiden einfachen Interpretationen widersetzt und die Menschen als Individuen zeigt, deren Leben sich nicht in simple Welterklärungsmuster einordnen lässt.

Jodi Bieber – Real Beauty

Jodi Bieber setzt sich in ihrer Arbeit *Real Beauty* mit den Körperidealen der modernen Mediengesellschaft auseinander, wie sie auch in Südafrika präsent ist. Bei ihr tauchen die Werbebilder– anders als bei Mofokeng – allerdings gar nicht auf. Das müssen sie auch nicht, denn die immer und immer wieder reproduzierten Schönheitsideale sind in unserer globalen Medienwelt so omnipräsent, dass jeder Betrachter sie vollständig internalisiert hat. Die Fotografin macht mit ihrem Titel *Wirkliche Schönheit* von Anfang an klar, dass für sie der Gegensatz zwischen dem Medienbild und ihrem realen Bild nicht zwischen »perfekter Schönheit« und »hässlicher Realität« verläuft. Sie will den Frauen ihre Würde und den Stolz auf ihren Körper zurückgeben, wenn sie ihre, nicht den Modenormen entsprechenden Modelle als die wahren Schönheiten darstellt, die sich nur in Unterwäsche gekleidet und damit ihren Körper zeigend, selbstbewusst den Blicken der Betrachter stellen.

David Goldblatt

David Goldblatt, der große Chronist und international bekannteste Fotograf Südafrikas hat in seinem, sich nun schon über 50 Jahre erstreckenden fotografischen Werk die mannigfaltigen Aspekte der Geschichte und Gegenwart seines Landes festgehalten. Sein Spektrum reicht von Landschaftsaufnahmen und urbanen Dokumentationen, über Momentaufnahmen bis zu Porträts aus allen ethnischen Gruppen. Bis in die 1990er-Jahre fotografierte er ausschließlich in Schwarz-Weiß, seit dem Ende der Apartheid und verstärkt seit 1999 realisiert er seine Arbeiten auch in Farbe. Er ermöglicht dem Betrachter Einblicke in die gesellschaftlichen Verhältnisse Südafrikas, die in der Gesamtschau ein kaum zu fassendes, heterogenes Bild von Lebensweisen und Orten darstellen. Sein fotografischer Blick geht oft in die Tiefe des Raumes und umfasst sowohl die Menschen, also auch die sie umgebenden (Stadt-)Landschaften, wodurch es ihm gelingt, die Abhängigkeit des Menschen von der ihn umgebenden Umwelt zu versinnbildlichen.

In seinen Landschaftsbildern tauchen immer wieder Spuren von Menschen auf, die den Verteilungskampf um das Land in Südafrika thematisieren, wie in seiner Arbeit *Kreuze des Protestes gegen die Farmmorde und in Andenken an die Opfer* von 2004. Nur auf den zweiten Blick sind die zahlreichen Kreuze im Vordergrund des Bildes zu erkennen, die sich in der Weite der sie umgebenden Landschaft zu verlieren scheinen. Goldblatt thematisiert in dieser Arbeit, indem er nicht nur die Gedenkstätte zeigt sowohl das hier angeprangerte Unrecht als auch seinen größeren Kontext, nämlich das Land selbst und deren Besitzer. Dies wird auch in der Arbeit *Schaffarm in Oubip* (2004)

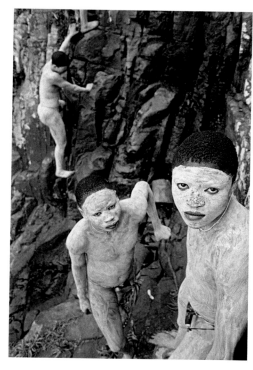

Bonile Bam
Initiation, Transkei/Ostkap, 2000
Initiations, Transkei/Eastern Cape, 2000

deutlich, denn hier ist nicht einfach nur die Ästhetik der weiten Ebene dargestellt, sondern durch den Titel werden Nutzung und damit impliziert die ganze Geschichte der Kolonialisierung und Ausbeutung der Natur markiert.

Andrew Tshabangu und Cederic Nunn

Die Schwarz-Weiß-Fotografie hat in Südafrika eine starke Tradition, die zahlreiche, auch jüngere Fotografen bewusst weiterführen. Die Arbeiten der zwei folgenden Fotografen haben aber nicht nur formal Gemeinsamkeiten: Sie befassen sich ausführlich mit der Dokumentation des Alltagslebens, vor allem der bis zum Ende der Apartheid unterdrückten Bevölkerungsgruppen. Diese Dokumentationen sind als emanzipatorischer Akt zu verstehen, der die ehemaligen Opfer als nun freie, selbstbewusst und souverän handelnde Individuen zeigt.

Bei Andrew Tshabangus Projekt *Johannesburg Transitions* scheinen wir ganz nah am täglichen Geschehen auf den Straßen Südafrikas dabei zu sein. In Schnappschussästhetik zeigt der Fotograf kurze Situationen, die sich jedoch zusammengenommen zu Mikro-Sozialstudien verdichten, die ein Leben voller Dynamik, aber auch Widersprüchen zeigt. Der schnelle Rhythmus des Stadtlebens in Johannesburg lässt sich in seinen Aufnahmen ebenso spüren, wie die langsamere Lebensweise auf dem Land, die er in seiner Serie *Villages* zeigt.

Cederic Nunn ist ebenfalls ein stiller Beobachter und Dokumentarist des Alltags jenseits von Klischees. Für den fremden Betrachter ergibt sich aus diesen Dokumentationen ein wichtiges, neues Bild: Die hier im Detail gezeigte südafrikanische Gesellschaft besteht auch jenseits

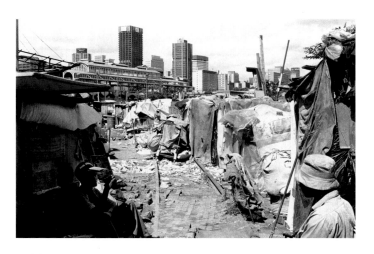

Cedric Nunn
Elendsquartiere in der Innenstadt, Johannesburg, 2001
Squatters in inner city, Johannesburg 2001

Viele der zeitgenössischen Fotografen dieser Ausstellung legen ihren Finger in diese Wunden, in der Überzeugung, dass die Wahrnehmung und Offenlegung des Ist-Zustandes der erste Schritt zu dessen Verbesserung ist.

1 http://www.artfacts.net/en/exhibition/david-goldblatt-santu-mofokeng-zwelethu-mthethwa-16000/overview.html. Zitat von Santu Mofokeng 2003.
2 Pierre Crocquet de Roesemond, *Enter Exit,* Ostfildern 2007. Zitate und Paraphrase des Vorworts von Rick Wester.

von Apartheids- und Postapartheidsproblemen. Es gibt ein ganz »normales« Alltagsleben mit seinen Licht- und Schattenseiten, das die Fotografen bildkünstlerisch anspruchsvoll umsetzen.

Bonile Bam – Initiation of the Mind

Eine scheinbare Zeitreise unternimmt Bonile Bam mit seiner Serie *Initiation of the Mind* von 2000. Er zeigt junge Männer aus dem Stamm der Xhosa während ihres dreimonatigen Initiationsritus, der auf jahrhundertealten Traditionen beruht. Die jungen Männer, äußerlich gut an ihrer weißen Lehmbemalung zu erkennen, unterwerfen sich gemeinsam strengen Ernährungs- und Verhaltensritualen, um später erfolgreich als vollwertige Erwachsene in ihrer Gemeinschaft anerkannt zu werden. Die geistige Reise und Reifung wird in eindrucksvoll stillen Bildern festgehalten.

Mikhael Subotzky

Der junge Fotograf Mikhael Subotzky hat sich mit seiner sich über fünf Jahre erstreckenden Dokumentation von den Zuständen in südafrikanischen Gefängnissen und dem Leben der Insassen während und nach ihren Haftstrafen einen Namen gemacht. Er ist Mitglied der renommierten Agentur MAGNUM. Seine Serie von 2004 anlässlich der dritten demokratischen Wahl in Südafrika zeigt unterschiedliche Wähler mit ihren Stimmzetteln. Im Vorfeld dieser Wahl gab es eine öffentliche Diskussion über die Frage, ob Gefängnisinsassen überhaupt das Wahlrecht ausüben dürften. Die Idee, eine ganze Gruppe von Bürgern in ihren Grundrechten zu beschneiden, scheint ein Muster der Apartheid fortzusetzen, ist aber andererseits in der Hilflosigkeit gegenüber der extremen hohen Kriminalität und der damit verbundenen Aushöhlung der gesellschaftlichen Ordnung nachvollziehbar. Die Kriminalität als Zeichen der Desintegration großer Bevölkerungsgruppen führt letztlich nur wieder auf die Geschichte der Kolonisation und Apartheid zurück, die sich durch die Einführung der Demokratie nicht revidieren lässt.

Proximity through Distance

Wiebke Ratzeburg

Photography is a medium of alienation. At first, the photographic process separates the photographer from the photographed objects and persons. The distance to the object becomes even larger when we as viewers see worlds that are far removed from us in terms of space, society, and time. This abstraction process enables the viewer, and, as an European-based author, I explicitly include myself, to access the foreign and the disturbing in a controlled form that allows for reflections on the conditions and makes empathy possible.

Among other things, South African photography draws its significance from such a political dimension. Over the course of many years, it depicted the inhuman rituals and catastrophic consequences of the Apartheid regime to a global audience. Despite the fact that a new democratic era broke out in 1994 with the end of Apartheid, the existing social dislocation has not yet been entirely overcome. The dedicated photographer therefore still has much to do.

The photographers' visual language has changed in the face of the numerous social problems, their complex causes, and the lack of simple solutions. There is no longer just the one unscrupulous political regime that is shown and exposed with its visible instruments of power. While the opponent seems to have been overcome, the repercussions of long centuries of exploitation and colonialisation developed a momentum that cannot be rolled back. As the present pictures clearly indicate, the hope that society would quickly recover from the effects of this conflict has not yet been redeemed even after more than twenty years of democratisation.

Santu Mofokeng—Billboards

We see instead photographs of a thoroughly modern—alienated—everyday reality. Santu Mofokeng's pictures depict the enormous billboards belonging to an artificial world of consumer goods in a postmodern patchwork at the centre of drab township streetscapes that are partially inhabited by individual passers-by. The 'unstyled' appearance of these real people and the functional desolateness of these places form a stark contrast to the prettified advertising world seen on the posters. Mofokeng demonstrates the chimeric form of photography in the postmodern consumer and advertising society: On the one hand, pictures of smooth, clean, and perfect people and things are generated photographically and aggressively situated. Alongside them, reality must appear like a dreary wasteland. On the other hand, however, works in the same medium as those by Mofokeng, can unmask this dazzling world of advertising and showing it to be an illusion. As regards to the impact of billboards in the townships,

Mofokeng said they were employed as instruments of power, used to proclaim laws and prohibitions during the Apartheid era.[1] Their present-day, over-sized appearance as billboards oriented entirely on automobile traffic seems to hover completely detached from the real life taking place below on its own semantic and pictorial level that nevertheless possesses a suggestive impact.

Pierre Crocquet—Enter Exit

The great strength of traditional documentary photography—namely calling attention to social and political evils and, in doing so, actively fighting them—sometimes results in dangerous expectations in present-day viewers because of its inherent simplification: The viewer automatically searches for the 'critical points' in the image, and by extension, for those responsible for these supposed injustices. Pierre Crocquet's pictures from his *Enter Exit* series comprise portraits of the inhabitants of a small community in South Africa. The people from various ethnic backgrounds are captured in their living and working environment. The lack of new, industrially manufactured consumer goods in the images immediately generates a knee-jerk association in the viewer: The pictures are documents of poverty, of 'marginal existences and simple people' excluded from social life because 'social isolation' is a consequence of poverty in the contemporary consumer society.'[2] Upon second glance, however, this interpretation is contradicted by the fact that the persons are portrayed as individuals and not as representatives of their class or ethnic group. They are by no means staged as suffering victims, but approach the viewer with dignity instead.

The task at hand, however, is not to lapse into the diametrically opposed perception cliché and romanticise these people in the face of their apparent contentedness. Such an interpretation would be doubly fatal because it represents a modern day projection of the colonialist delusion of the 'happy savage' who lives his life unburdened by civilisation. The strength of Crocquet's photographs rests in the fact that they resist both simple interpretations and show people as individuals whose lives cannot be categorised by simple explanatory patterns of the world.

Jodi Bieber—Real Beauty

In *Real Beauty*, Jodi Bieber deals with the modern media society's ideal image of the body as it is also exists in South Africa. But unlike Mofokeng, advertising images do not appear in her work. That is not necessary because the persistently reproduced ideals of beauty are so omnipresent in our global media world that they have been com-

Santu Mofokeng
Robben Island wie Sie es noch nie zuvor gesehen haben, 2002
Robben Island as you have never seen it before, 2002

pletely internalised by each and every viewer. The photographer's title *Real Beauty* makes it clear from the very beginning that for her, the contradiction between the media image and the real image does not run between 'perfect beauty' and 'ugly reality'. Her models do not conform to fashion conventions, but by portraying them as true beauties who display their bodies clad only in undergarments and self-confidently face the viewers' glances, Bieber wishes to return to these women a sense of their own dignity and pride in their bodies.

David Goldblatt

David Goldblatt, South Africa's great chronicler and internationally best-known photographer, has captured the diverse aspects of his country's past and present in a career as that has now lasted over fifty years. His spectrum of his work ranges from landscape photographs to urban documentations, from snapshots to portraits of persons of all ethnic groups. He took exclusively black-and-white photographs until the nineteen-nineties, but since the end of Apartheid, and especially since 1999, he has increasingly also worked in colour. He provides the viewer with insights into South Africa's social conditions that as a whole represent an almost unbelievably heterogeneous picture of lifestyles and places. His photographic glance often pierces the depths of the spaces and encompasses people as well as the (urban) landscapes surrounding them, enabling him to symbolise the dependency of the human being on his environment.

In landscape pictures such as his *Crosses in protest against and in commemoration of farm murders* from 2004, traces of human presence regularly appear that take up the topic of the distribution of land in South Africa. The numerous crosses in the foreground of the picture that seemingly fade into the vast expanses of the surrounding landscape are first recognisable upon a second glance. By not only showing the memorial, Goldblatt deals in this piece with the injustice denounced here as well as its larger context, namely the land itself and its owners. This is also evident in *Sheep farm at Oubip* (2004) because the aesthetic of the vast plane is not only simply portrayed but

the title also designates its use and, by implication, the entire history of the colonialisation and exploitation of nature as well.

Andrew Tshabangu and Cederic Nunn

Black-and-white photography has a strong tradition in South Africa that is consciously being carried on by younger photographers today. The works of these two following photographers share more than just formal similarities: They comprehensively deal with the documentation of everyday life, particularly of the segments of the population who were oppressed until the end of Apartheid. The documentations are to be understood as emancipatory acts that now depict former victims as free, self-confident, and autonomously acting individuals.

In Andrew Tshabangu's *Johannesburg Transitions* project, we seem very close to daily occurrences on South Africa's streets. The photographer makes use of a snapshot aesthetic to show brief situations that, taken as a whole, condense into micro social studies depicting a life full of dynamism as well as contradictions. His photographs enable us to sense the quick rhythms of urban life in Johannesburg as well as the slower pace in the countryside he portrays in his *Villages* series.

Cederic Nunn is likewise a quiet observer and documentarian of everyday life beyond the clichés. For the outside observer, these documentations result in an important new picture: The South African society shown here in detail also has an existence over and above the problems of Apartheid and post-Apartheid. There is a very 'normal' everyday life with its positive and negative sides that the photographers capture here in a pictorially ambitious fashion.

Bonile Bam—Initiation of the Mind

Bonile Bam undertakes an ostensive journey through time in his *Initiation of the Mind* series from 2000. He depicts young men from the Xhosa people during their three-month initiation ritual that rest on centuries-old traditions. The young men, who are easily recognisable from the white clay paintings on their bodies, jointly submit themselves to strict dietary and behaviour rituals in order to later be successfully recognised in their society as full-fledged adults. The spiritual journey and maturation process is captured in impressively calm images.

Mikhael Subotzky

Over the course of more than five years, the photographer Mikhael Subotzky has made a name for himself documenting the conditions

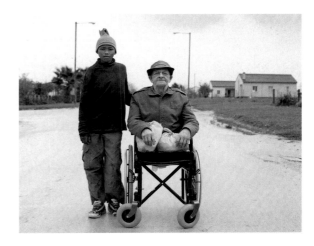

Pierre Crocquet
Enter Exit [5], 2006

in South African prisons and the lives of the inmates during and after their incarceration. He is a member of the renowned MAGNUM agency. His 2004 series on the occasion of the third democratic election in South Africa depicts a range of voters with their ballots. There was a public discussion in the run-up to this election whether prison inmates were entitled to exercise the right to vote. The idea of cutting off a whole group of citizens from their basic civil rights seemed to continue a pattern going back to the Apartheid era, but which nevertheless also seems understandable in the face of extremely high rates of criminality and the associated erosion of the social order. Criminality as an indication of the break-up of entire demographic groups ultimately leads back to the history of colonization and Apartheid that cannot be rewritten by the introduction of a democratic system.

Many of the contemporary photographers in this exhibition place their finger in these wounds, convinced that the perception and disclosure of the status quo is the first step to improve it.

1 http://www.artfacts.net/en/exhibition/david-goldblatt-santu-mofokeng-zwelethu-mthethwa-16000/overview.html. Quotation from Santu Mofokeng 2003.

2 Pierre Crocquet de Roesemond, *Enter Exit* (Ostfildern, 2007). Quotations and paraphrases from the foreword by Rick Wester.

1994–2010 Freedom

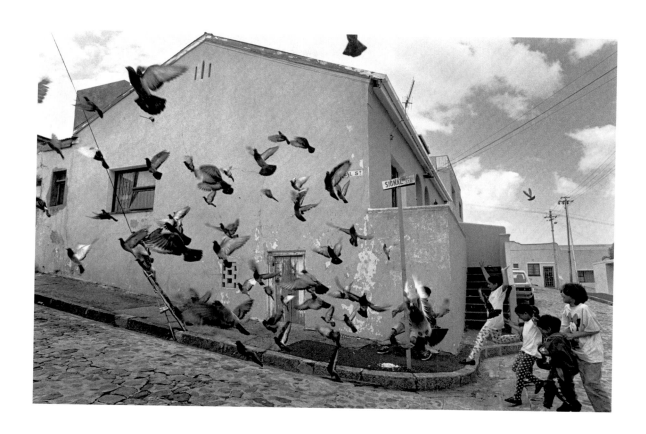

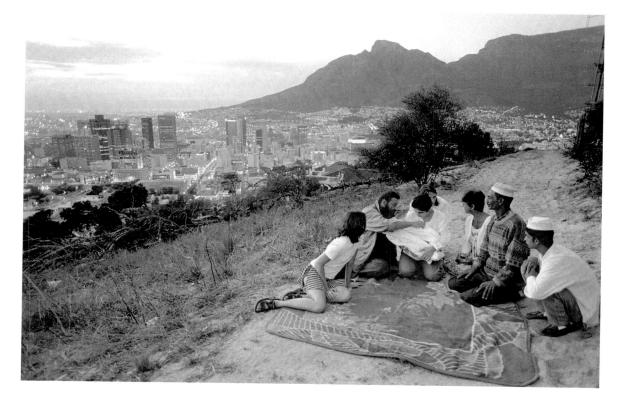

George Hallett
Vögel auf der Signal Street, Bo-Kaap, Kapstadt, 1996

George Hallett
Namensgebung, Bo-Kaap, Kapstadt, 1997

George Hallett
Birds on Signal Street, Bo-Kaap, Cape Town, 1996

George Hallett
Naming of the Child, Bo-Kaap, Cape Town, 1997

George Hallett

Jann Turner und Eugene de Kock. Sie fragt ihn, ob er wisse, wer ihren Vater umgebracht habe, bei den Anhörungen der Wahrheits- und Versöhnungskommission (TCR) in Kapstadt, 1997

Die südafrikanische Wahrheits- und Versöhnungskommission wurde von der Regierung der Nationalen Einheit eingesetzt, um die Geschehnisse während der Apartheid aufzuarbeiten. Der Konflikt zu jener Zeit führte zu Gewalt und Verletzungen der Menschenrechte auf allen Seiten. Kein Teil der Gesellschaft entkam diesen Gewalttaten. Jann Turners Vater Dr. Rick Turner wurde am 8. Januar 1978 von einer Kugel, die durch das Fenster seines Hauses in Bellair, Natal, flog, getroffen und starb in den Armen seiner 13-jährigen Tochter. Nach Monaten der Ermittlungen hatte die Polizei, wie vorauszusehen war, noch keinerlei Hinweise auf den Täter. Rick Turners Mörder wurde nie identifiziert. Allerdings wird allgemein angenommen, dass er von der Sicherheitspolizei getötet worden war. Eugene de Kock war ein ehemaliger Oberst der südafrikanischen Polizei während der Apartheid. Die Medien gaben ihm den Spitznamen «Prime Evil». Er war Befehlshaber der C1-Einheit, der sogenannten Vlakplass, eine Abteilung der südafrikanischen Polizei, die zur Bekämpfung von Aufständen eingesetzt wurde. Diese war für die Ermordung vieler Anti-Apartheid-Aktivisten verantwortlich. De Kock wurde für seine Verbrechen gegen die Menschlichkeit zu einer Gefängnisstrafe von 212 Jahren verurteilt.

George Hallett

Jann Turner and Eugene de Kock. She asked him if he knew who killed her father at Truth and Reconciliation Commission (TCR) hearings in Cape Town, 1997

The South African Truth and Reconciliation Commission was set up by the Government of National Unity to help deal with what happened under Apartheid. The conflict during this period resulted in violence and human rights abuses from all sides. No section of society escaped these abuses. Jann Turner's father Dr Rick Turner was killed on 8 January 1978, he was shot through a window of his home in Bellair, Natal and died in the arms of his thirteen-year old daughter. After months of investigations and predictably so, police investigations turned up with no clues. Rick Turner's killers were never identified. However, it is widely believed that he was murdered by the Apartheid security police. Eugene de Kock was a former colonel of the South African Police force during Apartheid in South Africa. Nick-named 'Prime Evil' by the media, he was the commander of the C 1 unit, so called Vlakplass, of the South African Police counter insurgency group, who was responsible for killing many anti-Apartheid activists. He was sentenced to 212 years imprisonment for his crime against humanity.

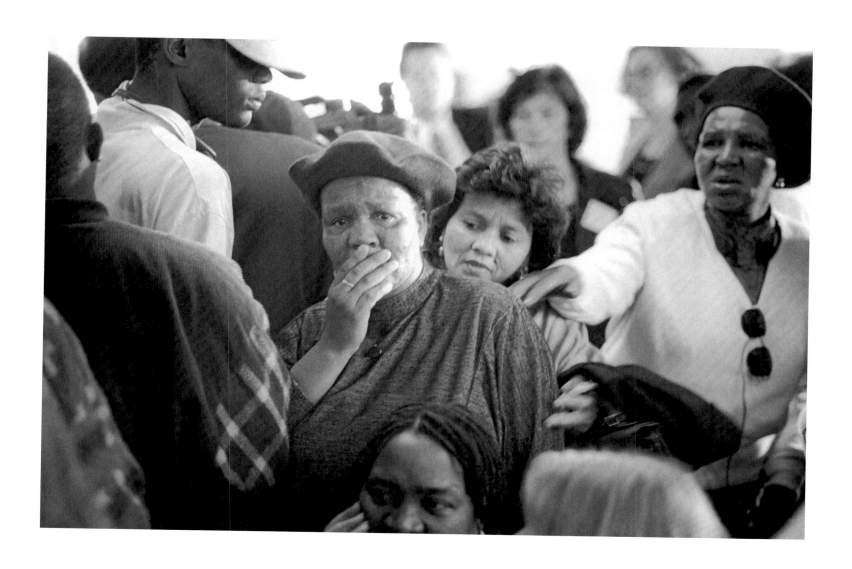

George Hallett
Mutter eines Angeklagten, nachdem sie gehört hat, wie ihr Sohn den
Angriff auf Amy Bhiel beschrieb, TRC-Anhörung, Kapstadt, 1997

George Hallett
Mother of accused after hearing her son describe the attack on Amy
Bhiel, TRC hearings Cape Town, 1997

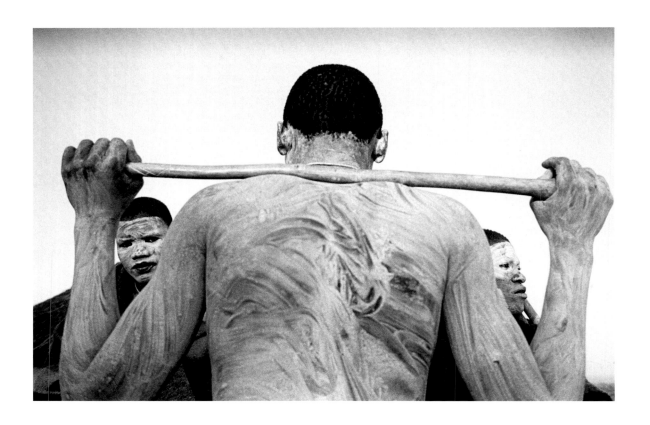

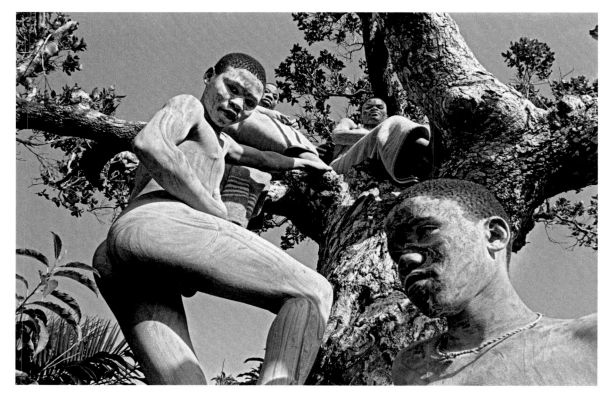

Bonile Bam
Initiation, Transkei / Ostkap, 2000

Das Ritual der männlichen Beschneidung (allgemein bekannt als Initiation) bei jungen
Erwachsenen bei dem Volk der Xhosa in Südafrika basiert auf einer alten Tradition.
Es markiert den Übergang von der Kindheit zum Erwachsenen.

Bonile Bam
Initiation, Transkei/Eastern Cape, 2000

The ritual of traditional male circumcision (commonly known as initiation) of young
adults goes back generations among Xhosa people of South Africa. It marks the
transition from boyhood to manhood.

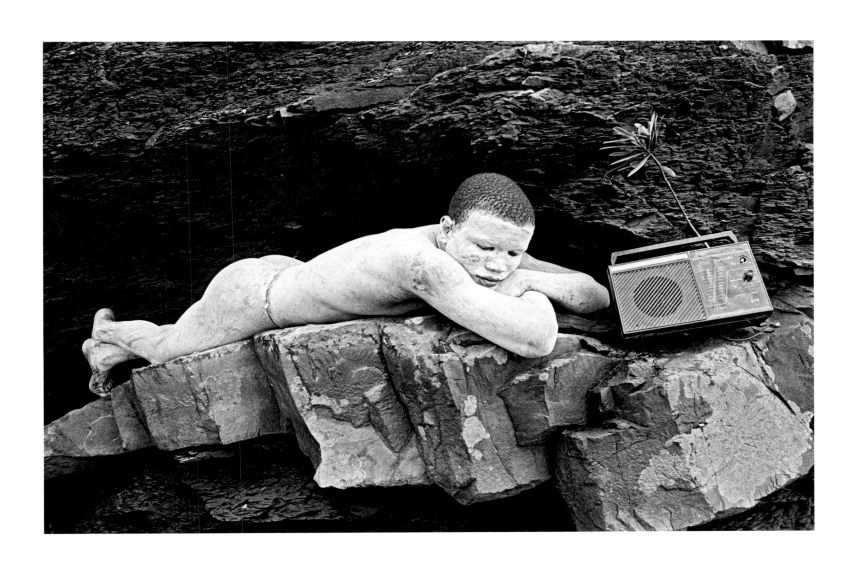

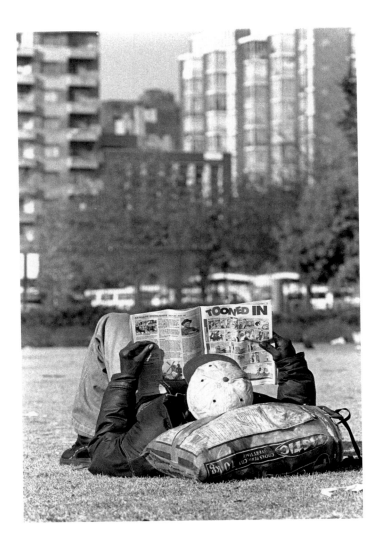

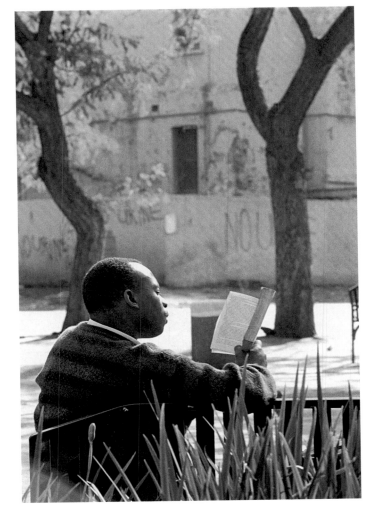

Cedric Nunn
Joubert Park, Innenstadt von Johannesburg, 2000

Joubert Park, inner city Johannesburg, 2000

Cedric Nunn
Parkszene in der Innenstadt von Johannesburg, 2001

Inner city Johannesburg park scene, 2001

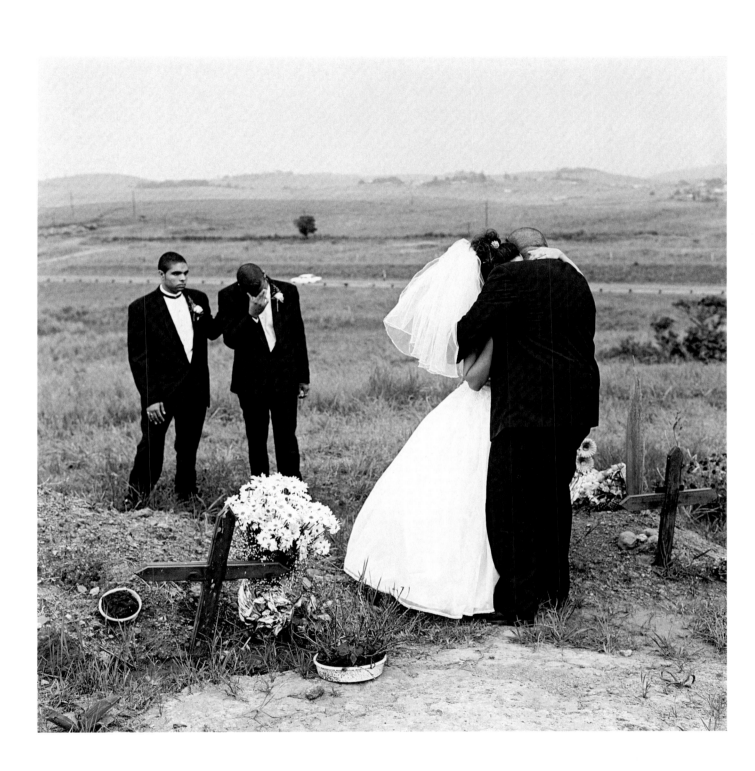

Cedric Nunn
Deborah Eksteen wird von ihrem Ehemann Noel Norris getröstet, als sie
kurz nach ihrer Hochzeit das Grab ihres kürzlich verstorbenen Vaters
besucht, Mangete, 2001

Cedric Nunn
Deborah Eksteen is comforted by her groom Noel Norris while visiting
the grave of her recently deceased father immediately after her wedding,
Mangete, 2001

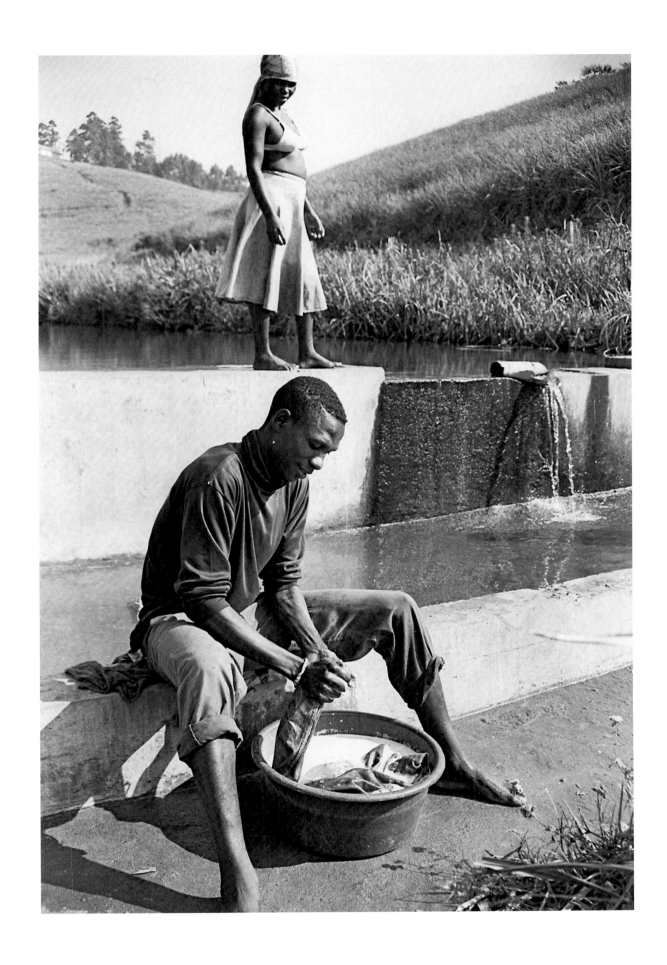

Andrew Tshabangu
Ein Mann beim Waschen seiner Kleidung, 2003

Andrew Tshabangu
Man washing clothes, 2003

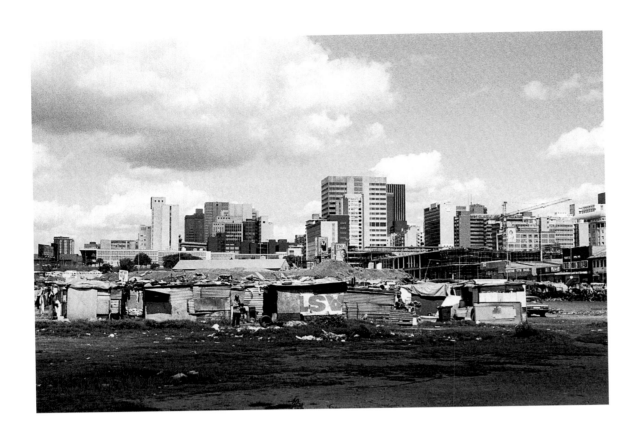

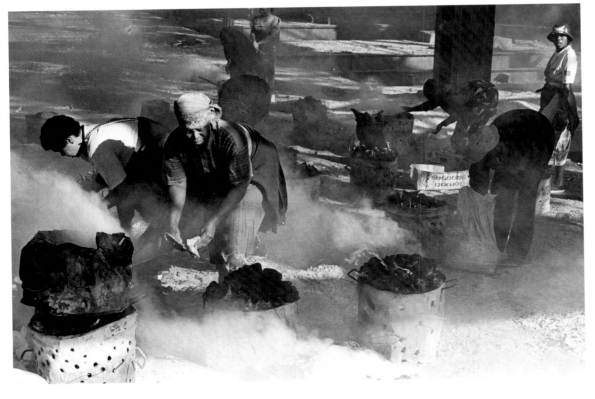

Andrew Tshabangu
Unerlaubte Stadtsiedlung 2, 2004

Turbin Hall, Johannesburg, 2000

Andrew Tshabangu
City informal settlement 2, 2004

Turbin Hall, Johannesburg, 2000

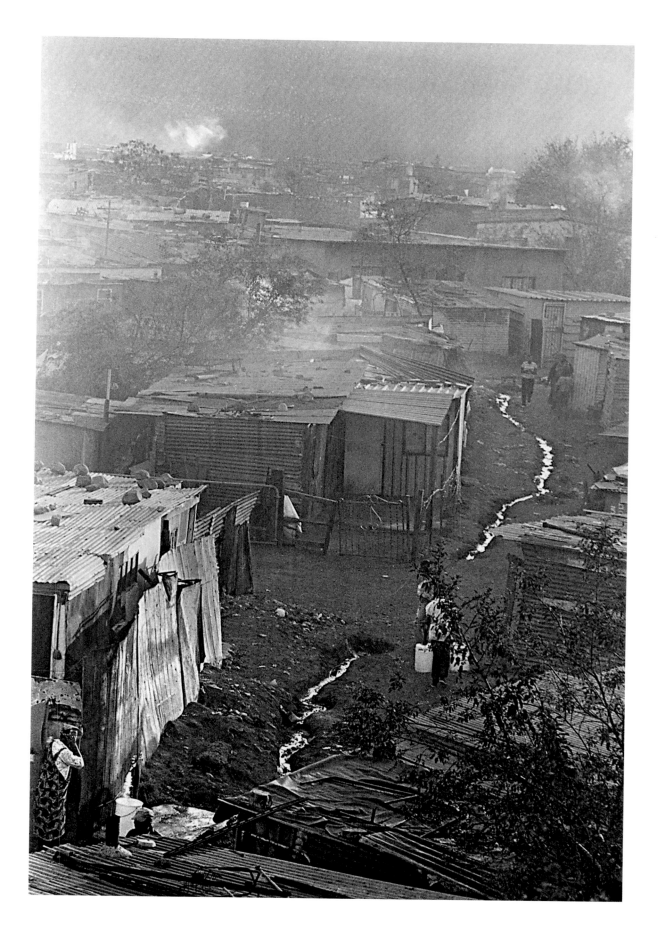

Andrew Tshabangu
Wasserlauf, Kliptown, Johannesburg, 2005

Andrew Tshabangu
Cascading water, Kliptown, Johannesburg, 2005

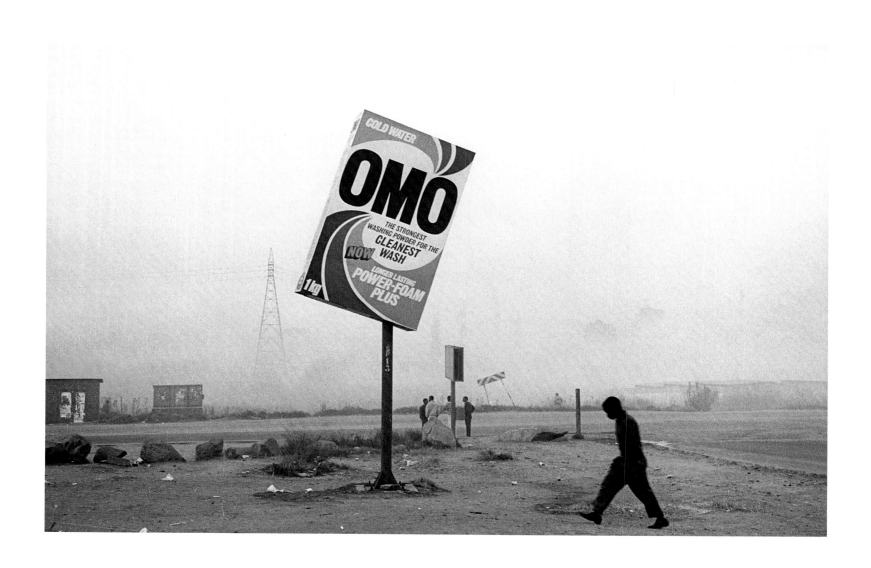

Santu Mofokeng
Winter in Tembisa, 1991

Tembisa wurde 1957 als Township gegründet.

Santu Mofokeng
Winter in Tembisa, 1991

Tembisa was established as a township in 1957.

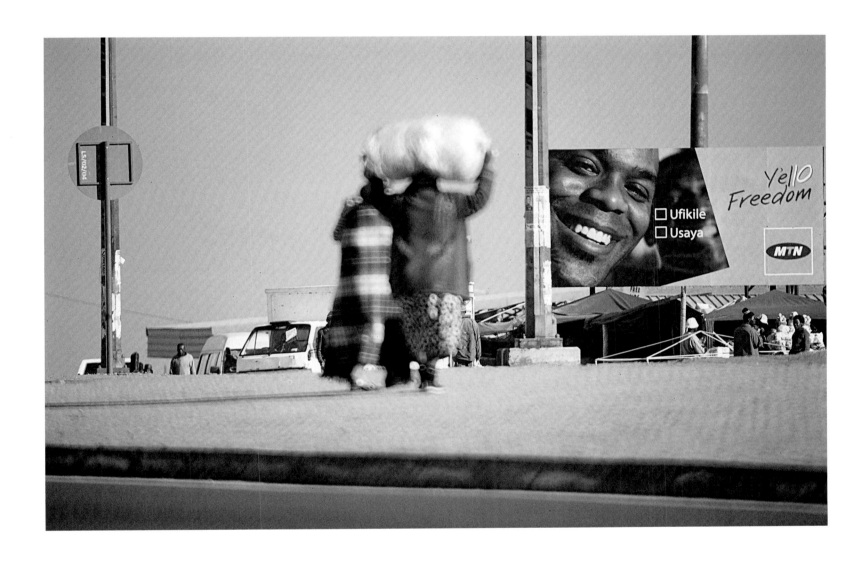

Santu Mofokeng
Demokratie ist für immer, Yello Freedom, Baragwanath-Busbahnhof,
Diepkloof, Pimville, Soweto, 2004

Santu Mofokeng
Democracy is forever, Yello Freedom, Baragwanath Terminus,
Diepkloof, Pimville, Soweto, 2004

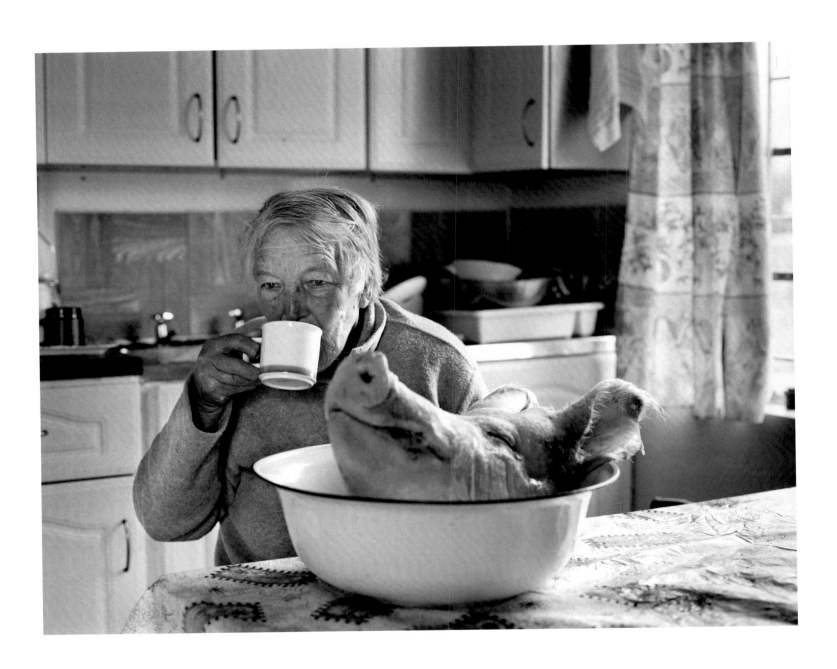

Pierre Crocquet
Enter Exit [3], 2006

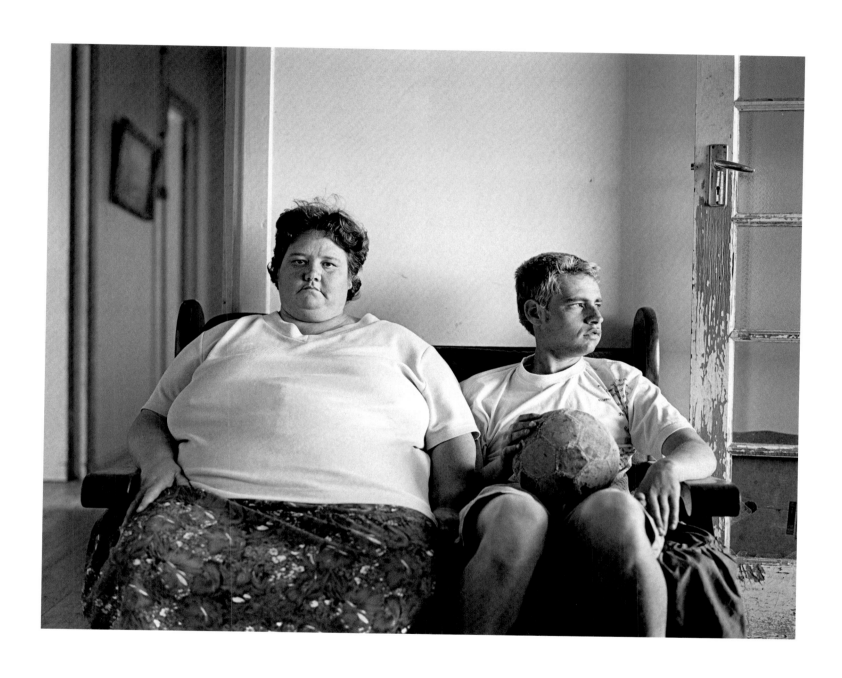

Pierre Crocquet
Enter Exit [32], 2006

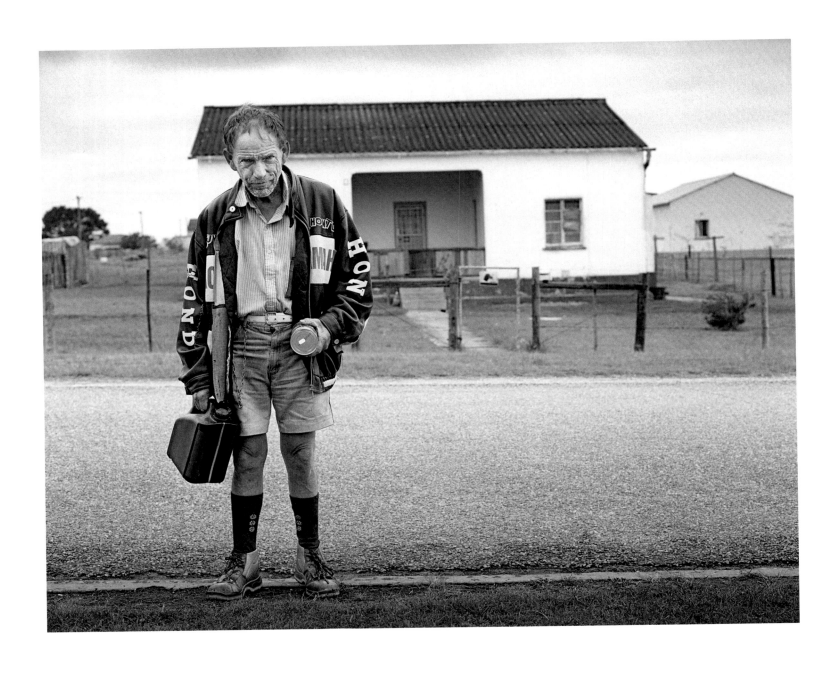

Pierre Crocquet
Enter Exit [4], 2006

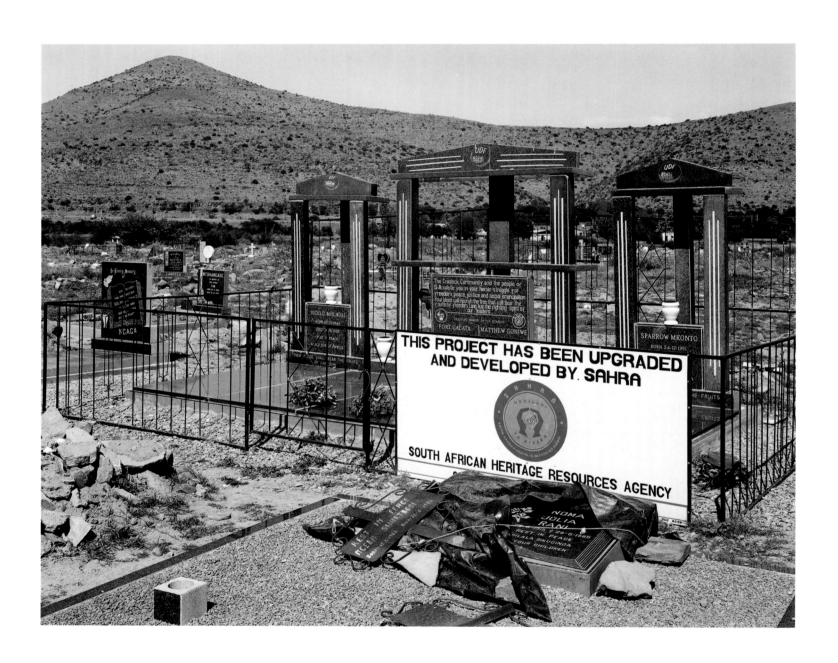

David Goldblatt
Die Gräber der vier aus Cradock, Cradock, 14. Oktober 2004

David Goldblatt
The graves of the Cradock Four, Cradock, 14 October 2004

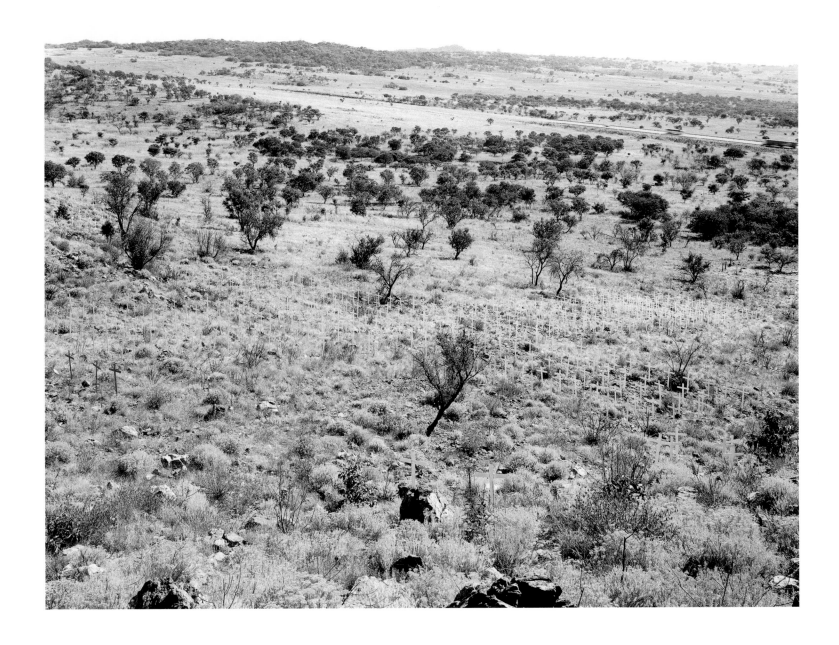

David Goldblatt
Kreuze des Protestes gegen die Farmmorde und in Andenken an die
Opfer, Rietvlei, Limpopo, 19. Juni 2004

David Goldblatt
Crosses in protest against and in commemoration of farm murders,
Rietvlei, Limpopo, 19 June 2004

David Goldblatt
Schafsfarm in Oubip zwischen Aggenys und Loop 10, Bushmanland,
Nordkap, 5. Juni 2004

David Goldblatt
Sheep farm at Oubip, between Aggenys and Loop 10, Bushmanland,
Northern Cape, 5 June 2004

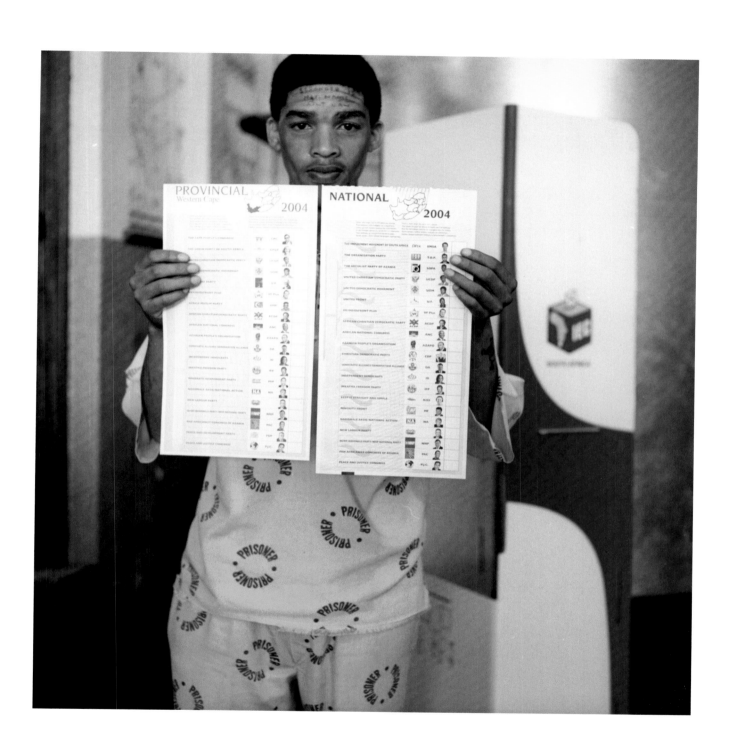

Mikhael Subotzky
Wähler im Gefängnis 1, Dwarsrivier-Gefängnis, 2004

Mikhael Subotzky
Prison Voter 1, Dwarsrivier Prison, 2004

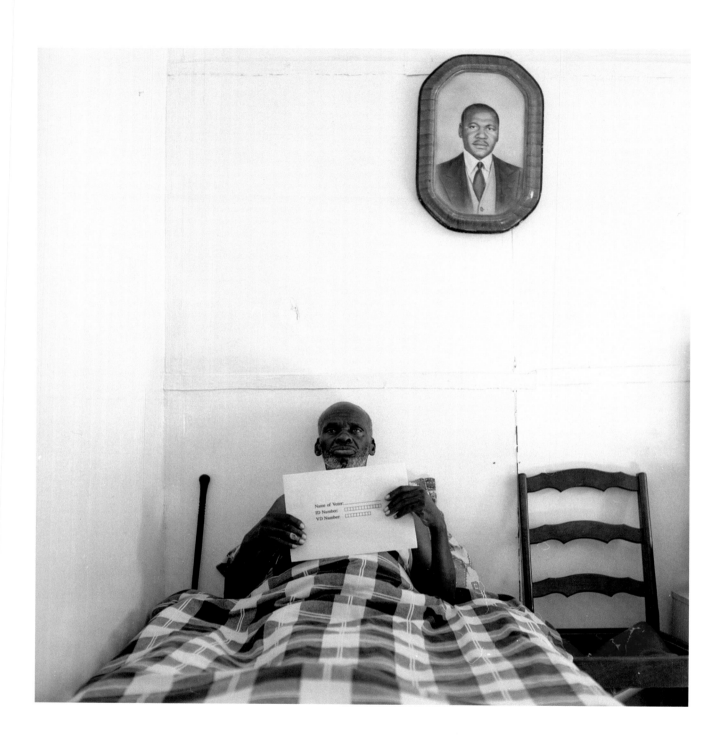

Mikhael Subotzky
Blinder Wähler, 2004

Mikhael Subotzky
Blind Voter, 2004

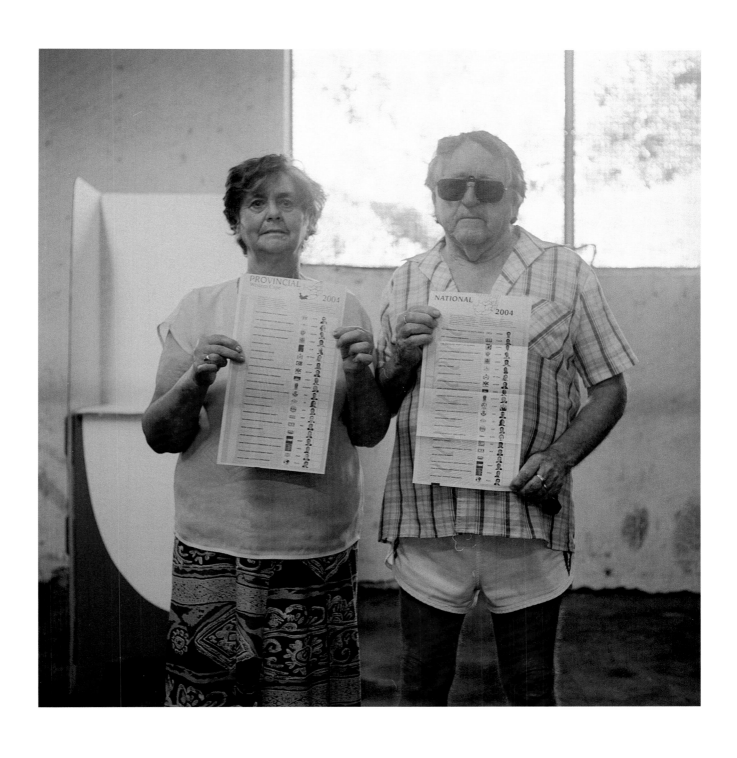

Mikhael Subotzky
Wähler, 2004

Mikhael Subotzky
Voters, 2004

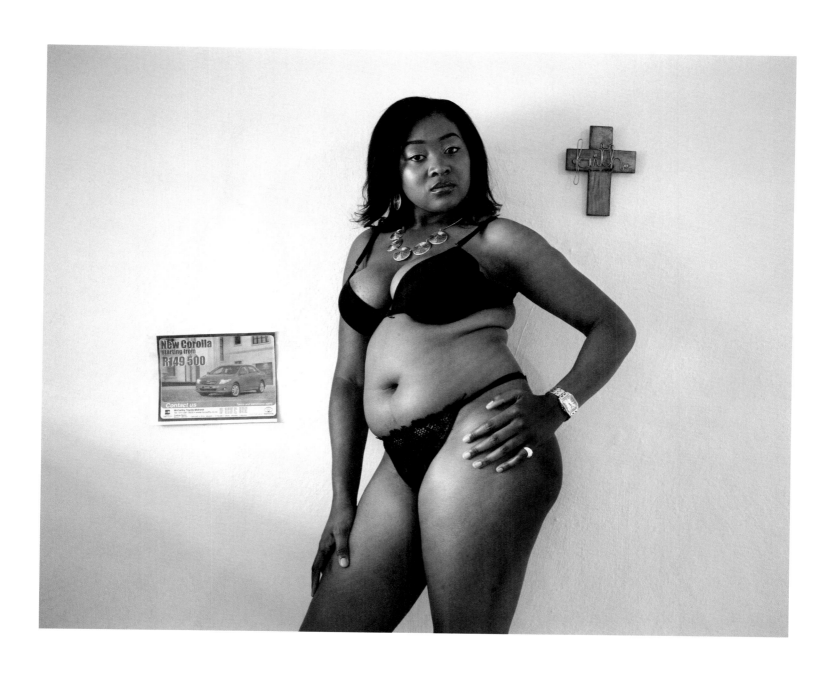

Jodi Bieber
Wahre Schönheit, Brenda, 2008

Jodi Bieber
Real Beauty, Brenda, 2008

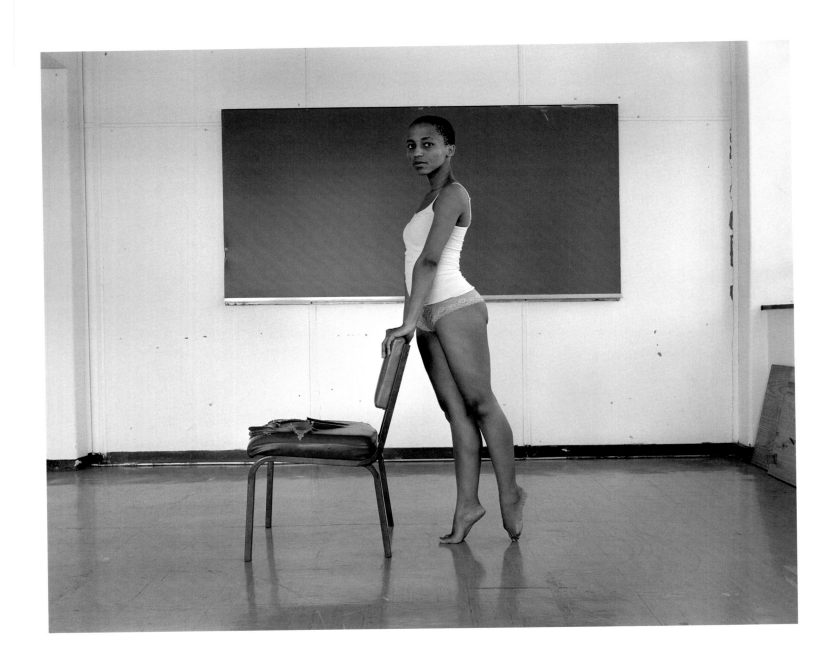

Jodi Bieber
Wahre Schönheit, Onthatile, 2008

Jodi Bieber
Real Beauty, Onthatile, 2008

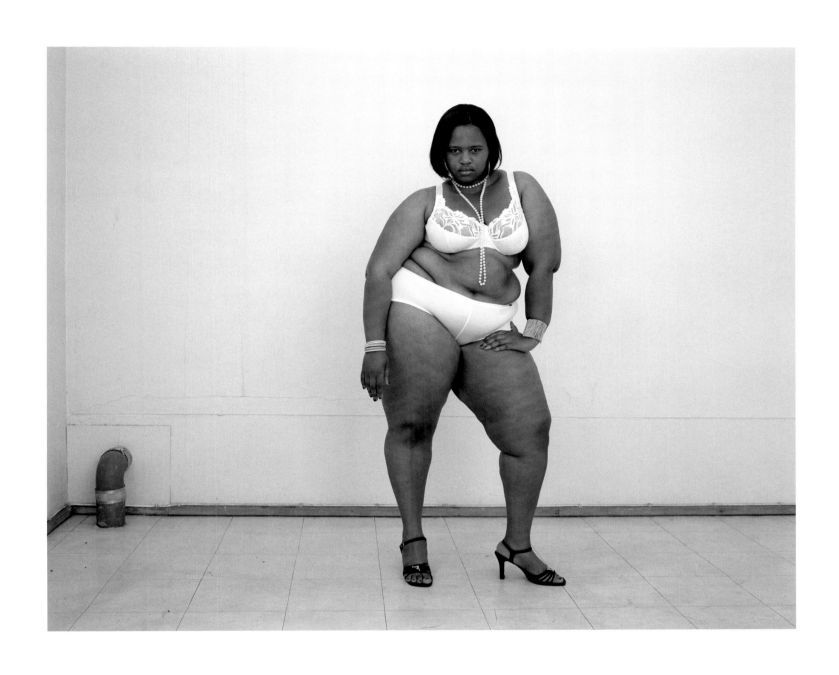

Jodi Bieber
Wahre Schönheit, Babalwa, 2008

Jodi Bieber
Real Beauty, Babalwa, 2008

Kurzbiografien Short Biographies

Bonile Bam
Born 1974 in KwaZakhele, Port Elizabeth
Lives and works in Johannesburg
Seippel Gallery Johannesburg, www.seippel-gallery.com

Jodi Bieber
Born 1966 in Johannesburg
Lives and works in Johannesburg
Goodman Gallery Johannesburg, www.goodman-gallery.com

Pierre Crocquet
Born 1971 in Cape Town
Lives and works in Cape Town and Johannesburg
Caprice Horn Galerie Berlin, www.capricehorn.com
Seippel Gallery Johannesburg, www.seippel-gallery.com

David Goldblatt
Born 1930 in Randfontein
Lives and works in Johannesburg
Goodman Gallery Johannesburg, www.goodman-gallery.com

Bob Gosani
Born 1934, died 1972
BaileySeippel Gallery, BAHA, www.baileyseippel.co.za; www.baha.co.za

George Hallett
Born 1942 in Cape Town
Lives and works in Cape Town
www.joaoferreiragallery.com

Ranjith Kally
Born 1925 in Isipingo, Province of Natal
Lives and works in Durban
BaileySeippel Gallery, BAHA, www.baileyseippel.co.za; www.baha.co.za

Alf Kumalo
Born 1930, Alexandra, Johannesburg
Lives and works in Johannesburg
alfkumalomuseum@tiscali.co.za

Peter Magubane
Born 1932 in Johannesburg
Lives and works in Johannesburg
David Meyer-Gollan, Green Light Africa Entertainment

Gideon Mendel
Born 1959 in Johannesburg
Lives in London and works mainly in Africa and the United Kingdom
www.gideonmendel.com

Santu Mofokeng
Born 1956 in Johannesburg
Lives and works in Johannesburg
Maker Studio-Lunetta Bartz, www.makerstudio.co.za

G. R. Naidoo
Born 1928 in Province of Natal, died 1982
BaileySeippel Gallery, BAHA, www.baileyseippel.co.za; www.baha.co.za

Cedric Nunn
Born 1957 in Nongoma, KwaZulu
Lives and works in Richmond, KwaZulu-Natal
BaileySeippel Gallery, www.baileyseippel.co.za

Sam Nzima
Born 1934 in Lillydale, Limpopo
Lives and works in Lillydale Bushbuckridge
BaileySeippel Gallery, www.baileyseippel.co.za

Mikhael Subotzky
Born 1981 in Cape Town
Lives and works in Johannesburg
Goodman Gallery Johannesburg, www.goodman-gallery.com

Andrew Tshabangu
Born 1966 in Johannesburg
Lives and works in Johannesburg
Galerie Seippel Cologne, www.galerie-seippel.de

Unknown *Drum* Photographer from BAHA
BaileySeippel Gallery, BAHA, www.baileyseippel.co.za; www.baha.co.za

gille de vlieg
Born 1940 in Plymouth, England
Lives in KwaZulu-Natal, South Coast, works in urban and rural areas around Johannesburg
www.africamediaonline.com

Paul Weinberg
Born 1956 in Pietermaritzburg
Lives and works in Cape Town
BaileySeippel Gallery Johannesburg, www.baileyseippel.co.za

Diese Publikation erscheint anlässlich der Ausstellung /
This catalogue is published on the occasion of the exhibition
Südafrikanische Fotografie 1950–2010 /
South African Photography 1950–2010

Kurator / **Curator**
Ralf-P. Seippel, Köln/Johannesburg

Freundeskreis Willy-Brandt-Haus e.V.
Freundeskreis Willy-Brandt-Haus, Berlin, Gisela Kayser, Ela Papen

● ● ●
Museum Goch
● ● ●
● ● ●
Museum Goch, Stephan Mann, Steffen Fischer, Jasmin Schöne

stadthaus ulm

Stadthaus Ulm, Karla Nieraad, Wiebke Ratzeburg

Katalog / **Catalogue**
Herausgeber / **Editor**
Ralf-P. Seippel, Johannesburg, Delia Klask, Köln

Konzeption / **Concept**
Ralf-P. Seippel, Delia Klask

Autoren / **Authors**
Luli Callinicos, Johannesburg; Andries Oliphant, Pretoria; Wiebke Ratzeburg, Ulm

Fotografen / **Photographers**
Bonile Bam, Jodi Bieber, Pierre Crocquet, David Goldblatt, Bob Gosani, George Hallett, Ranjith Kally, Alf Kumalo, Peter Magubane, Gideon Mendel, Santu Mofokeng, G. R. Naidoo, Cedric Nunn, Sam Nzima, Mikhael Subotzky, Andrew Tshabangu, Unknown *Drum* Photographer from BAHA, gille de vlieg, Paul Weinberg

Redaktion / **Editing**
Delia Klask, Köln

Redaktionsassistenz / **Assistance**
Lily McLeish, Tobias Lehr, Köln

Lektorat / **Copyediting**
Karin Osbahr, Hatje Cantz, Alix Sharma-Weigold

Übersetzungen / **Translations**
Lily McLeish, Karin Osbahr, Peter Senft, Michael Wolfson

Grafische Gestaltung und Satz / **Graphic design and typesetting**
hackenschuh communication design, Stuttgart
Christina Hackenschuh, Markus Braun

Schrift / **Typeface**
PMN Caecilia, Avenir

Herstellung / **Production**
Angelika Hartmann, Hatje Cantz

Reproduktionen / **Reproductions**
Repromayer, Reutlingen

Druck / **Printing**
sellier druck GmbH, Freising

Papier / **Paper**
LuxoArt Samt 150 g/m²

Buchbinderei / **Binding**
Conzella Verlagsbuchbinderei, Urban Meister, Aschheim-Dornach

© 2010 Hatje Cantz, Ostfildern, authors, photographers, galleries, designers, Bailey's African History Archive (BAHA)
© 2010 for the Unknown *Drum* Magazine Photographers Bailey's African History Archive (BAHA), BaileySeippel Gallery

Erschienen im / **Published by**
Hatje Cantz Verlag
Zeppelinstrasse 32
73760 Ostfildern
Deutschland / Germany
Tel. +49 711 4405-200
Fax +49 711 4405-220
www.hatjecantz.com

Informationen zu dieser oder zu anderen Ausstellungen finden Sie unter www.kq-daily.de / You can find information on this exhibition and many others at www.kq-daily.de

Hatje Cantz books are available internationally at selected bookstores. For more information about our distribution partners, please visit our homepage at www.hatjecantz.com.

ISBN 978-3-7757-2718-1

Printed in Germany

Umschlagabbildung / **Cover illustrations:**
Vorne / **front**
Bob Gosani, Hochverratsprozess: Ende von Runde eins, 1957 / **Treason Trial: End of Round One, 1957**

Hinten / **back**
Bob Gosani, Liebesgeschichte, Sophiatown, 1954 / **Love Story, Sophiatown, 1954**

Sam Nzima, Mbuyiswa Makhubu trägt den verwundeten Hector Pieterson, gefolgt von dessen Schwester Antoinette, Soweto, 16. Juni 1976 / **Mbuyiswa Makhubu carrying wounded Hector Pieterson followed by his sister Antoinette, Soweto, 16 June 1976**

Cedric Nunn, Deborah Eksteen wird von ihrem Ehemann Noel Norris getröstet, als sie das Grab ihres kürzlich, kurz nach ihrer Hochzeit verstorbenen Vaters besucht, Mangete, 2001 / **Deborah Eksteen is comforted by her groom Noel Norris while visiting the grave of her recently deceased father immediately after her wedding, Mangete, 2001**